S0-AQO-402

Just Passing Through
A Seven-Decade Roman Holiday: The Diaries and Photographs of Milton Gendel

Milton Gendel; Edited and with an introduction by Cullen Murphy

A treasure trove of photos and diary entries that bring the *dolce vita* generation to life.

"I'm just passing through," Milton Gendel liked to say whenever anybody asked him what he was doing in Rome. Even after seven decades in the Eternal City, from his arrival as a Fulbright Scholar in 1949 until his death in 2018 at the age of ninety-nine, he refused to be pigeonholed. He was always an American—never an "expat," never an émigré—but he also couldn't leave, so deep were his ties, and this dual bond left an indelible imprint on his life and art.

Born in New York City to Russian immigrant parents, Gendel first made his way to Meyer Schapiro's classroom at Columbia University, and from there to Greenwich Village, where he and his friend Robert Motherwell joined the circle of surrealists around Peggy Guggenheim and André Breton. But it was Rome that earned his enduring fascination—the city supplied him with endless outlets for his curiosity, a series of dazzling apartments in palazzi, the great loves of his life, and the scores of friendships that made his story inextricably part of the city's own, from its postwar impoverishment through the years of *il boom,* and well into the twenty-first century.

Gendel did much more than just pass through, instead becoming one of Rome's foremost documentarians. He spoke Italian fluently, worked for the industrialist Adriano Olivetti, and sampled the latest currents of Italian art as a correspondent for *ARTnews*. And he was an artist in his own right, capturing the lives of Sicilian peasants and British royals alike on film and showing his photographs at the Roman outpost of the Marlborough Gallery. Then there were his diaries, a casement window thrown open onto a who's who of artists, writers, and socialites sojourning in the city that remained, for Gendel, the *Caput Mundi*: Mark Rothko, Princess Margaret, Alexander Calder, Anaïs Nin, Gore Vidal, Martha Gellhorn, Muriel Spark. His longtime home on the Isola Tiberina was the nerve center of the dolce vita generation, whose comings and goings and doings he immortalized in both words and images.

Here, for the first time in print, are the diaries and photographs of Gendel, selected and edited by Cullen Murphy. *Just Passing Through* brings together the most striking artifacts of one of the past century's richest and most expansive lives, salted with wit and insight into the figures who defined an era.

Farrar, Straus and Giroux | 11/8/2022
9780374298593 | $35.00
Hardcover with dust jacket | 272 pages

89 Black-and-White Images, Colored Endpapers
| Carton Qty: 20 | 9.3 in H | 6.1 in W
All rights:FSG

Just Passing Through

Just Passing Through

A Seven-Decade Roman Holiday

The Diaries and Photographs of

Milton Gendel

Edited by Cullen Murphy

Farrar, Straus and Giroux
New York

Farrar, Straus and Giroux
120 Broadway, New York 10271

Copyright © 2022 by the Heirs of Milton Gendel
Introduction copyright © 2022 by Cullen Murphy
All rights reserved
Printed in the United States of America
First edition, 2022

Photograph of Vittoria Berla Olivetti and twins copyright © the estate of Gordian
Troeller. Courtesy of Ingrid Becker-Ross.

Photograph of Judith Venetia Montagu at her Isola Tiberina home copyright © the
estate of Gordian Troeller. Courtesy of Ingrid Becker-Ross.

Photograph of Milton Gendel with camera copyright © Igor Palmin. Courtesy of Igor
Palmin.

Library of Congress Cataloging-in-Publication Data
ISBN: 978-0-374-29859-3

Designed by Jonathan D. Lippincott

Our books may be purchased in bulk for promotional, educational, or business
use. Please contact your local bookseller or the Macmillan Corporate and
Premium Sales Department at 1-800-221-7945, extension 5442, or by email at
MacmillanSpecialMarkets@macmillan.com.

www.fsgbooks.com
www.twitter.com/fsgbooks • www.facebook.com/fsgbooks

10 9 8 7 6 5 4 3 2 1

Frontispiece: Knife Grinder, Isola Tiberina, Rome, 1959.

With gratitude to the family of Milton Gendel:

Monica Incisa Gendel

Sebastiano Gendel

Anna Gendel Mathias

Bartolomeo Gendel

Massimiliano Gendel

Jesse Mathias

Katie Mathias

Philip Mathias

Anna: What are you writing, Daddy?

A letter.

Letter to myself, which is this daily retrospective. The more detailed I make it, the easier it reveals itself. Oh my affect, where is it? Hack it on to anything. Anna's progress in arithmetic. Ordering meals. Building Piazza Mattei. Talking to the dog. Paying the dentist's bill. Answering the telephone.

—Diary entry, Tuesday, December 17, 1974

Self-portrait, Via Appia Antica, Rome, 1950

Introduction

Milton Gendel was waiting by the open door of his apartments in Palazzo Primoli, not far from Piazza Navona, in Rome, when I stopped by for a first visit, in 2011. His slender frame was angled comfortably against the doorframe, the pose of a younger man. He was already ninety-two. During the seven years he had left, I saw him three or four times a year, whenever I was in Rome. We had been introduced by a mutual friend, which in Gendel's case could have been almost anyone. His range of friends and acquaintants was wide, his capacity for extending it unconstrained. To know Gendel was to achieve one degree of separation from an improbable array of characters. Some are people you'll have heard of: Diana Cooper, Mark Rothko, Iris Origo, Princess Margaret, André Breton, Robert Motherwell, Anaïs Nin, Gianni Agnelli, Gore Vidal, Martha Gellhorn, Alexander Calder, Muriel Spark . . . and a thousand more like these. Others are people who have left no public footprint but with whom he was just as happy to spend his time—the ordinary Romans he lived among for seven decades, from his arrival in the city in 1949, at the age of thirty, until his death in 2018, just two months shy of his hundredth birthday.

"Placing" Milton Gendel—defining his life, his work, his context, his *role*—is not a conventional task. He was a photographer, a critic, a sounding-board, a facilitator, a convener, a collector. Asked why he had chosen to spend his life in Rome, he would generally reply that he was "just passing through," which is what everybody is doing in Rome, whether they know it or not. His various homes in the city were certainly a desti-

nation for others passing through—writers and artists, actors and journalists, aristocrats and arrivistes and members of what used to be called the jet set. It was a long twentieth-century moment that will someday have a name, with the ancien régime still palpable in its twilight but so much else upended or made new. Privately, Gendel was a diarist, leaving behind daily entries totaling some ten million words. The diaries cover everything from mundane details of Gendel's family life to accounts of his travels and observations about books, movies, and the arts. Meticulously, they also memorialize the scene, and the conversation, at numberless intimate gatherings. Gendel was a superb writer, with an ear for the sharp as well as the absurd, a sly sense of humor, and a gift for decisive assessment. (The sex scenes in *Zabriskie Point*, he writes in one entry, bring to mind "coupling dogs trying to obey the laws of the Stanislavski method." The painter Balthus, he writes in another, resembles "a lizard with a high IQ" whose slow, deliberate speech "gives even banalities a certain weight.") At the same time, he was personally unobtrusive. That angled pose in the doorway, watching my approach, captures something of his manner. In a

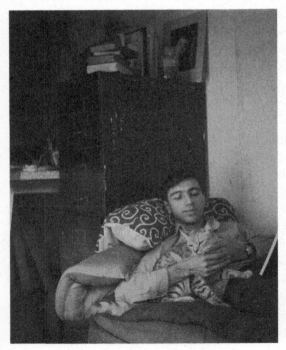

Milton Gendel and Mr. Katz, 61 Washington Square, New York City, 1944

Sargent painting, he might be the shadowy figure in the background, the one you wonder about.

One way to get an immediate feel for the man was to pass through the heavy wooden doors into the suite of rooms that took up most of the piano nobile of the Palazzo Primoli. He had only recently moved in when I arrived—he had lost a previous apartment, in the Palazzo Doria Pamphilj—and was still unpacking, but the walls were already hung with paintings (modern, baroque), and the shelves already sagged with his books. Still unpacked were a lifetime of photographic negatives waiting to be catalogued, and the library recently left to him by Cesare D'Onofrio, the noted historian of Rome. Every horizontal surface—floors, tables, windowsills—held objects collected over a lifetime: Etruscan pottery, Roman marbles, medieval carvings, crèche figures from Naples, bas-reliefs in bronze, commemorative medallions, coins and medals, candlesticks, masks, Judaica. For decades, Gendel made a weekly pilgrimage to the flea market at Porta Portese. On a desk, nestled in a wooden concavity to prevent its rolling, sat a cannonball recovered from the breach of the Aurelian Wall, in 1870, when the forces of Italian reunification overcame the last resistance of Pope Pius IX. In a bedroom, a pair of shoes had been framed and hung on the wall, the soles facing outward. Once, years earlier, Gendel had accidentally walked on some wet white paint; when he put his feet up one evening, his friend Alexander Calder had seen an opportunity and drawn a wiry portrait of Gendel on each surface, one in profile and one full face.

In time, I came to know Gendel's wife of nearly forty years, the artist Monica Incisa della Rocchetta, and his daughter, Anna Mathias, whose mother, Judy Montagu, Gendel's second wife, died in 1972. I also came to appreciate, firsthand, Gendel's peculiar magnetism. He was, as Anna once described him, "his own cultural microclimate." There was hardly a subject one could mention about which he lacked knowledge—ancient tombs, modern politics, gallery prices, romantic entanglements, Renaissance history, Victorian literature, local genealogy—and yet he was never the first to bring a subject up. He had a way of steering conversations while seeming to be in the passenger seat. Monica Incisa captured some of these qualities in the course of a conversation not long after Gendel's death.

Milton was very curious—well educated, but extremely curious. Often we would spend time in bed, each of us reading a book,

and then we would read to one another and discuss what might be interesting. He knew a lot about lots of things, and had a way of conveying them to you in a deep but amusing way. He was a very good listener. He was not modest—he knew perfectly well what he was—but he was modest in his attitudes. He never spoke over other people, which with Italian men happens very often. He really looked at people, and listened to them. He always waited until you spoke. If you asked him a question, he would take time to think about it. I don't think I ever heard him say something stupid, which happens even to the best of us. At the same time, though, he was never boring.

Looking back on the century of his life, it is hard to discern anything like an overt strategy. Some people are visibly driven in a particular direction. They conduct their affairs like a high-stakes chess match. Gendel was deliberate and serious about many things, quick to seize opportunities, and sometimes insistent about aesthetic decisions; but following a master plan was not part of the repertoire. He played a helpful role in the careers of hundreds of people, but not in a transactional way, as if gain for himself were the true object. He put immense effort into writing his diary, but it would remain private. He took photographs wherever he went, binding them carefully in volumes of his own design, but exhibited nothing until he was fifty-eight, and even then the exhibition came about by accident, and was someone else's idea.

Over lunch one day across the street from Palazzo Primoli, Gendel's longtime friend Barbara Drudi, a scholar and critic, put it this way: "He had a kind of good fortune. He never pushed his destiny. He never searched for success. And something happened anyway."

•

Milton Gendel, the son of Jewish immigrants from Russia, was born in New York City on December 16, 1918. His father, Meyer, owned a garment business; his mother, Anna, was a seamstress. An older brother, Edward, would become a doctor.

Milton always thought of himself as a New Yorker, even after seven decades in Rome. He attended Columbia University as an undergraduate

Summer in New York, aged ten

and then, with his friend Robert Motherwell, stayed on to pursue a master's degree in art history. His mentor, for whom he worked as an assistant, was the legendary art historian Meyer Schapiro. In the late 1930s and early '40s, the New York art scene had been both fortified and turned upside down by the arrival of the surrealists—airlifted (literally) from war-torn Europe by the collector Peggy Guggenheim—and Milton was soon immersed in this world. The apartment he shared with his girlfriend (later his first wife), Evelyn Wechsler, at 61 Washington Square, became an artistic and social hub.

Gendel and Motherwell were invited to join the staff of André Breton's surrealist magazine *VVV*. Gendel left an account of those heady years, published as a short monograph, *The Margin Moves to the Middle*, in 1993:

> The dominant personality was Breton, a full-bodied man with a big head banked with wavy hair, who had a deliberate histrionic manner. He would stand up, put one foot forward, and declaim—statements or lines of poetry—accompanying himself with elocutionary gestures. I imagined this repertory as going back to sessions of the States-General during the French Revolu-

With Evelyn Wechsler,
his first wife, outside
the Washington Square
apartment, 1944

tion . . . Peggy Guggenheim's planeload of protagonists of the arts
and intellect had included her second husband, Max Ernst, who
was generally silent during Breton's meetings but visually present.
He looked like the American bald eagle on the Great Seal of the
United States, flown in somehow from Europe. At the Guggen-
heim house on the East River, where the *VVV* group frequently
spent their evenings, Ernst sat enthroned in an armchair with a
theatrically high back that gave him an odd dimension, as if he
had undergone the shrinking process described in *Alice in Wonder-
land*. Among the younger "Europeans" was the Chilean, Matta
Echaurren, who had studied architecture with Le Corbusier in
Paris, but then had become a painter. He was the liveliest member
of the group, galvanically in movement as he spewed torrents of
words.

What brought this life to an end—for Gendel, though not for others in
this Greenwich Village circle—was the United States' entry into the war.
Gendel believed he should join the fight, and in 1942 he enlisted in the
army. The decision caused a rupture with André Breton, who told him,
"Vous voulez participer à cette bêtise, mais je dois dire que ça c'est con" [You want to
take part in this stupidity, but I must tell you it's idiotic].

Joining the army would prove decisive, though not in a predictable way. After attending language school at Yale, Gendel was sent to China, where in 1945 and '46 he assisted with the repatriation of Japanese soldiers. It was there, with a borrowed Leica, that he began taking photographs, chronicling ordinary life in Chinese cities. Returning to New York, he worked briefly as a writer for *Funk & Wagnalls Encyclopedia*—his archivist impulses getting a thorough workout—while applying for a Fulbright scholarship to take him back to China. He won the Fulbright, but by then China's civil war had culminated in the victory of Mao Zedong's Communists. Access was no longer possible for an American. Gendel decided to go to Rome instead, where he would study Italian architecture as it had developed in the period after reunification. Gendel had been in Rome once before, when he was twenty, as Europe was spiraling into war. He returned with Evelyn in December 1949.

Gendel held on to everything. I remember seeing the battered filing cabinets at Palazzo Primoli that held his diaries and his correspondence. So it is not surprising that there survives a copy of a letter that Evelyn sent home within weeks of taking up residence in Rome:

> We are indefatigable tourists, leaping from monument to ruin to gallery. Weekends we've been making excursions to Tivoli (Villas d'Este and Adriana), to Ostia Antica, and to Viterbo, touring the countryside en route, through Caprarola (Palazzo Farnese) and the medieval hill towns, with lots of Etruscan rock tombs on the side. We have by now a considerable collection of small portable treasures looted from every site within a fifty-mile radius of Rome. Also, we got blessed from three feet away by the Pope himself in person on Xmas eve in St. Peter's, and on the following day we got blessed by a priest in Santa Maria Maggiore, who leaned on a wooden box in the wall to tap us each on the head with a long wand, like a prankish schoolboy.

Not long after their arrival, Evelyn met the novelist and essayist Sybille Bedford—whose ramshackle apartment, near the Spanish Steps, Gendel helped to rewire—and began a long affair. Her marriage to Milton came to an end. Evelyn eventually returned to New York and became a literary agent and book editor. She and Milton remained friends.

The Fulbright ended in 1951, but Gendel stayed on. He had picked up Italian—a very good, precise Italian, though he always spoke it with an American accent—and was gradually becoming embedded in Rome. His influential architect friend Bruno Zevi had introduced him to Adriano Olivetti, the industrialist and social visionary, and Olivetti took him on as his English-speaking public relations adviser. Gendel also turned his hand to translation, starting with Zevi's book *Saper vedere l'architettura*, which would eventually be published in English under the title *Architecture as Space*. Meanwhile, Gendel was writing for *ARTnews* about modern painters in Italy such as Alberto Burri and Toti Scialoja; eventually he became the magazine's official Rome correspondent. Later he wrote a series of books about architectural monuments, like the Colosseum and Hagia Sophia. Throughout his time in Rome, he helped friends by writing bits of text for their exhibitions and introductions for their catalogues.

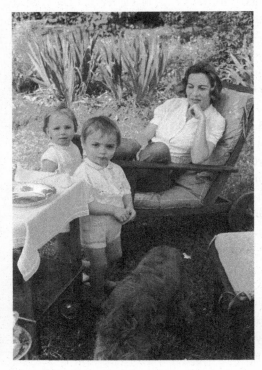

Vittoria Berla Olivetti
with the twins Natalia and
Sebastiano, Rome, 1960
(Photograph by Gordian Troeller)

Very early on—in April 1950—Gendel made a connection that would lead to a lifelong friendship: with Countess Anna Laetitia Pecci-Blunt, known as Mimì, an impresario of the arts in Rome both before and after the war and a shrewd collector of paintings, books, and maps. She was a great-niece of Pope Leo XIII, who had baptized her, and a larger-than-life figure who spoke five languages. She maintained a palazzo in Rome, at the foot of the Capitoline Hill, and a seventeenth-century villa outside Lucca—Villa Reale di Marlia, in Capannori, which had once been owned by Napoleon's sister.

A gallery owner had arranged for an invitation to a reception being held by Pecci-Blunt, and on a wet night Milton and Evelyn made their way to the palazzo. Milton had already begun keeping a diary:

John Deakin, the English photographer, had been preening himself about an invitation to Countess Pecci-Blunt's. *Fabulously rich, you know. Magnificent apartment and collection of modern paintings. Don't touch my suit, must wear it on Wednesday; must look my best, you know.* When my invitation came, I didn't mention it to Deakin because I wanted the joke of walking into the place and finding him there. It rained the night of the party, and Evelyn had to walk gingerly over the Capitoline Hill to Piazza d'Aracoeli, trying to keep her shoes out of the puddles. Three footmen took our coats in the reception hall, a vast barrel-vaulted room covered with frescoes. Then followed three or four reception rooms, also vast, also frescoed and filled with sofas, heavy tables, soft lamps, flowers, and Renaissance paintings. These rooms were not occupied; the party was concentrated in the last hall, a final barrel-vaulted room full of chattering guests.

Pecci-Blunt's first words to Gendel were: *"Oh yes. I know who you are."* His friendship with Mimì, like those with Peggy Guggenheim and the writer and art expert Tom Hess, helped open doors to what would otherwise have been an impenetrable social world.

Peter Benson Miller, an art historian and a friend of Gendel's, mounted a major exhibition of his work in 2011 and is in the process of organizing another exhibition. Until 2019, Miller was the Andrew Heiskell Arts Director at the American Academy in Rome. We spoke one afternoon in

the academy's garden, on a bench by an olive tree. Miller brought up "an ease and almost nonchalance" that Gendel possessed, an ability to make friendships that transcended social class or creative field or nationality:

> It's not enough just to meet people. You have to maintain and cultivate relationships, especially in a country like Italy in the '50s, where people didn't invite you to their house after meeting on the street. Milton had the kind of character that understood the art of conversation. He knew how to listen. He hardly ever talked about himself. And so he maintained—I don't know what the right word is—but he maintained a sort of air of mystery that made people want to know more. He understood how to take a back seat so that other people felt important and good about themselves. And he knew how to match people up with each other who in normal daily life would not have otherwise met. He could also think several steps ahead of people. He knew, if they had a project, who could help them.

Gendel was never a professional photographer or a photographer with a capital *P*. He admired and was influenced by—and wrote about—Henri Cartier-Bresson, but he did not take photographs in order to have them shown in public (though he showed them to his friends), just as he did not keep his diaries for public consumption. He had started traveling with his Rolleiflex camera soon after arriving in Rome—making trips to Sicily and elsewhere—and the camera became an adjunct to his life. He stopped taking pictures only in his last years, because his hands sometimes shook, making even the large glass of whiskey he enjoyed in the evening a challenge.

That Gendel exhibited at all was a fluke. In 1977 his friend Carla Panicali, who headed the prestigious Galleria Marlborough, in Via Gregoriana, faced an unexpected gap in her exhibition schedule—something had fallen through. She persuaded Gendel to show his photographs. A few years later Sophie Consagra, the director of the American Academy in Rome, oversaw a second exhibition. Gendel took photographs for the same reason he kept diaries, in order to remember and record. He was a quintessential observer, led as much by the eye as by the ear. He organized and filed his negatives and contact sheets with care. Once a year he would

gather a selection of prints and arrange them on heavy beige cardboard stock, one spread after another, writing names and locations underneath by hand. Then he would bring the loose pages to a bookbinder, along with the leather to use for covering the boards, and have a bound volume created to his specifications.

There was a soft quality to Gendel's movements, as there was to his picture-taking. In a letter to a friend, written soon after meeting Milton, Judy Montagu described him as moving "like a panther." He knew when to leave the conversation, take his camera out, quietly snap some pictures, then rejoin the conversation. Monica Incisa described those moments:

> He managed to be unobtrusive. First of all, he was always a participant in the group. He wasn't like, you know, a photographer that you hire and sits apart. He somehow managed to speak and then maybe take a picture and then put the camera down. And he was never noticeable. You knew he was taking pictures but you

Judith Venetia Montagu at her Isola Tiberina home, Rome, 1960 (Photograph by Gordian Troeller)

didn't think about it. Secondly, he was doing a lot of editing after the fact, so he never would publish or use photographs where the pictures of people, or the composition itself, were not successful. And he always used the best possible picture of a person. His pictures are never aggressive. He was respectful of the things he took pictures of. His pictures have a certain sweetness. He took pictures like the way he spoke.

Peter Miller went further, using the language of criticism that Gendel would have understood perfectly but never used about his own work. Indeed, he did not write much about his photography at all. Here's Miller:

To take the kinds of photographs he took requires a certain distance, because a camera is something that separates, and there is a kind of self-consciousness not only for the person taking the pictures

Anna, Natalia, and
Sebastiano, Isola Tiberina,
1972

but also for the people being photographed. It adds a barrier in a way. But at the same time that there's a distance, there also has to be complicity. People in formal situations do not allow themselves to be photographed in the way that he did, in many cases very distinguished people with social codes governing personal relationships. He wouldn't have felt comfortable taking those pictures and they would not have felt comfortable being photographed if complicity did not exist. It goes back to what made Milton such an alluring character and so effective in his management of a wide network of friendships from vastly different levels of society—his ability to be both inserted and separated. To be a part of the party yet also to look at it with a certain amount of distance.

Inserted and yet separate: the idea speaks to an element of stage-setting, at once deliberate and unconscious. The stage setting began with the places Gendel inhabited. The books and paintings and objects were arranged densely in a way that may have looked haphazard—and that in fact felt natural and comfortable—yet required great care. The arrangement seemed designed to provoke conversation. I don't recall Gendel directing specific attention to anything in his home; he didn't need to. A visitor's eye generated ample questions on its own.

In an essay entitled "On the Road / Off the Road," Marella Caracciolo Chia, a writer and a friend of Gendel's, described his distinctive habitations over the years. In Washington Square, Milton and Evelyn had painted the wooden floors of their apartment with wavy black and red lines and had adorned the rooms sparely with scavenged or homemade furnishings. "It is our favorite salon," Anaïs Nin recalled, "because it is roomy, vast, casual, nonchalant. No one ever fusses over you. You can come and go." In Rome, Gendel lived first in an apartment in a small palazzo on Via di Monserrato, near Palazzo Farnese, then moved to quarters in Piazza Campitelli, on the edge of the old Jewish Ghetto. He kept those lodgings as a studio and office after moving, in the early 1960s, into two floors within Palazzo Pierleoni Caetani, on Isola Tiberina, the slender, ship-like island whose bridges on either side link the Ghetto, on one bank, with Trastevere, on the other. In the diaries, this iconic residence is always referred to simply as "the Isola."

The filmmaker Michelangelo Antonioni used the residence, and Gen-

del's bedroom, in his 1960 movie *L'Avventura*. In the early 1970s, Gendel took a floor in Palazzo Costaguti, on Piazza Mattei, overlooking the famous turtle fountain. His friends Gabriella Drudi and Toti Scialoja—Barbara Drudi's aunt and uncle—lived upstairs. In 2007 Gendel moved his studio and office to a ground-floor apartment in Palazzo Doria Pamphilj and from there he moved to Palazzo Primoli.

In the last years, he continued to see visitors and to write and was often assisted by his grandson Bartolomeo, who was able to run errands, keep filing up to date, and handle issues with the computer. Gendel would take a bus in the morning to Primoli from the home he shared with Monica in the Ostiense neighborhood of Rome, near the Pyramid of Cestius and the Protestant Cemetery.

Monica described for me the first time she stepped foot inside the Isola apartments, a dwelling she wonderfully referred to as Gendel's "container":

> I'd never seen anything before that I would walk into and say, *This is it!* There was a little door, and then you would go up the steps. And then you would come to this big room that had arches, and the arches had iron rods so that it wouldn't collapse on you. It had a sofa, it had a table made of slabs of marble. But it was not so much the things—the things were good, but not extraordinary. I've seen many more extraordinary things in palaces. And yet everything worked together, the spaces and the furniture, in such a way that you were never disturbed by any detail. What was also different was the lighting. Milton knew exactly what to do with light. Lighting on the ceiling makes every room smaller. It comes down cold, and doesn't work for people or for their surroundings. Milton knew how to place lights in such a way that they complemented the room. The first time I came to the island I was struck by that. And then there was the informality of everything. Some people would sit on the floor, adjusting to the space in a way that was suitable and comfortable and easy. I came from a totally different world where nothing was easy, nothing was suitable, nothing was comfortable. Everything was codified. You did this, you did that. Milton did whatever he liked. It was a revelation.

Marella Caracciolo Chia once described for me what she called Gendel's natural sprezzatura, if there can be such a thing—a studied carelessness that was simply part of his character.

I practically grew up in Milton's home, because of his friendship with my parents and my friendship with Anna, and even as a child I appreciated his magical touch. Milton was the architect, the collector, the decorator. He had a knack for finding the most beautiful places to live for next to nothing. In the 1950s and '60s and '70s, you could still live in a palazzo for a song. His eclecticism and his eye for the beautiful objects he found at the flea market at Porta Portese were exceptional. At Porta Portese, you never knew quite where everything came from. Milton continually bought new things—even if they were new

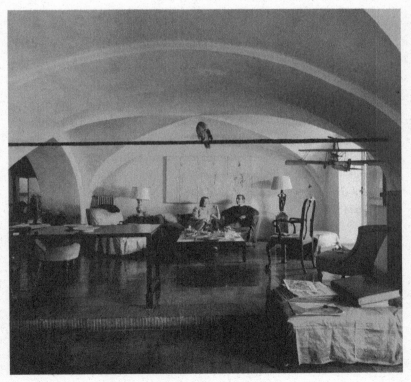

Judy and Milton at the Isola Tiberina home, Rome, 1960

old things—because they stimulated his imagination and his sense of humor.

A lot of houses in Rome had been untouched for generations—the houses of all the old princely families. Milton's homes were never finished, always a work in progress. Some things went with him everywhere. There was the famous brass bed, the one that Antonioni used in *L'Avventura*. And the square marble table with the Latin inscription. And the contemporary artwork—the Toti Scialojas, the Calder shoes, the portraits of himself. The paintings went up, up, up the walls, right up to those high ceilings. So did the books. It was theatrical and exciting—but also comfortable. "Come for a drink," he would say, and the types of people you found at his home were always surprising. He wrote his life through his houses—there's an autobiographical narrative that comes through in a very truthful way.

•

Milton Gendel's diaries are centered on people—people stopping by for a drink, people at lunch or dinner or on picnics, people going to the movies or to an exhibition, people encountered on the street, people involved in book projects or magazine assignments, people coming to fix the plumbing or get payment for an overdue bill. Money is intermittently a problem. Personal relationships become complex—in the telling, other people's relationships mostly, but his own as well.

After the end of his marriage to Evelyn, Milton fell in love with Vittoria Berla Olivetti, who was briefly married to Adriano Olivetti's son Roberto. Milton and Vittoria had two children, the twins Sebastiano and Natalia, born in 1958.

But when Gendel remarried, in 1962, it was to someone else he had begun seeing: Judith Venetia Montagu, whose British lineage was old and distinguished. (Martha Gellhorn used a fanciful version of this triangle as the grist for her 1961 novel *His Own Man*, set in Paris, not Rome, and with the bohemian sinologist Ben Eckhardt in the role of a young man torn between two very different women.) Judy Montagu was well-connected and close to Princess Margaret. Other friends included Bindy and Tony Lambton, Patrick Leigh Fermor, Pamela Egremont, John Julius Norwich,

and Rory and Romana McEwen. Gendel's own friendships with such people would continue after Judy's death in 1972.

In a recent letter, Anna Mathias, Judy and Milton's daughter, born in 1963, recalled how her parents met:

> My father was spotted as a possible beau for my mother by Lady Diana Cooper, who, recently widowed, would go to Rome with Evelyn Waugh. Diana, plotting, invited Milton to stay with her at the Château de Chantilly, in vain, but she persisted and instead took Judy to Rome, to him, in 1957. There my parents met, at a party held by Patrick and Jennie Cross (he ran Reuters and she was Robert Graves's daughter) on the roof terrace of their apartment in the Palazzo del Grillo, overlooking Trajan's Market. My mother was no beauty (though my father described her "stony noble features"), and while neither poised nor elegant, her being encompassed a captivating vitality, a reckless generosity, a flashing intelligence and wit, and a fascination with all whom she met. Although rich in terms of both money and a wide range of friends of all nationalities and backgrounds, Judy's sophistication came more from her eclectic and political family, meteoric success as an officer during the war, and her lack of snobbery. Both grandfathers were Lords, and the ancient house of Stanley—of Bosworth Field and the hockey cup—was grand and remarkable for its eccentrics and iconoclasts. Bertrand Russell, Rosalind Carlisle (the battle-ax temperance chatelaine of Castle Howard), and Judy's great-uncle Henry, the first Muslim convert of the British peerage, were among my mother's maternal relations. Her father's family, the Montagus, were the second Jewish family in Britain to be ennobled, after the Rothschilds. Judy's father, Edwin Montagu, was a distinguished Liberal politician and Secretary of State for India, whose Montagu-Chelmsford Reform of 1923 advocated independence for India more than two decades before the event. Moreover, it was he who insisted on an addendum to the Balfour Declaration, that no native peoples be displaced should the nation-state of Israel be established. My mother thrived in the war when she and her cousin Mary Churchill served in the antiaircraft batteries of the Auxiliary Territorial Service, but

spent many weekends on leave in London with Sir Winston and Lady Churchill, who played a fundamental part in giving her a haven away from her demanding and acerbic mother. Having come out of the army as a major and a chauffeured instructor of ack-ack guns, my mother spent most of the late 1940s and early '50s between England and the U.S., where her closest friends included the Cushing Sisters and Joe Alsop. By the time my parents met, my mother—who tended to fall deeply in love—had often had her heart broken or twisted. The letters and crushed orchid from the Earl of Verulam's younger son, Bruce Grimston, who was shot down in action; the dalliance with Patrick Leigh Fermor; the mysterious engagement to Ray Livingston Murphy, the literary scholar and Yale historian—all took their toll. And although my parents did have happy times and shared a fundamental bond in their fascination with people, my mother's health was relentlessly poor, and the last years of her life and of their marriage were strained and difficult.

In the diaries, mentions of a young woman named Monica Incisa della Rocchetta eventually begin to appear. There is a passing reference to an encounter in 1970, when Monica tells Milton she is working for Merrill Lynch. "Thought she was saying Mary Lynch," Gendel wrote, "like Fanny Farmer, and couldn't imagine what sort of brokerage that might be."

A friendship deepened, and in 1981, Milton and Monica were married at the Connecticut home of Cleve and Francine du Plessix Gray. Monica recalled the first time they met:

I was going dancing at a place called Piper, which was the first discotheque in Rome, in 1968. I was going with a couple of half-English/half-Italian friends, and a girlfriend named Gaia de Beaumont. She was at a party at Milton's on the Island. So we went inside to say, Gaia, got to go. And that was when I met him. He was married to Judy, and I was fascinated by both of them. A week or so later Gaia called me up and said, Do you like Milton, and I said, Yes, yes, and she said, Would you like to come to dinner? I'll invite him, too. This was not for romantic purposes—he was fifty. But he had a personality that I found very attractive.

And then somehow we became friends. He used to take me to exhibitions. We would have the occasional lunch or dinner. Judy died in 1972, and he went to Japan with his daughter Anna, who was then ten. I didn't see him for a while. When he came back, we started seeing each other again.

He knew me better than myself. He was compassionate. He was compassionate also in a wider sense. He never refused to give money to somebody in the street, and didn't make a fuss about it. He liked animals and understood them. Every time I'd see something or read something, I would want to speak about it to him. I still have this feeling. I never met anybody that corresponded to me as well as he. It was not only physical passion, or whatever, but he was somebody I deeply admired and really liked. I even liked a lot what I *didn't* like.

The day before he died, Milton was alert and talking about a typo in an article he had just read in *The New Yorker*. Monica sat with him as he fell asleep. She remembers altering the pattern of her own breathing, slowing it down to synchronize with his.

Monica Incisa della Rocchetta and Milton Gendel on their wedding day in Warren, Connecticut, 1981

Monica Incisa, Piazza Mattei, Rome, 1995

•

In November 2018, a month after Gendel's death, the American Academy in Rome, where Gendel had been an honorary member of the Society of Fellows, held a long-planned celebration to mark his centenary. The papers are available on the academy's website. In 2011 and 2012 the academy and the Museo Carlo Bilotti sponsored exhibitions of Milton Gendel's work. The richly illustrated catalogue—*Milton Gendel: A Surreal Life*—includes essays by the editors, Peter Benson Miller and Barbara Drudi, and several others, including Lindsay Harris, Alberta Campitelli, and Marella Caracciolo Chia. (Chia's "On the Road / Off the Road" appears in this catalogue.) Barbara Drudi's *Milton Gendel: Uno scatto lungo un secolo*, published in 2017, focuses biographically on the important years from 1940 through 1962. Gendel's photographs—seventy-two thousand in all—are held by the Fondazione Primoli, whose president, Roberto Antonelli, and archivist, Valeria Petitto, have made them available for this book. Gendel's diaries, the most detailed source of information about his life and circle, remain in the hands of his family. The diaries will ultimately find an institutional home.

Gendel's son, Sebastiano, lives in Rome, where he is a physician. He is the father of two children. Gendel's daughter Natalia, Sebastiano's twin

sister, died tragically in 1989, an event marked in Cosima Spender's recent Netflix documentary *SanPa*. His younger daughter, Anna Gendel Mathias, is a school governor, teacher, writer, and archivist who lives with her husband, Charles, in Essex in a historic house called Nether Hall. They have three children. Monica Incisa della Rocchetta continues to live where she and Milton spent many years, just outside the Aurelian Wall. She remains active as an artist and illustrator.

In presenting selections from Milton Gendel's diaries, I have sought to be guided by the needs of the reader rather than the demands of a scholarly apparatus. The diaries, which depict Rome in one era as intimately as those of Samuel Pepys depicted London in another, will get their scholarly due one day. In this volume, many entries are excerpted rather than printed in full. Occasional spelling errors have been corrected. And Gendel's shorthand abbreviations have been unpacked and presented as actual words.

—*Cullen Murphy*

Just Passing Through

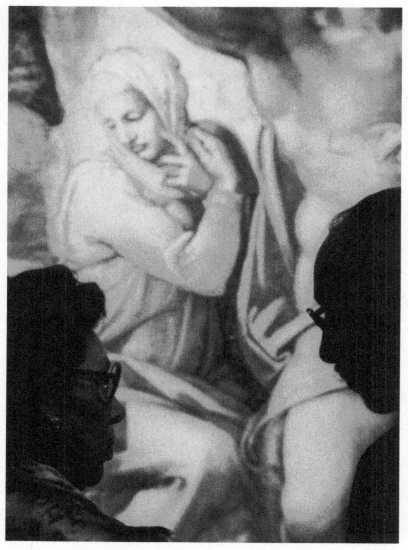

Princess Margaret and Fabrizio Mancinelli of the Vatican Museums, Sistine Chapel, 1993

Rome. Sunday, September 17, 1967

Porta Portese at 8:00. Nothing of interest except a big black krater one of the diggers had hidden in a box, wrapped in newspaper. Lunch at Piazza Campitelli.

To Gore's* for a drink. The feeling set in—what am I doing here? Gore's apartment, arranged by an interior decorator and furnished with upper-bracket junk—so many chairs from Anna Maria Aldobrandini, a Roman head, pairs of Chinese vases flanking the sofa. A big tapestry placed off-axis because of the construction of the room, but then framed between two ten-foot baroque candelabra. A display of prints of seventeenth-century personages in a lozenge-shaped group over the sofa. The house is like his work, which is also slick, easy, and sometimes sleazy. The real accomplishment is his career, which from its unfavorable beginnings—those unspeakable novels—has been perfected as an intricate, smooth-running mechanism. A Rolls-Royce engine of a career. And of course he is very engaging.

To Judy† he had reported that the Snowdons‡ had apologized to him for the terrible evening in the nightclub at Porto Cervo. I don't believe they would fly that low. Gore is very good at *broderie anglaise*—and can turn an

*Gore Vidal (1925–2012), novelist, screenwriter, critic, controversialist. Starting in the 1960s, Vidal spent most of his time in Italy, at first living in Rome, later dividing his time between Rome and a villa on the Amalfi coast.

†Judith Venetia Montagu (1923–1972), daughter of Edwin Montagu and Venetia Stanley. She was married to Gendel from 1962 until her death. In the diaries, he typically refers to her simply as "J."

‡The Snowdons—Princess Margaret (1930–2002), sister of Queen Elizabeth II, and her husband, the photographer Antony Armstrong-Jones (1930–2017), Lord Snowdon—were both close to the Gendel family. Margaret was a longtime friend of Judy Montagu.

Flea market, Porta Portese, Rome, 1979

incident so that it in effect revolves around himself, like a description he gave of seeing Mrs. Kennedy after the assassination, in which he became a chief actor along with her, but unfortunately I had read the same detail in a magazine account and recognized that he had substituted himself for one of her entourage. Not that he wasn't close to her, but he wants it to have been more.

Rome. Wednesday, October 18, 1967

Lunch at Piazza Campitelli, and afterward drove out with Bill Pepper[*] to a field on the Appia Antica, where Beverly had some huge pieces of shiny metal sculpture, all framed boxes or toppling stacks of open cubes, with mirror shine on the outside and linings of enamel in blue and yellow. Row of cars and in back of a truck, John Ross[†] with black cloth on his head taking photos. Beverly was Sadie-Thompsoning around in light-blue pants and laced shirt—snapping, too, with a 36mm camera. Crew of ten men waiting to unbolt the sculptures and put them in a truck. Ross said the scene reminded him of the miracle sequence in *La Dolce Vita*.

On the Appia Antica, the whores, all in very bright colors—reds and oranges—and miniskirts, sit on rocks or get into little groups and horse around. Near the Raccordo Anulare, one grabbed another around her waist from behind and hefted her up, shouting, "*Guarda 'sta pancia!*" [Look at this belly!]

Bill is leaving *Newsweek*, he said, because he earned $10,000 on extra articles alone last year—sold by his agent—and had such good offers for books, including one on Pope Paul, that he figured he could get along without the magazine. Especially, he said, as we own our house. But Gore was very unkind and seemed to resent another competitor entering the field. "You'll starve, Bill. Think it over." That Gore Vidal—he can make you angry sometimes. I had dinner with him one evening, with Bill Styron, just the three of us, and Gore was sounding off about the Kennedys and saying different things about U.S. politics, and at the end of it, he said, now that's not for Leonard Lyons or anyone.[‡]

Gore says he never had an income. He had saved $4,000 when he got out of the army, and his father gave him $10,000, and he never had anything else except what he earned. "Why do you think I've published so

*Curtis Bill Pepper (1917–2014), *Newsweek* bureau chief in Rome. His wife, Beverly (1922–2020), was an acclaimed sculptor of monumental outdoor works.
†John Ross (1920–2006), American photographer, known particularly for his images of Egypt.
‡Leonard Lyons (1906–1976), Broadway and gossip columnist for the *New York Post*.

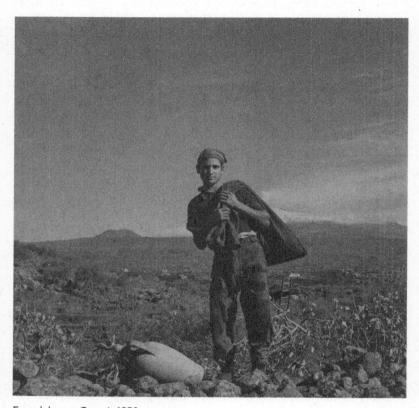

Farm laborer, Caraci, 1950

much and so quickly? I didn't have time to sit around, nor a rich wife, like Styron, and build up a picture of the literary man."

Rome. Monday, November 13, 1967

Massai, the liquor store in Via del Progresso, has given notice that if we do not pay up on Adriana's* bill—62,000 lire—they intend to go to court.

Work on Olivetti proposal for school of industrial design. Lunch at Piazza Campitelli.

Walk to St. Peter's. After two or three years of having the nave encumbered with seats—for the Council—the church looks as it used to do. What balls was taught about the interior. Upjohn at Columbia† used to say with conviction that the space had been falsified by the decorations. The mosaics and sculptures and the architectural details were out of scale, and thus one had no real idea of the vast proportions of the building. This is not true. The visitors give the scale themselves immediately. The space is measurable, in terms of the familiar classical orders—it is clearly one of the largest such spaces in existence. Comparable—as a question of scale— is the Pantheon. The Upjohns were thinking of another kind of space and comparing it to that of St. Peter's, to the disadvantage of the latter: the kinds of space developed from the end of the Imperial Roman times to the Gothic period. In other words, spaces created with unmeasurable elements, which give an illusion of incommensurable continuity.

It was a beautiful day, and at 4:00 the basilica was still very light. Beams striking down from the window over the front doors. Small figures of visitors moving along the great concourse that is the nave. I was reminded of Pennsylvania Station. It was wrong to destroy it. In a Communist country, it would not have happened for the same reason that so much was preserved in Italy: poverty.

Rome. Saturday, November 18, 1967

Olivetti industrial school project. Lunch with Anna.‡ Afterward we read. She can pick out a number of words and could do more, but attention

*Adriana, a cook who worked for the Gendels in the 1960s; dismissed for theft.
†Everard M. Upjohn (1903–1978), a historian of art and architecture, came to Columbia University in the 1930s. His great-grandfather, Richard Upjohn, had popularized Gothic Revival in the United States. Gendel, a Columbia graduate, wielded the phrase "the Upjohns" to refer to a familial school of thought.
‡Gendel's younger daughter, Anna Venetia Gendel (Mathias), born in 1963.

Judy Gendel holds the newborn Anna Venetia, Isola Tiberina, 1963

flags. She made a scene before we sat down. Rare for her, but she retired to her bedroom and rolled up with a blanket. When I asked her what the matter was, she said, "I am not very happy." Why not? "I can't explain it." The main trouble was that she had gone into the kitchen to ask Anita,[*] "What's for lunch," and was vexed to hear that it was chicken. She wanted spaghetti. In the end she had both.

Sunshine. Work.

Claire Sterling[†] had a cocktail party for a Trinidadian guest, who was part of her Ghana life. There were a man and a woman from the Ghana embassy. Long talk with Ada Sereni,[‡] who went with her husband—socialist—in 1927 to settle on a kibbutz near Tel Aviv and stayed there for twenty years. He was parachuted into Germany during the war, caught, and killed at Dachau. Claire, playing hostess, mixed us around. Number of people I never spoke to. Left with Gore Vidal and the Peppers. Gore's manner gets more and more formal, like royalty or the pope. Curled up with Beverly in the back seat. Our routine. Said my hair still smelled good. Gore got out at Largo Argentina, and Beverly talked ill of his mate, Howard Austen:[§] "It's like an ordinary little housewife." Carla Panicali,[¶] who was at the Peppers with Carlo, had brought back from NY a heap of hot pastrami, corned beef, hot dogs, pickles, and peppers. It was a feast. The Peppers at their best.

Rome. Sunday, November 27, 1967

To Porta Portese with Josephine.[**] A dilapidated late eighteenth-century writing table with straight legs and three drawers, the top in

<hr>

[*]Anita Alessandri (1921–2012) for many years oversaw the Gendel home as nanny and housekeeper. Along with Princess Margaret, she stood as one of Anna Gendel's godparents.

[†]Claire Sterling (1919–1995), American journalist based in Rome; married to the novelist Thomas L. Sterling (1921–2006).

[‡]Ada Ascarelli Sereni (1905–1997), Italian-born Zionist. She lived in Palestine but returned to Italy after the Second World War to discover the fate of her husband, Enzo, and coordinate clandestine immigration of Jews to Palestine. Author of the memoir *Ships Without a Flag* (1974).

[§]Howard Austen (1929–2003), lifelong companion of Gore Vidal. They met in 1950, shortly after Austen's graduation from New York University.

[¶]Carla Panicali (1925–2012), a preeminent art dealer in Rome and a friend to many modern artists in Europe and North America; married to the painter Carlo Battaglia (1933–2005). As proprietor of the Rome branch of Marlborough Fine Art, she sponsored the first exhibition of Gendel's photographs, in 1977.

[**]Josephine Powell (1919–2007), American-born photographer and collector, lived in Rome for two decades before moving to Istanbul. With her traveling companion Gosina Mandersloot, she often accompanied Gendel to the Porta Portese flea market on the southwestern edge of Rome's historic center.

Gore Vidal, Villa Emo, in the Veneto, 1970

crude marquetry, which I had seen the week before, today reappeared all fixed up and neatly shined with French polish. The asking price was 120,000 lire, whereas the week before it had been 60,000. A present for Judy, I thought, as she needs a better desk than the table I've rigged up for her in the sitting room. Went back twice, haggling the while, then a third time and saw that the Neapolitan dealer would let me have it for my price—60,000. I started with an offer of 50, then said I had made a giant effort to make it better and now he could *venirmi incontro* [meet me halfway]. He did. I guess he couldn't face trucking the thing back to Naples. He called one of the *furgoncino* men [van drivers], who make deliveries, and for 1,500 lire he contracted to deliver it to the Isola.

Pleased with the acquisition. If J doesn't like it, Josephine says she'll buy it.

Rome. Tuesday, December 5, 1967

Lunch at Piazza Campitelli. Anita, mousing around the island, got into a talk with Padre Bianchi, who is in charge of fixing up the Sacconi Rossi's HQ next door to us.* He was having the river police drag away old woodwork and furniture, to burn, as he hadn't the time or patience to call in junkmen or antique dealers. I met this well-to-do Franciscan at 3:00 and inspected the things that were being thrown out. It was junk rather than antiques, and the antiques that were there—a chair, some busts, and so on—were quite rightly being kept. Padre Bianchi was very cordial and showed me all the things they were doing—installing a kitchen and a regular john. The old outhouse on the balcony has been destroyed. He remarked that they had copied our railing and the idea of metal gate shutters from us, and this would maintain *una armonia*. He was grateful that I had given permission for them to tie into our water line. We went downstairs and inspected the skulls and bones of the families of the members of the *confraternita*. It was clean and dry. The ventilation is good. Padre Bianchi remarked on the romantic effect of a beam of sunlight striking a heap of bones.

At the end of the crypt, old Padre Samuele, the Franciscan triple-threat artist who lived until his death two years ago in the little monastery to

Sacconi rossi means "red sacks." The term refers to the cowls of a religious *confraternita*, a lay brotherhood, originally established to tend the remains of the unclaimed dead, especially those who drowned in the Tiber. The *confraternita* maintains a crypt underneath Santa Maria Addolorata dei Sacconi Rossi, on the Tiber Island.

Anna Gendel, Il Palazzone, Cortona, 1967

the right of San Bartolomeo, and who worked in some of the best studios in Rome, had rigged up a *sepolcro* of now-tattered backdrops and painted scenes. This was to be removed. A museum would be made of the red *sacconi*, the crucifixes, and odds and ends—symbols—of the organization. It is almost extinct. Padre Bianchi is the *direttore della basilica dell'Aracoeli*. What the Franciscans need a refectory for in the Sacconi Rossi rooms was not clear.

Rome. Wednesday, December 6, 1967

At 8:00 to Carla Panicali's. Dinner for the Calders.* Very lively. Louise Calder tangled with me at once on Vietnam, not realizing we were more or less on the same side. But that was partly because she has become so rabidly anti-government that she speaks well of de Gaulle. Calder a great, fumbling, white-haired thing in red shirt and red tie. Almost incomprehensible because he slurs his words since he had a heart attack. Slurred them before, too. But he is swift and piercing in his glances and seems to hear everything from all sides of the table. Horseplay with a datepick in the shape of a woman. Calder making a kind of mobile out of a fork and the pick and a date.

Louise is the [grand]daughter of Robertson James, the fourth James brother, who never amounted to anything, as she says. She was raised in Paris. They have given up living in the U.S. and are now in the village of Saché, near Tours.

Calder is back now for a week or so to arrange about a *ballet mécanique* that is to be done at the Rome Opera in the spring. They are to choose the music to accompany the ballet from possibilities proposed by the opera. Today they listened to Berg and Vivaldi but have not yet decided.

Rome. Saturday, December 16, 1967

Fetched J at the station at 12:30. Great heap of luggage. J pleased with life, full of London and future plans.

Lunched with Anna. J enthusiastic about her desk.

Work at Piazza Campitelli.

At 8:00, found J and Anna finishing the decorating of a Christmas tree; they had rushed to the shops and bought balls and lights and tinsel.

*Gendel had known the sculptor Alexander Calder (1898–1976) since the 1940s; among other things, they shared an interest in the design of camouflage. Louisa Calder (1905–1996) was a great-niece of William, Henry, and Alice James.

Anna Laetitia "Mimì" Pecci-Blunt, Villa Reale, Marlia, 1961

Guests gathered for a joint birthday party with Toti:* Denis & Catherine Mack Smith,† Carla Panicali, Carlo Battaglia, the Scialojas, Lucio and Babinski,‡ Josephine, and Sandro d'Urso.§ Toti gave me a splendid present of a cut-velvet diary, with lock, inside of which are a series of his poems and drawings of mice and other animals. There is a fine Etruscan Mouse, couchant on a tomb. Josephine gave me a light and a roll of black paper for making silhouettes. From J a green suede sweater jacket. Others weren't told it was a birthday, except for Viviana,¶ who got a bellyache and couldn't come but sent a bottle of whiskey and ties for both.

Talked for a couple of hours with J. The Queen came to lunch at Patrick's** while J was staying there and talked to her for some time about what a good friend she is to Princess Margaret. J very taken with Prince Charles, who is studying archaeology and anthropology and is an amateur potter. He said he loathed Gordonstoun and used to cry every time he had to go back, but now is very happy at Cambridge. He is going to fix up his rooms and is thinking of putting mattress ticking on the walls. No palace and no dormitory is safe from derivatives of bohemia. Mattress ticking: shades of the 1930s.

Rome. Sunday, December 17, 1967

A bright, cloudy day. At noon, walked to Porta Portese through Trastevere and along the melancholy abandoned bulk of the Ospizio di San Michele. Passing through the gate of Porta Portese, I discovered that, in the half a kilometer of clothes and shoe stands, the last of the real Porta Portese junkmen were to be found at intervals; these are the ones who have not promoted themselves, or not quite, to the level of antique dealers, like those who cluster together in the middle of the market.

*Antonio "Toti" Scialoja (1914–1998), Italian painter and poet; husband of Gabriella Drudi (1922–1998), Italian writer and critic. The Scialojas were close to the Gendel family. December 16 was Gendel's birthday.
†Denis Mack Smith (1920–2017), a fellow of All Souls College, Oxford, and a historian of modern Italy; his wife was the former Catharine Stevenson. Gendel provided assistance on Smith's book *Italy: A Modern History*, first published in 1958 and revised in 1969.
‡Lucio Manisco (b. 1928), Italian journalist; shared an apartment with Gendel in Via di Monserrato during Gendel's early years in Rome. Berrit-Inger Babinski was Manisco's German girlfriend.
§Alessandro d'Urso (1913–2000), Neapolitan lawyer and aristocrat.
¶Viviana Pecci-Blunt (1923–2016), daughter of the patron and collector Anna Laetitia (Mimi) Pecci-Blunt. In 1949, she married Count Luciano della Porta.
**Patrick Plunket (1923–1975), equerry to Queen Elizabeth II and deputy master of the household; godfather to Anna Gendel.

Salotto window, Piazza Campitelli, Rome, 1971

Among the "antique dealers" I bought a crèche horse and a donkey—small, the horse is about a foot long—seventeenth or eighteenth century, from the man who sold me the series of six paintings, Old Testament scenes and two of the Legend of Gargano, some years ago. He reminded me of this, and I asked him whether they were from the south, around Naples. No, from the Abruzzi-Molise region, in the mountains. Four thousand lire for the crèche animals. Farther on there was a cast-iron figure of a man in a toga. Although I wasn't interested in the thing, I got drawn into a bargaining session that ended with this heavy burden under my arm, and myself 7,000 lire poorer.

Piazza Campitelli in the afternoon.

At 8:00, Nika Hulton* at Isola for a drink. She is handsome—dark hair, white skin, red lips—but her nose is feral, a Montenegrin heritage. *Méfiante*, like some of the rich and powerful, and part of the *méfiance* was her way of announcing, when I spoke to her on the phone a few days ago, that she was inviting us out to dinner if I would pick an evening. That was all right, but she repeated it a couple of times this evening, and it means "I am rich and don't want to be a burden, but don't think I'm not aware of it." She wanted to talk about taxes and safe ways of keeping money. Everyone talks about money now because of the devaluation of the pound and the "attacks" on the dollar. Nika says, "I am rather funny, I know. I can be amusing, but I tend to go on a little too long." She is quick. I like the rhythm. On the penalties of age, she said that one of the worst was becoming invisible. She was in a taxi in Paris the other day, and the driver kept addressing her as Monsieur. When she got out, she said, "Why do you call me Monsieur? I am a woman, I am not a man." He said with a shrug, "*Je n'avais pas remarqué*" [I hadn't noticed].

Rome. Tuesday, December 19, 1967

Much phoning around and communicating with Gabriella on producing some literary people to meet Stephen Spender.† He arrived off the Turin train as we were finishing lunch. White-haired, somewhat oatmeal-faced, a little stooped. Gentle and rather fuzzy manner. Soft voice.

Diana Cooper‡ once said to Judy, "You must remember when you

*Nika Hulton (1916–1995), writer and art collector; born Princess Nika Yourievitch. Her ancestry mingled Russian and Montenegrin nobility.
†Stephen Spender (1909–1995), English poet, novelist, and critic.
‡Lady Diana Cooper (1892–1986), who connected social, political, and cultural circles in

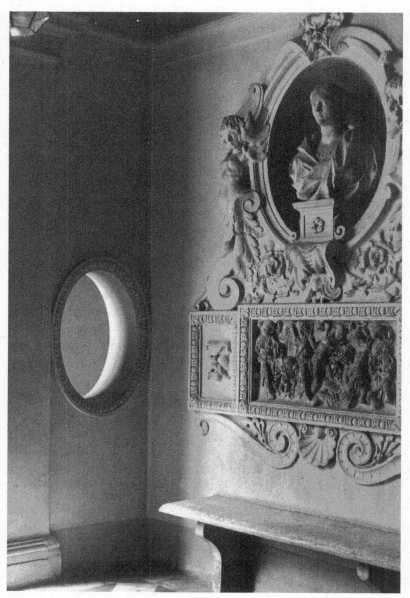

Palazzo Costaguti, Piazza Mattei, Rome, 1979

worry about having Spender to stay that you needn't think of him as a great man." J refers to him habitually as Wetty, because his manner is dank. Among her pals, that is how he is referred to.

A fuffle, because the American Cultural Institute hadn't caught up with him. They are the organizers of the *Martedì Letterari*. He was to speak at six at the *Eliseo*, but no one had met him at the station, and he didn't know what he was supposed to do.

Work at Piazza Campitelli.

At 8:00 drove with J—J in pain because of tight shoes, and dressed in an improvised way as her trunk has never arrived from London—to 14 Via Ventiquattro Maggio, by the Quirinal, where the Carandinis* live. They were giving a post-lecture reception for Stephen. (Evelyn Waugh, with his bitchy right-wingery and his vein of anti-Semitism, used to refer to Stephen as *Shtephen Shpender*. Once I said, I don't understand what you mean by this common accent you put on his name. It's about as funny as the Italian version of your name, *Eveleen Wowg*.) Contessa Carandini on phone to J: "And we have arranged for the police to be kind about the parking." As they were. Creaking up in an ancient elevator. Splendid apartment with great windows overlooking the gardens of Palazzo Colonna. Furnished fifty years ago. Like an English country house drawing room, but perched up above Rome.

The others left, and we—the Spenders, J, the Sterlings, and I—went to Sora Lella's.† Here we got on to Ezra Pound, whom Spender defended as a great poet and a great supporter of poets, the most generous he has ever known. Eccentric, though, when he got on to politics, when suddenly he would announce that the Jewish conspiracy had made taxes high or started the war. I was intemperate and said that it would have been more just to treat him like the poor slobs who were tried for treason. Poets should have greater responsibility rather than lesser. Everyone so eager to be on the side of the arts, from Mrs. Roosevelt to Lionel Abel, that they shut their eyes to what Pound had done. His broadcasts were minimized, though he himself had asked to do them—cheap.

Spender managed to get away from the sofa and go to bed—he leaves

London for nearly half a century; an actor too; wife of the politician and diplomat Duff Cooper (1890–1954) and mother of the historian and documentary maker John Julius Norwich (1929–2018).

*Count Nicolò Carandini (1896–1972), Italian diplomat and for many years president of Alitalia. His wife was the diarist Elena Albertini Carandini (1902–1990).

†A restaurant on the Isola run by Elena Fabrizi (1915–1993), an actress and sister of the character actor Aldo Fabrizi.

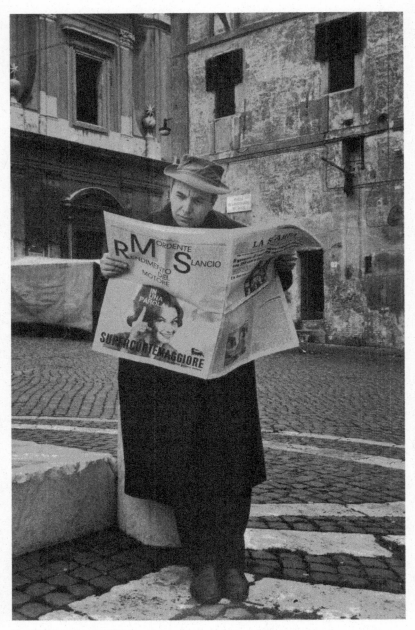

Toti Scialoja, Rome, 1962

for Bari to give his lecture again, tomorrow. I read his speech during the day; on our walk out of the house in the rain in the morning, he had pulled a bunch of crumpled papers out of his pocket while looking for some change and had remarked, "Oh, my speech." I asked to read it, and he reluctantly handed it over. When Adalgisa* saw the heap of crumpled sheets, she seized them and took them to her ironing board, so I was able to give them back in apple pie order. What delicate attention, having your speech pressed. It is a plain straightforward effort on the subject of relations between American and English literature. First we chased them, and now they seem to be chasing us. For the Americans, an Anglophile like Eliot is no longer the prophet. It's back to Wallace Stevens and William Carlos Williams, the native product, speaking with American speech rhythms, according to Spender.

Rome. Thursday, December 21, 1967

Strolled up Via Frattina. Great knot of people. An angry man said to a policeman, *Non c'ha lo sfollagente?* [Don't you have a blackjack?]. The crowd was trying to get a look at the actress Claudia Cardinale. Out of the midst of it came Balthus† and his new wife and old lover, Setsuko. On the way from Japan, his suitcases were lost, and he was trying to buy some clothes. Balthus is like a lizard with a high IQ. Deliberate movements of the head. Quick eye. From the lizard comes slow deliberate speech, which gives even banalities a certain weight or at least measure.

Rome. Sunday, February 2, 1969

Eight-thirty to Porta Portese with Josephine, looking for a present for J, whose birthday it is on Thursday. Found a pair of copper *coronette* with big glass jewels, and a needlework memorial of something—a piece of eighteenth-century brocade framed in the middle and then varieties of Union Jacks around it. Also bought a glass globe for the hall at the Isola that the painter had smashed, and a copper plaque of Cavour.

*Adalgisa Gigli (1902–1986) oversaw the household at Piazza Mattei. Gendel referred to her as his "secretary."
†Balthasar Klossowski de Rola (1908–2001), the painter known as Balthus, was the director of the French Academy, in Rome, in the 1960s and '70s. His second wife was the Japanese painter Setsuko Ideta (b. 1943).

Cortile d'Onore, Castel Sant'Angelo, Rome, 1980

Dinner at Vecchia Roma: J, Spender, Liz,* Marie-Claude.† MC suddenly said that there was no real difference between Russia and the U.S. We were talking about Yevtushenko. Spender finds him self-seeking. He disliked hearing Yevtushenko answer a question about whether he would write a poem honoring Pasternak's mistress, as she had been martyrized by the police. Silly question, which he should have refused to answer. Instead, Y replied that he was a loyal Communist and would not do honor to a woman who had infringed the currency regulations. Later that evening, Spender witnessed Yevtushenko making a deal with *Life* magazine for an article and stipulating that the dollars be banked for him abroad.

At this point, MC declared that Russia was just as free as the United States. It was some time before I realized that she was equating them from a Chinese point of view. Spender said it was a straight Marxist line, but also did not get that it was coming from left of left. MC blazed up when I said I didn't like systems that killed people to prove their point (why didn't she use Vietnam against me?), and she hotly denied that anyone had been killed in China. No one, or at the most very few.

Spender, who is constrained on first acquaintance, progressively thaws, quickens, and warms to conversation. He was conjecturing over what present might please his next host, Philippe de Rothschild,‡ who lives near Bordeaux. I said, "Cash is always welcome. Why don't you give them money?"

Rome. Wednesday, February 12, 1969

Letters, chores.

J, Caspar,§ and I off in rain to Via Appia Pignatelli to dine with the FitzHerberts.¶ A religious lunatic there—Prof. Anderson.** Meg had asked

*Lizzie Spender (b. 1950), daughter of Stephen, an actress; married to Barry Humphries (b. 1934), known for his alter ego, Dame Edna Everage.
†Marie-Claude Deffarge (1924–1984), photographer and journalist, and a friend of Gendel's from his earliest days in Rome; longtime partner of the photographer and journalist Gordian Troeller (1917–2003). Deffarge and Troeller produced books and films together.
‡Philippe de Rothschild (1902–1988), who developed the Château Mouton Rothschild vineyards; also a writer, producer, and race car driver. He began the practice of commissioning artists—Braque, Miró, Chagall, Warhol—to design the labels on his bottles.
§Caspar Fleming (1952–1975), son of *James Bond* author Ian Fleming and Ann Fleming.
¶Giles Eden FitzHerbert (b. 1935), British diplomat. His wife Margaret FitzHerbert (1942–1986) was the daughter of Evelyn Waugh.
**Robin Hay Anderson (b. 1913), the author of biographies of Pius V and Pius VII. On Easter Sunday 1966, Evelyn Waugh collapsed and died after writing a postcard to Anderson with the words, "Many thanks for your interesting sympathetic letter. We live in a dark age. I cannot hope to live to see it lighter."

Piazza del Popolo, Rome, 1950

the women to come with long dresses, as he was upset by the sight of legs. The man looked strained. Cadaverous. As if he had licked his lips raw. Auberon Waugh* there with his wife. Muriel Spark† and an Italo-American called Dario who claimed that when he lived in Palazzo Delfini, he could look into my kitchen and see me wandering around in my underwear. Muriel Spark very different. Unsirenlike as compared with the only other view of her, months ago, at the Sterlings'.

Prof. Anderson fled as we were sitting down. A Thai girl in a scarlet minidress had come in. Or perhaps it was my asking whether a lump of sugar, stained, had been dipped in LSD. He left leaflets behind, which were read at the table. Catholic right-wing stuff. Meg said, Oh, is it Fascist? There was an item about Father Charles Coughlin, of Michigan. Thought he was dead. Caspar enjoying himself, probably because he was without his mother. He wore a kind of Regency rig with ruffled shirt and bell-bottom trousers. To Muriel Spark, he said that he wasn't drinking because he was taking antidepressant pills, which didn't go with alcohol. Auberon Waugh much better than I remembered. Joked about how he had been the victim of the Scissors Man. Something they told the children when they asked how he lost his finger. Muriel S asked to see. He held his hand up. Index finger of left hand gone. Birth? No, blown up in Cyprus, on maneuvers.

Rome. Sunday, March 9, 1969

Porta Portese. Portrait of Mazzini: 3,000 lire. Bottle in shape of La Source: 800 lire. Catalogue of Mostra Garibaldina 1932: 100 lire.

Cloudy day.

Nine o'clock. Paul and Talitha Getty for a drink.‡ They had found J asleep, and she was just getting up. I dislike it when I see from the bridge that the lights aren't on in the living room. Gettys just back from London and full of their troubles over buying a house in Cheyne Walk. Sixteen thousand pounds being asked for seven-year lease by Cadogan Estates. They have now offered 11,500. J says agents are almost all crooked.

It's the Rossetti house. Paul: And I think perhaps we'll hear the squeaks of Swinburne and the kiss of the lash.

*Auberon Waugh (1939–2001), British journalist and satirist; eldest son of Evelyn.
†Muriel Spark (1918–2006), Scottish novelist and essayist; perhaps best known for *The Prime of Miss Jean Brodie* (1961).
‡John Paul Getty, Jr. (1932–2003), son of the oil tycoon and a British philanthropist, and his second wife, Talitha Dina Pol (1940–1971), Dutch actress and model. Talitha Getty died in Rome after an apparent drug overdose.

Pope Pius V, Isola Tiberina, Rome, 1974

Rome. Friday, March 21, 1969

Yesterday, on return from the airport, stopped at the Isola to meet the tenant. Movie actor Rod Steiger.* Was down in the cellar mousing around. Mr. Steiger? *Sì.?* Plump not to say fat man, with big coarse face. On his plumpness he was wearing a lavender roll-neck blouse (plump men in this style look like governesses). Around his neck was a gold chain, and from it hung a gold sunburst, which swayed and dangled when he moved. Upstairs a valet—Bradford?—was putting clothes into our closets. Place was a mess, as he had arrived a few minutes after we left from Fiumicino. A chauffeur also straying around.

Steiger said he would be away for several weeks in the middle of his tenancy and that his wife would be coming for only two weeks—Claire Bloom—with eight-year-old daughter. I said we would try to get the chairs upholstered while he was away and before his family arrived. He looked surprised. Why bother? With a child in the house and all, why don't you do it after we've gone?

Wasn't I American? Yes. And without thinking I said, You are American, aren't you? But as he is a famous star, I was supposed to know this, so I tried to retrieve by adding, Well, of course I know that, even if you are playing Napoleon (which he is, in the Bondarchuk production of *Waterloo*).

How's the maid? Is she honest? Yes, I think so. The last one [Adriana] was honest for ten years, then stole everything.

Oh, your wife told me about that. And I've been thinking that the story would make a good script. You see, there's Anna Magnani[†] in the basement. She's the cook. And this rich woman upstairs. And a famous actor comes here on a visit, or a tenant. The cook gets ahold of the wad he leaves and runs away. Then you see that she has set up a house just like this one again and does everything like her former mistress. And then in the end she hangs herself from that bar.

That sounds terrific, I said. We could shoot it here.

Oh, I wouldn't do that, it's such a mess.

*Rod Steiger (1925–2002), American actor. He won an Oscar for *In the Heat of the Night* (1967), in which he starred with Sidney Poitier. Steiger was among many who rented the Isola residence for short periods. (Marlon Brando was another.) He was married for ten years to the actress Claire Bloom (b. 1931); the daughter mentioned here is the opera singer Anna Steiger.
†Anna Magnani (1908–1973), Italian actress; first won international renown in Roberto Rossellini's *Rome, Open City* (1945).

Sacconi Rossi procession, Isola Tiberina, Rome, 1960

Antonioni* shot part of the *Avventura* here, and they didn't make too much mess. The bedroom scene took place in our bedroom, so the bed has been immortalized.

Steiger said, Say, what's wrong with the Italian art scene? It all seems derivative. Or are there any good young painters around?

Woofle waffle art talk. It bores me before it can begin.

Parted with many expressions of mutual esteem.

Rome. Wednesday, April 2, 1969

Reading *Portnoy's Complaint*, by Philip Roth. Reminds me somewhat of Céline's anti-Semitic diatribes, though from the inside and much wittier. The hero describes himself as trapped in an elaborate Jewish joke. So is the book, with some teeth in it. It is brilliant. But caricatural and pseudo-literary. Like Gore Vidal. The Yiddish G. Vidal. Both deal in comic strip characters.

Paris. Wednesday, April 23, 1969

The Dalís† came to lunch. Met in the Ritz bar.

Salvador Dalí a splendid figure with his joke mustache, his gold-headed cane (belonged to Victor Hugo), his diamond stickpin (Alfonso XIII's), and his ruffles and velvets from the *marché aux puces*. Gala, his wife, demure and restrained at first. We spoke about crows, as Tom‡ said Dalí had suggested that they write a book together about crows.

Lunch at L'Espadon. Gala provocative: *"Vous êtes courageux? Mais, vraiment vous êtes courageux? Alors aidez-moi à manger ces pieds de porcs."* [Are you brave? Really brave? Then help me eat these trotters.] Also provocative with the waiter. Described how she goes off, leaving Dalí, for a trip to Italy, which she is crazy about.

Audrey§ asked me why I wasn't using my asparagus tongs. Instead of telling her that I preferred the sensual feel of the vegetable, I said I wasn't

*Michelangelo Antonioni (1912–2007), Italian director. In *L'Avventura* (1960), the characters Anna and Sandro make love in the Gendels' Tiber Island home.

†Salvador Dalí (1904–1989), Spanish surrealist artist. Gala, his wife (1894–1982), was born Elena Ivanovna Diakonova.

‡Thomas B. Hess (1920–1978), editor of *ARTnews* for almost a quarter of a century. One of Gendel's closest friends.

§Audrey Hess (1924–1974), New York civic leader, active in politics, education, and the arts; wife of Tom Hess and granddaughter of the philanthropist Julius Rosenwald.

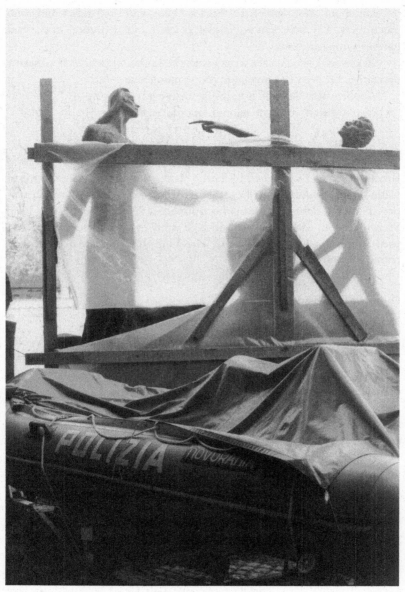

Padre Martini sculpture, Isola Tiberina, Rome, 1991

sure how to use them. Should have known better, as she immediately gave me a demonstration. I clacked them, and Dalí launched into a brilliant account. "*Ah vous faites ça. Est-ce que vous connaissez Chypre?*" [Ah, you do that. Do you know Cyprus?] And what was the greatest event that ever happened there? Yes, the birth of Aphrodite. And when she came up out of the waves, you know what she did? (*Venus pudica?*) Yes, she covered herself, but she was also very cold, chicken flesh all over, and her teeth were chattering. On the shore where everyone had gathered to watch her, they chattered their teeth in sympathy, and the next year, when they commemorated the event, they repeated this, and every year they did the same. Then this spread into the country, inland. On the shore to make more clatter, they had collected seashells and made a noise with them. Inland there were no shells, so they imitated them in terra-cotta, and these went all over as the cult spread, and they came to Spain, and that is how we got the castanets—*crotalas*, they are called." A girl came up and asked for his autograph. He was pleased.

I asked Gala whether she had known Iris Tree* at Cadaqués, on the Costa Brava, where I know they spend most of the year. "*Ah, vous savez, je n'aime pas tellement les poétesses et les poétesses britanniques*" [Well, you know, I'm not too fond of women poets, nor of British women poets]. Dalí heard this and said he remembered her. She worked all winter on some poems. Then in the spring she took them down to the beach. A wind blew up and carried off the sheets, and she went running down the beach after them.

On the student protests, he began to reminisce about a visit to the art school in Madrid, where he was a student, by King Alfonso XIII. All the boys had decided to ignore the king, as they were antimonarchical—anarchists and communists. The king came in, asked for a cigarette, chatted for a while, and then to dispose of the butt took aim with his fingers and flicked it across the courtyard into a spittoon. His skill brought down the house. They whooped with admiration, and the visit turned into a success.

He is a big personality; I did not imagine that I would like him so much.

London. Thursday, April 24, 1969

At 6:00 to Hyde Park Hotel to pick up Harold Acton.† Full of his state din-

*Iris Tree (1897–1968), British poet, actress, bohemian. As a model, she was photographed by Man Ray, sculpted by Jacob Epstein, and painted by Vanessa Bell and Amedeo Modigliani.
†Harold Acton (1904–1994), Anglo-Italian writer, historian, and aesthete; the character Anthony Blanche in Evelyn Waugh's *Brideshead Revisited* is based in part on Acton. His books include *The Last Medici* (1932) and *The Bourbons of Naples* (1956).

Restoration, Villa Borghese, Rome, 1995

ner at Windsor. To Kensington Palace, where there was much more about the dinner, urged on by Princess Margaret and Harold. I was amused at the thought that Harold wouldn't be too pleased to know that it was my suggestion that he should be asked.

Tony [Snowdon] came in, excited as usual by something he has cooked up. A souvenir for the investiture of Prince Charles [as Prince of Wales]. It is a mailing tube in shiny black paper with a legend in white saying that it is a souvenir of the investiture at Caernarfon Castle. Inside are silk-screen repros of old prints of the castle. Gave us a set. Meanwhile, Pcss M was showing Harold her photos taken at his house last summer. "J, come and look." "I've seen them, ma'am." "Yes, but you haven't seen them bound." She had had them bound in black leather stamped with gold fleurs-de-lis.

Tony again excited—about a trailer he had been given to try out. It was in front of the door. Would we come back and spend the night? Pcss M said she wouldn't spend the night in the trailer. We all went out, except her, and swarmed over it, getting into the beds, which Tony let down. Even poor stiff old Harold. Pcss M appeared and made angry comments about it being late for the accountant. A dignified fellow was drawing up in a Rolls. Accountant!

London. June 12–17, 1969

Monday evening a dinner party here for the Whitneys,[*] Jane and Max Rayne,[†] Solly Zuckerman,[‡] and Margaret Du Cane.[§] Zuckerman is said to be well-liked, but I don't care for him. He is very self-assured but glosses over and can't take the trouble to answer a question. I had seen that the Rizzoli publication had cannibalized an old German work—Brehm's *Tierleben*. I asked Solly's view of this, saying that it was a reboiling, but wanting some suggestion for a better text. "Oh, Brehm, yes, I have the first edition. He is completely outmoded." Double ploy; but then not one suggestion. Betsey at dinner working the sentiment line. How was my mother? Then looking shocked and horrified when I said she died years ago. This

[*]John Hay "Jock" Whitney (1904–1982), publisher, collector, and ambassador to the Court of St. James's. His wife was the philanthropist Betsey Cushing Roosevelt Whitney (1908–1998).
[†]Max Rayne (1918–2003), later Lord Rayne, British developer and philanthropist. His wife was the former Lady Jane Vane-Tempest-Stewart (b. 1932).
[‡]Solly Zuckerman (1904–1993), South African–born British polymath: physician, zoologist, science adviser, author.
[§]Margaret Anne Du Cane (b. 1932), later Viscountess Stuart of Findhorn as the wife of Viscount David Randolph Moray Stuart.

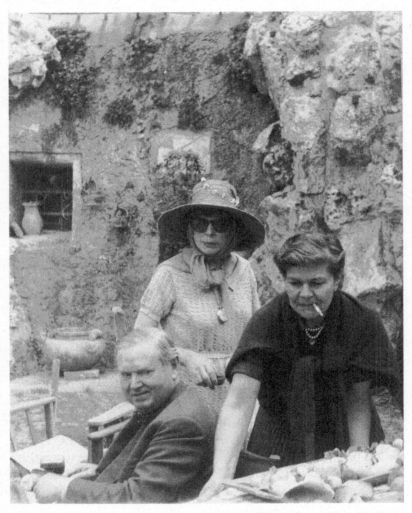

Evelyn Waugh, Lady Diana Cooper, and Marion "Babs" Johnson (Georgina Masson), Villa Doria Pamphilj, Rome, 1963

just proved that we weren't in close enough touch, she said. We must bring Anna to NY.

Jane scathing about Lucian Freud—told her I brought the *New Yorker* piece on Weinberg the Imposter, which had a description of Freud's early trouble with cocaine. This for Tony, who had been so delighted at Fenton* when I told about this, and Lucian had hissed like an angry cat. *It's not true.*

Many people poured in after dinner. Arnold Goodman† shocked—an unexpectedly old-fashioned reaction I thought, but J said it was class— over Caspar's being with a girl. You mean he has now seduced a young girl? What is to happen? What about her parents? I had to persuade him that things had changed. Chelsea set contingent—in the midst of Diana Cooper, Hofs,‡ Lambtons,§ etc.—in came John Stefanidis,¶ Marina Emo,** and group, some in funny clothes. Roy Strong,†† National Portrait Gallery, self-consciously dressed in yellow suit and broad-brimmed hat.

London. Thursday, July 15, 1969

At 7:30 to London Zoo, where Solly Zuckerman was giving a dinner. Drinks first in the aquarium. Wonderful wandering around, drinking in the subaqueous penumbra and observing the bizarre shapes of eels, lungfish, and others, and the merry turtles. Went around tropical cases with Cecil Beaton,‡‡ who complained that he never had a real holiday, his last was at Spetses, eight years ago. A lily pad on its way to the surface reminded him of a Klimt. Some of the fish—the dragonfish in particular— did look like dressmakers' creations.

Then a promenade across the grounds to the Small Mammal House. Running or rather walking conversations. Annie Fleming complaining about the disappearance of the manatee. Fred Warner:§§ And is there a

*Fenton House, the Lambton family estate near Wooler, in Northumberland.
†Arnold Goodman (1913–1995), later Lord Goodman, legendarily well-connected British lawyer and political advisor.
‡Raimund von Hofmannsthal (1906–1974), son of the belletrist Hugo von Hofmannsthal, and his wife Elizabeth (1916–1980), born Lady Elizabeth Paget.
§Antony Lambton (1922–2006), Conservative member of Parliament, and the redoubtable Belinda "Bindy" Lambton (1921–2003), frequently painted by Lucian Freud.
¶John Stefanidis (b. 1937), Alexandria-born, British-based interior and landscape designer.
**Marina Emo Capodilista (b. 1932), translator of Joyce's *Dubliners* into Italian.
††Roy Strong (b. 1935), art historian, curator, museum director, diarist, and prolific author.
‡‡Cecil Beaton (1904–1980), British fashion photographer, war photographer, and designer of sets and costumes.
§§Frederick Warner (1918–1995), British diplomat; deputy permanent representative to the United Nations and ambassador to Japan.

Barbara "Babe" Paley, Sacro Bosco, Bomarzo, 1963

womanatee as well? Martha Gellhorn* there in white dress, raddled face. Ah, I see we are both here for the season, she said. Diana tottering around the cases where the nocturnal animals were moving around in simulated moonlight. Fascinating view of a couple of flying foxes making love while hanging upside down. They do everything hung up by their hooks, except relieving themselves: for this they turn right side up, of course. The male bats have enormous cocks and balls relative to their size. The one that was making love to a mate had a great hooked erection but never connected. There was a lot of nuzzling, nipping, and licking, and eventually he gave up and moved away. A third bat, a female, I thought, which had been hanging close by, then moved up close to the abandoned female. Later the male hooked its way back and distributed a nip or two and then left again to hang from the ceiling and encloak himself in his wings. Paddy† was shouting, Look at the textures, they go from fox fur to umbrella.

London. Friday, July 18, 1969

At five to Liverpool station in a taxi with J and Anna. Daumier railroad scene. Jammed into one of those compartments that go through the train, six or eight abreast. Only half an hour to Brentwood. Roy Strong, director of National Portrait Gallery, was on the train, also going to spend the weekend at Kelvedon. He is a dourly affected fellow, affecting modern gear. Short, big-bottomed, porcine, but also feral face with long bushy sideburns. The manner is that of a supercilious clerk in some luxury shop—women's wear, cloth, furs, shoes. Paul‡ appeared, but Margaret Du Cane, who was to be on the train, did not. So we got into a taxi with Roy and left Paul to wait with his car for Margaret.

London. Monday, July 28, 1969

Dinner for the Snowdons: plus Pam Colin,§ Margaret Du Cane, Charles

*Martha Gellhorn (1908–1998), novelist and war correspondent; for four years, the wife of Ernest Hemingway. Her 1961 novel *His Own Man* presents a fictionalized version of Gendel's relationships with Judy Montagu and Vittoria Berla Olivetti.
†Patrick Leigh Fermor (1915–2011), soldier, traveler, and writer. Artemis Cooper, granddaughter of Diana, would write his biography.
‡Paul Channon (1935–2007), member of Parliament and cabinet minister; son of the diarist Chips Channon. Later Baron Kelvedon, named for the family home, Kelvedon Hall.
§Pamela Colin (b. 1936), *Vogue* editor and food writer. She would marry David Ormsby-Gore, Lord Harlech (1918–1985), former British ambassador to the United States.

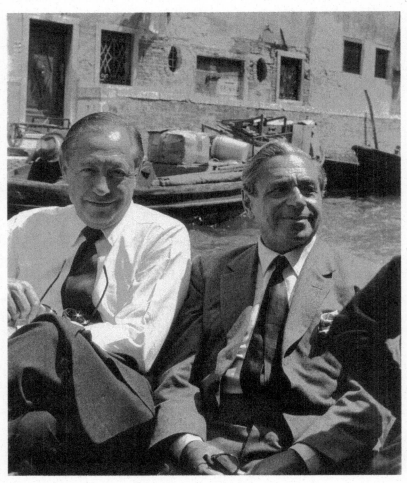

William S. Paley and Fulco di Verdura, Venice, 1963

Cecil,* John Craxton.† Drinks in the garden. Princess Margaret in flattering, draped white dress with a sort of shawl collar trimmed with gold bangles. Tony had on a white suit, green shirt, and a kind of stock tie. At dinner, when we sat down, I started off with Pcss M, but she veered to Charles Cecil, a tall, thin youth. Pam Colin chattered away about the investiture [of Prince Charles] and her plans to come to Rome again in September. After two courses and several efforts to detach Pcss M from Chas Cecil—Margaret Du Cane was stranded, and we talked for a time across the table—I got angry at her persistence and gave her up. At dessert she finally turned and engaged me. I barked at her with an angry face. What? She repeated her question, which was about Sen. Edward Kennedy's prospects after his TV explanations. She looked shaken by my annoyance. Which softened me. It then occurred to me that they must have had a row. Before dinner, Tony, when we went with Pam to see the stables, had said, Will you give me a key when it's done? I may be leaving where I am now.

People pouring in, the after-dinner guests. Tony grabbed me and started a three-way conversation with Pam. Then he sounded off against Diana Cooper. He claimed that when he greeted her, she had shaken hands coldly, then turned away, making a grimace to other people. He was obviously furious. Cold, set face with a mechanical smile on it. I said there was certainly a mistake, and I would tell her. Do so, he said. So I got ahold of her and repeated this piece of nonsense. She was upset and went over to him immediately and said, Now, what is this? He was cold and angry but soon they were talking away in an amicable way. Later she thanked me for the prompt intervention. I said I was sorry about the unpleasantness. Diana is great, though. She said, You know, it wasn't really unpleasant. One likes a flow of adrenaline occasionally.

Rome. Saturday, September 20, 1969

Met Josephine and Gosina‡ in the bar of Piazza della Pigna and we drove to Via Veneto. At the Sistina Theater, a very mixed crowd—no familiar faces except that of Anna Magnani. Theatrical, TV, movie people, it seemed. And all ages. Years ago in Rome, only the old and the middle-aged had money for tickets, and there were very few young to be seen. Now it graded from sixteen up. Lots of modern gear. Girls who seemed

*Lord Charles Cecil (b. 1949), banker, trustee, and high sheriff of Hertfordshire.
†John Craxton (1922–2009), British painter.
‡Gosina Mandersloot (1930–2004), Dutch photographer and journalist.

Cecil Beaton and Michael Tree, Spetses, Greece, 1961

to have forgotten their underclothes. Youths with long hair and velvet pants—purple and black and gold—with flapping bottoms. Lacey shirts. One youth in silver lamé, sort of chain mail.

A one-night stand of Josephine Baker, whom I had never seen. Expected an evening of nostalgia—"J'ai deux amours" and "C'est lui." The banana queen of the Folies Bergère of 1925. First half of program unendurable. No Josephine Baker. Just mediocre bands and guitarists and comics.

Josephine Baker had the entire second half of the program to herself. A magnificent, flawless performer, from her first appearance on the stage in a voluminous dress with white feather collar, arms aloft, and a great open-faced toothy grin. A charge ran through the theater. Nostalgia was not the note; she is up-to-date in sound, rhythm, and words. Teasing about her age. "N'ayez pas peur" [Don't be afraid], she said, making a move to unbutton. She is sixty-three. Then suddenly she took the whorehouse-madame's coat off, and underneath she was in black slacks with glittering bell bottoms. Very trim & lithe. Dancing, singing, walking into the audience trailing her wire. Entirely American, with seductive, fluent French with a heavy accent.

Rome. Saturday, September 27, 1969

In the evening we went to have a drink with Gore Vidal, and then to dinner. He said he had put out the picture of Jackie Kennedy Onassis again, but it has always been there on an end table by the sofa. With its dedication. Gore full of his trial for libel—William F. Buckley is suing him for $500,000 for calling him a pro-crypto-Nazi.* Don't see how they are going to define that one, either the prosecution or the defense. He had sent over some photocopies of his onslaughts on Buckley in *Esquire*, *Playboy*, and *Look*. These mags have taken the place of the little magazines of before the war. The big-circulation rags have moved in on the old vanguard. Which no longer exists. Everyone is up front today; it is the mass avant-garde.

In one breath Gore charges Buckley with anti-Semitism and reveals that when Buckley was a stripling, he took part in the vandalizing of a church in the town where he lived, because the church supported a Jewish

*The lawsuit stemmed from appearances by Vidal and William F. Buckley, Jr., the conservative columnist and author, on ABC News during the 1968 Democratic National Convention. Vidal called Buckley a "crypto-Nazi," and Buckley called Vidal a "queer." After a subsequent attack by Vidal in *Esquire*, Buckley sued the magazine and the writer. *Esquire* settled, and the suit against Vidal was dropped.

Cecil Beaton, Spetses Museum, Spetses, Greece, 1961

family that had bought a house on the green. Buckley's father was out-raged that he had come as far as he had—via some Texas oil wells—to wind up sharing frontage with Jews. In another breath, he says that Buck-ley went to Mexico with a couple of classmates when he was at Yale. One of them was [Harold K.] Guinzburg (of Viking Press)—hardly living up to his anti-Semitic principles)—and the three of them got into a church, where Buckley stole a seventeenth-century painting, which he has hanging on his wall to this day. Well, so what? It certainly doesn't prove pro-cryp-to-Nazi activity; it just shows that he was a thief when he was twenty. And for that kind of college boy, thievery comes under the heading of larks. Anyway, I don't see what good it would do him to produce this in court, except to shake B's character rating a little.

I am always explaining to people how manly Gore is, not the little tweaks and prods. Gore, I noticed, also gives his hair little pats and kept having a look at himself in the mirror of the elevator as we went down.

Villa Reale di Marlia, Lucca. Friday, October 10, 1969

I had been working about an hour when Laetitia phoned. She had been expecting a visit from a priest. "To tell me some stories, bad, I suppose, about the Boncompagnis.* I don't know what it's all about. Usually they want money. Mummy thought I ought to see him, perhaps it won't take longer than a quarter of an hour." Could I come over to Papa's sitting room? The priest [Padre Raffaele] was there and had some Etruscan things I might like to look at.

The priest was fat, dough-faced, with glasses, and wore the habit of the Passionist Fathers, which has a bleeding heart outlined in white stitches over the breast, and some initials. He seemed very intense and kept mop-ping his brow. He apologized for not speaking English. Laetitia said that I was an *intenditore* [connoisseur], and he produced from some paper lying on the desk a small bronze figure, corroded, which he said was of the fifth-century B.C. and had been found by some *contadini* [peasants] in the Viterbese, old friends of his, who had asked him to sell it for them as they were in dire need, and he had undertaken to do this favor.

They had also sent some vases, which he had left at the porter's lodge. I asked to see them, and on the way down the drive—we stepped out of one of the French windows—he kept up a busy patter about "*suo padre il*

*A prominent Italian noble family. Mimì Pecci-Blunt's daughter Laetitia (1920–2007) was married to Prince Alberico Boncompagni-Ludovisi.

Diana Cooper and Judy Gendel, Spetses, Greece, 1960

conte, signora principessa, e il signor principe, suo marito" [your father, the count, *signora principessa*, and the prince, your husband] and many references to Roman princes and princesses. At the lodge, he asked Romano's wife whether we could have a room to ourselves.* She closed us into the kitchen, and he produced some cardboard boxes out of which he drew from their newspaper wrappings a series of fakes of the sort you see at Porta Portese every Sunday. A large bucchero pitcher [black Etruscan ceramic] with embossed lions, another plain, a pair of Villanovan pitchers, also fake, and a Corinthian pitcher, ditto. The last was found to be broken in two when he unwrapped it, but he wasn't as upset as he might have been on finding something that he presently told us was worth *un milione* had been broken. His prices were astronomical, even had the wares been real. One hundred thousand each for the Villanovan pitchers, for instance. Two of his things were downright comic. They purported to be ancient lamps. One was very big, about ten inches long, and had a sort of neo–Art Nouveau face on it.

But it seemed that the really spectacular things those *contadini* near Viterbo had sent him were in Lucca, "*Ma lei, signora principessa, rimane a bocca aperta se vede quello che è*" [But you will be astonished, princess, when you see what it is]. He had an unctuous voice, which he kept consciously modulating. His tool of the trade, as he said he knew so many people and so many places in Lazio because he traveled around preaching. I said, Let's go see the big things in Lucca. Laetitia came back to the *scuderia* with me to fetch the car, and I told her that it was all fake, but we agreed that it was interesting to see the rest of the setup.

Padre Raffaele rattled on as we drove in. He led us into a house. There were no introductions, just a greeting, and Padre R whispered to us that it was safer not to mention names. We were taken into a master bedroom. Padre R pulled out some cartons that had been stored by the side of the bed under some heaps of magazines & newspapers and proceeded to pull out another assortment of larger fakes. A great amphora had hunting scenes on the side that looked like drawings from a 1920s mag like *Judge*. There was an "archaic" head and another "*vaso corinzio, così prezioso*" [such a precious Corinthian vase]. It was depressing, accompanied by the oily flow of his patter. All his terms and the things he said were just what you could hear from any of the fake sellers in Rome. The cardboard boxes all had labels with Tuscan addresses on them. The largest vase was packed

*Romano was the *guardiano*, or caretaker, at Villa Reale.

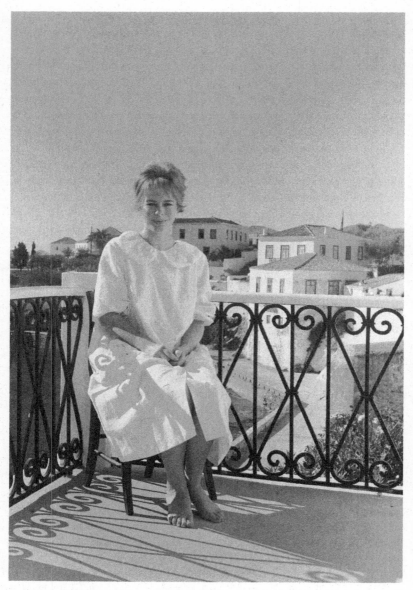

Lady Antonia Fraser, Spetses, Greece, 1961

in bits of foam rubber. We helped him pack everything up. Lots of foam rubber bits littered the floor. Just a second, he said, *"devo dare una piccola botta qua"* [it just needs a little touch here]. He stooped over and with his handkerchief whisked the bits under the furniture.

As we drove back, he praised the life of the monastery. "If you want to be happy for three days, marry. If you want to be happy for six days, slaughter a pig. If you want to be happy forever, become a monk."

Florence. Tuesday, October 14, 1969

Got the car and drove to Piazza SS. Annunziata. Palazzo Capponi is halfway down Via Capponi. Magnificent eighteenth-century palace with a great garden behind. Used to belong to the Antinoris, and it was here that Cora played as a child.* Finally found how to get to Sga. Cipriani's.† Attic floor. Door opened by young blond girl who showed us into a white sitting room. Tiny, overlooking garden laid out to converge on four magnolias, one of which had died and been replaced by a young one. Funny furniture. An armchair of steel tubing and catgut, like sitting in a cat's cradle. Sga. Cipriani was a solid blond woman with a plain but intelligent face. Gave us coffee. Friendly and simple. Took us down and ushered us through the whole spectacular collection. Her grandfather—*mio nonno*—Contini Bonacossi had assembled it all between 1918 and 1932. She identified each work and mentioned which had been given to the state. A deal that took fourteen years to reach. But a burden relinquished, not to speak of the insurance.

What a parade of spectacular pictures: Velázquez, Bassano, Zurbarán, Tintoretto, Murillo, Titian, El Greco, Goya, Pontormo, Carpaccio, and Cimabue, plus majolica and statuary. A Bernini St. Lawrence: *"Sì e documentassimo"* [Yes, and very well-documented]. Two Savoldos. The woman in a cloak doesn't look right. If the National Gallery painting is a Savoldo, then this is a studio work or a copy. The Pontormo boy looks all right, but not the portrait of a woman. Mazo. Herrera. Lotto. Must be the greatest collection still in private hands, or one of them.

Bid Sga. Cipriani goodbye after she asked advice on how to deal with a baby alligator that her daughter had just been given. Up my street.

*Cora Caetani (1896–1974), born Cora Antinori to a prominent Florentine family.
†Anna Maria Papi Cipriani (1928–2012), writer and film producer; granddaughter of Alessandro (1878–1955) and Vittoria (1871–1949) Contini Bonacossi. Much of the Contini Bonacossi collection of paintings, sculpture, and furnishings was ultimately given to the Uffizi Gallery in Florence.

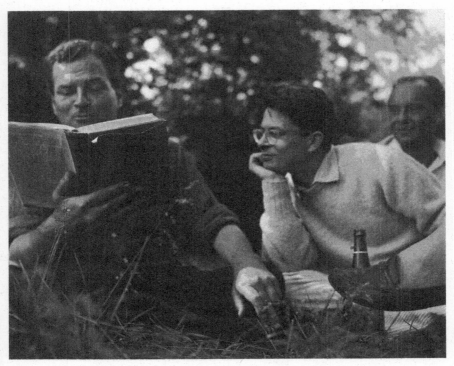

Patrick Leigh Fermor and Jean-Marie Mérillon, Lake Bolsena, 1962

Rome. Monday, November 24, 1969

The dinner with Gore. Found him with the Robilants.* "Oh, I've got things
to show you." Produced a book of Anaïs Nin's diaries of 1939–1944, open
at a page, and handed it to me. Fascinating paragraph describing Evelyn
and me and a visit to the Washington Square apartment, listing the names
of the guests. Vignettes from the past. Said that I always thought of her as
a joke. Not ha-ha, but with a smile. She was so precious and so arch. Gore
remarked that he had been very close to her. Yeah, shouted Howard. They
had an affair, didn't you know? Gore looked slightly pained and continued
to do so through the course of the evening. Howard I think has become
a trial to him. Especially since the modernization of the creature. He ap-
peared in ass-tight pants of many colors in stripes, bright-yellow turtleneck
sweater, and an orange scarf. Exclamations greeted his entry. He said, "Ya
know, I was so depressed today, I had to do something to cheer myself up."

Gore very likable this evening. Smooth and polished as an old Euro-
pean diplomat. *Suave* is the word.

In counterpoint, there was the yahoo behavior of Howard. Loud sal-
lies that are pretty unwitty. When Gore was reminiscing about seeing the
NY literary scene under the auspices of Anaïs when he got out of the army,
in 1945 or '46, Howard shouted, "I'll bet she hates you now for all the
books you've sold and for so much money."

Rome. Monday, January 12, 1970

At 8:00, Pod† came to the Isola, with Xmas presents—a colored wool belt
for Anna, which she put on as a tail and wagged it around the room. Some
perfume for J and a reproduction of Louis XIV's medal struck for the
opening of Versailles. Full of his Moroccan trip. Saw the Gettys—Gore
had asked him to call—and found them drugged most of the time but
amiable when they recognized him.

Paestum. Thursday, January 29, 1970

Finally we were on the road, the coast road, as far as the turn for Paestum.

*Alvise Nicolis di Robilant (1925–1997), managing director of Sotheby's in Italy, and his wife, the
artist Elizabeth "Betty" Stokes di Robilant (b. 1931), a painter and longtime friend of Cy Twombly's.
†René Podbielski (1914–1989), Polish-born writer and one of the developers, of Costa Smer-
alda, in Sardinia. His wife, Gisèle (1918–2006), was an economist.

Patrick Leigh Fermor, Limni, Greece, 1963

Weather had cleared. No more rain. A guard told me that the director, Carmine Finaldi, was in the bar, having a coffee. I found him there. A short, sturdy man with graying, wavy hair. Brown eyes, alert. Neat, quick, serious.

Finaldi took us down to *il deposito* [the warehouse] to show us the great discovery of the year before, the tomb painting called *Il Tuffatore*, "The Diver." In fact, that is exactly what it shows—a nude man diving. He got excited about this work. He dwelled on the finesse of the lines and the composition. Finaldi showed us an extraordinarily complicated and bepainted vase of very large size that had been found in the tomb. The basement was chockablock with *corredi* [grave goods] of the fifty-odd tombs that had been dug up in some artichoke fields just outside the walls. In one tomb they found a vase signed by Python, the only other known being in the British Museum—stolen from Paestum in the course of some clandestine excavations in the nineteenth century. Finaldi has a complete Neapolitan accent and makes an *s* before a consonant sound like *sh*. I asked him where he had been before Paestum. He laughed: at Bagnoli, with NATO. He was a navy man who got fed up with planning for a war of obliteration. Gave it up to study archaeology.

We drove out to the artichoke fields, where men were hauling some slabs out of the ground with a winch on the end of a little tractor. A wonderful scene, the fields stretching to the hills, on one side the walls of the city. Sun behind clouds. Finaldi showed me the big holes—the very big ones that held the chamber tombs and smaller ones the casket tombs. When Finaldi was called to what turned out to be the Tomb of the Tuffatore, the pickax had emerged from a crack in the stone with some paint on its end. They proceeded carefully.

Rome. Monday, February 2, 1970

Lunched solo, Piazza Campitelli. Walked to the Pyramid of Cestius. To pay respects to Caresse Crosby's ashes.* A stool in the middle, and on it an object covered by a black cloth, and on top of the cloth a red rose. Some flowers around, but pretty meager. On the altar a bible was open at some psalms—in German. An American flag in a stand at one side.

*Caresse Crosby (1892–1970), born Mary Phelps Jacob. She married Harry Crosby, with whom she founded Éditions Narcisse (1927), the Black Sun Press, in Paris. Much later she established a center for artists and writers in the sixteenth-century Castello di Rocca Sinibalda, north of Rome.

Diana Cooper, Isola Tiberina, Rome, 1969

I lifted the black cloth, and underneath there was a shiny aluminum pot holding the ashes. Signed the book. Only a page and a half of signatures. Wandered among the tombs [of the Protestant Cemetery] for a while. Reading the Russian inscriptions. There was Mita's* mother. With Italian grace, they had perpetuated the old duchess's Russophilia. The inscription said, "Of a Russian mother, she felt herself to be a daughter of Russia."

The old section, with Keats's tomb, has been spruced up, replanted and resown.

Also paid respects to my old favorite—the twenty-one-year-old Devereux Plantagenet Cockburn, late of the Scottish Dragoons—who sought his health in many foreign climes. Unsuccessfully. He lies there with his head propped up on his elbow, looking up to heaven. His haircut is à la Prince Albert. The sculptor was a pretty poor journeyman—Spence. The date around 1850.

Walked back, found Josephine at the door, come to pick up some work for Mazza.† She looked frazzled.

Later on, I went over to her place to approve the color photos for the *Colosseum* [book]. After all the fretting and the hard work, she has done a good series, with a few spectacular and romantic views.

To the Isola, where I found Gore talking to J; Peggy Guggenheim‡ came in shortly afterward. White, mink-lined coat, white boots. She was somewhat shocked by Roloff's memorial service for Caresse.§ It turned into a regular cocktail party full of people who didn't know Caresse. But it began on the right note—Roloff said a few sentimental words. Grady, the poet, read a poem to Caresse, but he was already drunk. The whole thing turned into an Irish wake. Perhaps Caresse would have liked it. Gore reported that Caresse had once told him that she had slept with both her sons. Peggy said, But she had only one, and he killed himself.

Dinner at Mario's in Via della Vite. Gore had been very funny before Peggy came, about Roloff's going to work on him one evening last week.

<hr>

*Contessa Mita Corti (1923–1986), born Mita Colonna di Cesarò. Daughter of the anthroposophist Don Giovanni Colonna di Cesarò (1878–1940) and Barbara dei Conti Antonelli (1888–1969), a noblewoman of Russian origin.
†Vittorio Mazza (1916–1992), photographer in Rome, often developed and printed Gendel's pictures.
‡Marguerite "Peggy" Guggenheim (1898–1979), American art patron and a friend of Gendel's dating back to his years in Greenwich Village; daughter of Benjamin Guggenheim, who went down with the *Titanic*. From 1942 to 1946 she was married to the German-born painter and sculptor Max Ernst. Her palazzo in Venice is now a museum.
§Roloff Beny (1924–1984), Canadian-born photographer who lived most of his life in Rome.

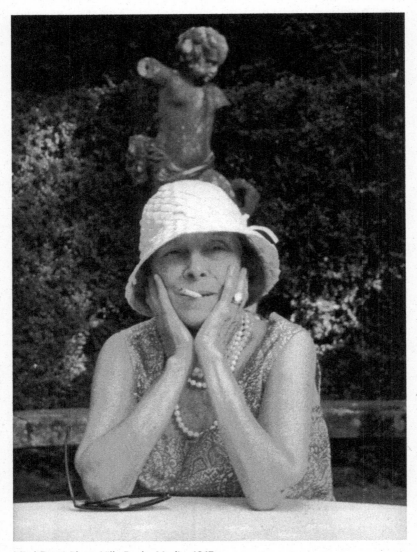

Mimì Pecci-Blunt, Villa Reale, Marlia, 1967

Would Gore write a book on Italy for which R would do the photos? Gore finally said, But look, won't my name wash yours out? He had been looking at a sample—the book on India that R had done with Aubrey Menen in which R is written very large and Menen very small.*

Coming out of the restaurant, Gore discovered that his black, antelope, red-lined coat was ripped down the back. Imprecating against my car—he heard it snag.

For a self-proclaimed—frequently—son of the American aristocracy, his reactions were on the vulgar side. "Do you know how much this coat cost? It's a Dior." First time I've ever heard a man put forward this kind of claim.

Rome. Sunday, February 22, 1970

Drove Peggy to Isola around 9:00. She had on a flamboyant pajama suit of blue and purple. Lively dinner.

Gore: Is it a Jewish trait to complain and whine? Is it something from the ghetto? Howard . . .

MG: But *you* don't complain, and you're always boasting about your Vidal Venetian ghetto blood.

He was supposed to sign some books for a Joan Axelrod, who will sell them in London for charity. I brought Peggy a copy of *Confessions of an Art Addict* for her to sign, since we were having a book signing. Gore grabbed it and said he would sign that, too. Everything he cribbed could be sold for money, even his telephone pad. He wrote on the flyleaf of her book: "My best book, Gore." She took it from him and wrote under it: "My worst book, Peggy."

Rome. Monday, February 23, 1970

Telegram to [*Newsweek* book division editor Joseph] Gardner asking him to send my Colosseum outline to Peter Quennell.† Then I spoke to Peter on the telephone on Saturday; he said that he knew nothing of an outline. He wanted to know what arrangements there were at the Colosseum for latrines. I telephoned Frank Brown at the American Academy‡ to ask him.

*The book alluded to here, with photographs by Beny and text by Aubrey Menen, is *India* (1969).
†Peter Quennell (1905–1993), prolific British biographer, historian, editor, and critic.
‡Frank Edward Brown (1908–1988), archaeologist and Yale professor, and director of the American Academy in Rome.

Gordian Troeller, Piazza Campitelli, Rome, 1962

"Why, that's a question that never occurred to me. And it's one that concerns every theater and amphitheater of antiquity, come to think of it."

Rome. Tuesday, February 24, 1970

Notre Dame book. Lunch at Isola with Kate Walsh* and Peggy Guggenheim. Kate fascinated by Peggy. Current of gossip about Kate Moffat† and the Beach Boy, which interested P. She has a nose for amorous goings-on and an appetite for vicarious participation.

Kate claims—she is not very reliable—that she heard the following dialogue between Peggy and Gore the other evening.

Gore: Well the major pastime is still screwing.

Peggy: Not for me. I gave it up fifteen years ago.

Gore: What for?

Peggy: I can't get anybody decent anymore.

Gore: You should just pay cash. You can afford it. And get what you want. I do.

To Gore's, where we found Grace Stone, the old American writer,‡ Mario Praz§ and the Marchesa Ricci, his inamorata, and Howard. Gore took us to dinner at a new restaurant, which serves French food. It is in the quarters of the old, pretentious Il Ghiottone, which went out of business—near Piazza Caprettari—and is run by African and Oriental nuns. It has the name of L'Eau Vive. Gore, who hasn't a firm command of French, thought it meant "brandy."

Crowded and noisy but plenty of elbow room. Marchesa Ricci, though, was somber; perhaps she had not been drinking. Full of complaints about the long wait between courses. Mrs. Stone more forthcoming—I sat between them—but radiating the pathos of the aged. She is trying to keep up. Has an apartment at the Nazionale and is full of little stories that show she is in demand. "Rome at least has no literary establishment. At the time I was in New York, I gave a little party and invited Lillian Hellman. Next day she called up to say that she couldn't come if Elizabeth Hard-

*Katherine Victoria Walsh (1947–1970), actress, best known for her role in Roger Corman's *The Trip* (1967) written by Jack Nicholson.
†Katharine Smith Moffat (1933–2001), wife of the screenwriter Ivan Moffat (*Giant*, 1956; *The Great Escape*, 1963), then of the novelist Peter Townend.
‡Grace Zaring Stone (1891–1991), American novelist. Her best-selling books include *The Bitter Tea of General Yen* (1930) and *Escape* (1939).
§Mario Praz (1896–1982), Italian scholar and critic, and a historian of interior design. His residence on the top floor of the Palazzo Primoli is now the Museo Mario Praz. Gendel had rooms on a lower floor of the same palazzo—his last office and studio in Rome.

Peggy Guggenheim, Palazzo Venier dei Leoni, Venice, 1969

wick would be there. Then Gian Carlo Menotti refused to come when he heard that Jimmy Merrill would be there, I suppose because the Merrill Foundation had refused to give him money for Spoleto . . . and so it went." Never heard so many names dropped in one anecdote.

When we got home, after dropping Mrs. S. at the Nazionale, Kate reported that she had talked to Howard about his cookbook. He was already planning a sequel. Guess what it would be called? Kate said smartly, "*Myron Breckenridge.*" He was thunderstruck. How did she know; who had told her? It had taken him months to think it up. Would she please not breathe a word of it to anyone? No, she said. I really don't think I can promise that; after all, I thought it up by myself.

Rome. Thursday, February 26, 1970

Rothko is dead.* Gabriella [Drudi] gave me the news on the telephone this morning. He had had heart attacks in the past; this last was fatal. Gabriella very upset, and this set me wondering why I didn't have a stronger feeling about this loss. Mark I had known for perhaps thirty years—maybe more, and had seen him during his Roman visits—the first a long time ago, in the early '50s, when he was in a *pensione* with Mell on the Janiculum, and he was laid up for days with what we called footrot. A joke. His moment of Roman glory was the one-man show at the Galleria d'Arte Moderna. And that must have been six or eight years ago. I never had a close friendship with him, and the idea that he was a great artist was more an acceptance than a conviction on my part.

Gabriella asked me to do a memorial piece on him for the *Messaggero.* Up to my neck as I am, I suggested that Toti do it, and I would ask Sandrino about getting it in.

"*Sono secoli che non ci vediamo*" [We haven't seen each other in ages], said Sandrino when I called him. When I broached the subject of Rothko's death, he knew all about it and more.

Gabriella had also heard that Mark's death was suicide, and this made her feel worse. He was a family man. Mell had begun to drink heavily, and he hadn't come to Italy during the summer because he was afraid to leave their small child in her drunken care. So he must have been desperate

*Mark Rothko (1903–1970), born in present-day Latvian American painter. He committed suicide in his studio on East 69th Street in Manhattan. His second wife, Mary Alice "Mell" Rothko (1922–1970), died several months later.

Peggy Guggenheim, Palazzo Venier dei Leoni, Venice, 1969

to kill himself. Carla Panicali had had the news from Frank Lloyd* in a phone conversation, casually. They had been talking about other things, when Frank said, Oh, don't think about selling that Rothko you've got; his prices will be going up now. Why, asked Carla? Because he is dead, said Frank. Gabriella knew that things were very bad with him. Last time she saw him in NY, he looked wrong. He had long hair and modern clothes, and had become thin. In his heart he was always a family man, a patriarch, business suits, with a paunch. NY was a killer. A man like that had no one to reassure him. When Matisse was paralyzed and lay in bed, he still had people around him who appreciated him and confirmed his identity. De Kooning had the good luck to be in Fourcade's care.† But otherwise . . . Rothko was "discovered" by the press and the magazines and then completely ignored. A news item. He was over. At his studio he seemed pathetically eager to have Gabriella's views. Was he painting well? Was he as good as he had been? She sounded crushed by heavy feeling.

Rome. Friday, March 20, 1970

Mexico City museum book.

Dinner at Isola. Kenneth and Jane Clark,‡ Adolph and Esther Gottlieb,§ Enrico d'Assia,¶ and Kate Walsh.

Adolph: Clark?

That's Sir Kenneth Clark. He's from England.

Esther is a very nice, quick, forthcoming woman. We had reminiscences about meeting in NY thirty-five years ago. Probably with Alfredo Valente,** who now it appears has a chair of design at some college.

Talk about Rothko. Esther had nursed him through his breakup with

*Frank Lloyd (1911–1998), Vienna-born international art dealer specializing in abstract expressionism; cofounder of the far-flung Marlborough Gallery. After Rothko's death, he was the target of civil and criminal actions involving works by Rothko. An appeals court called his business practices "manifestly wrongful and indeed shocking."
†Xavier Fourcade (1926–1987), proprietor of the Xavier Fourcade Gallery in Manhattan. He represented Willem de Kooning and many others.
‡Kenneth Mackenzie Clark (1903–1983), British art historian and museum director; his television series *Civilisation* was broadcast in the late 1960s. Clark's wife was Elizabeth Winifred Martin Clark (1902–1976), known as Jane.
§Adolph Gottlieb (1903–1974), American abstract expressionist painter; married to the educator Esther Gottlieb (1907–1988).
¶Enrico d'Assia (1927–1999), born Prince Heinrich Wilhelm Konstantin Viktor Franz of Hesse-Kassel; painter and designer.
**Alfredo Valente (1899–1973), Italian-born American photographer and art collector.

Elaine and Willem de Kooning, New York, 1981

his first wife and his marriage to Mell. But in the last several years they had drifted apart.

Both Adolph and Esther remarked that he had been evasive on the telephone and said, Give me your number, I'll call you back in a few days. But he always had their number.

Later, Adolph complained that Rome didn't seem to know he was here. The embassy, the cultural attaché, had done nothing about him.

That's easy; as they don't know anything, they also don't know about him.

Sir Kenneth very agreeable and conversational. He was pleased with the success of his TV series on civilization and described how enjoyable it had been going over his education and making a narrative out of it. He was scrupulous about rereading any author he thought to mention, but had not done any boning up on facts and details. Rousseau, he said, on rereading, was magnificent.

He chose the accompanying music. The staff provided by the BBC couldn't have been better.

Pleasing contrast between the polished aristocratic English product and the rougher homegrown NY painter.

Jane not drunk, but full of the problems of life in England. How the immigrant must be stopped. In the country, neighbors—but I think she meant employees—gardeners, servants, etc.—still a heavy tax on them to drive them into industry. Some people were not suited to industry, said she.

Rome. Wednesday, March 24, 1970

I suggested that we go to see *Romeo and Juliet*, in English, at the Pasquino. A foreign-film movie house in Trastevere. Met Josephine and Gosina in Via Arenula by Via dei Falegnami. and we walked to Piazza Santa Maria in Trastevere. Pasquino draws the same crowd that the Eighth Street Playhouse drew and for all I know still draws. Young and not so young in the going bohemian rigs and hairstyles. Now beards, some beads a lot still, and sharp clothes. Many foreigners—Americans, Swedes, Israelis. The film by Zeffirelli is remarkably good. He is one of the best Italian directors and immeasurably better than Visconti. Real command of history and the medium. His Italian garden is a convincing one. No effects for effects' sake—everything follows an interior logic. So that in the scene of a ball at Casa Capulet, when he begins to twirl the camera and blur the scene, it is just right. Magnificent scenes, such as the one of the nurse sailing across

Salvador Dalí and Tom Hess, Hotel Ritz, Paris, 1970

the piazza and then being teased and roughed up by Mercutio and his louts. The lout atmosphere is very well done and gives Mercutio his frame. Agreeable to watch healthy fresh young Romeo and Juliet—who are acted by teenagers who turn in a competent and engaging performance as the silly adolescents that the two children were. Bit players superb—the prince and the parents. Color impeccable. Settings, costumes, and details flawless as far as I could see.

A good movie exalts you, as a bad one depresses.

I was exalted.

London. Thursday, April 30, 1970

To Kensington Palace for dinner. Princess Margaret on the doorstep in a black dress with a complicated necklace of wood hung with gold elephants—a NY creation by DeLillo, a supersede of Ken Lane, the previous Junk Jewelry King. Tony came in later, off his motorbike, dressed like Robin Hood in black. Boots up above calf, tight pants, black shirt. Full of the devil. Shah* had sent some caviar, which we had as the first course, then steak. Harold Acton had been there for his book of memoirs. Tony imitated his unctuous voice: "Just a little thing which might offer a few moments of amusement . . ."

Pcss M took us into her sitting room downstairs to show her collection of shells—in two big lighted vitrines. She didn't know the exotic names of them, but kept picking up favorites—fantastic shapes—mainly from Japan. The emperor, she explained, is a marine biologist and had assigned a great conchologist to her, who guided her buying. Or were they presents?

Tony talked about the kidnapping threat. He was pleased with the way he had handled David, but it sounded cockeyed to me.† He kept it quiet and went down to the school and asked the headmaster to swear all the children to silence. This is foolish and risky. Much better to tell the child, as he's bound to find out anyway. I suddenly remembered that Ed‡ and I had been threatened with kidnapping when Pa had the dress factory and there was some labor trouble. When I told this, it seemed to diminish the drama of the threat to David.

*The Shah of Iran, Mohammad Reza Pahlavi (1919–1980).

†Anonymous calls to newspapers had revealed an alleged plot to kidnap David Armstrong-Jones, Viscount Linley, in order to gain the release from prison of the notorious London crime-syndicate bosses Reginald and Ronald Kray.

‡Edward Gendel, MD (1913–2006), Milton's brother, a psychiatrist in New York City.

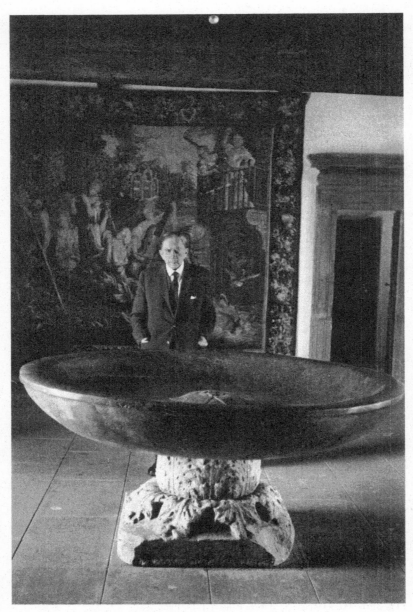

J. Paul Getty, La Posta Vecchia, Palo Laziale, 1971

London. Tuesday, May 12, 1970

Party [given by the Gendels] a mob scene. For Catherine Guinness, who is eighteen. Princess Margaret came without Tony, who was still in Wales on a job. She sat for a long time talking with Mopsa* and John Craxton.

Marguerite Littman† brought Henry Geldzahler,‡ whom I don't like on principle and didn't take to in the flesh—which he has a great deal of. She also brought David Hockney—he has a quick and shrewd eye—and his or their boyfriend.

Talitha [Getty] came with a couple of pop stars—Mick Jagger, a well-mannered fellow with blabber lips and a miserable-looking waif in a sable coat down to her heels—Marianne Faithfull. They remind me of Andy Warhol's dictum: One day everybody will be famous for at least fifteen minutes.

Talitha asked J to introduce Marianne Faithfull to PM. MF then picked up some lilies of the valley out of a vase and thrust them at Pcss M. After the introduction, PM said [to Judy] in a resounding voice, How extraordinary—offering me your flowers. And stuck them back in the vase.

Rome. Wednesday, May 20, 1970

Found Kathy Tynan§ in the piazza at the Isola, unsuccessfully trying to get in. Pina¶ out somewhere. Pretty and fresh-looking. Very enthusiastic about the apartment. Helped or rather did all the arranging of flowers in vases. Took her to lunch at Piazza Margana—out of doors. Lots of exclamations over the beauty of Rome. She is here to do an article on Visconti and his films for U.S. *Vogue* and *The Sunday Times*.

Complaint about the Snowdons' anniversary party. Not only that, according to her, it was dull, but embarrassing for them, the Tynans. Feeling

*Mopsa Young (b. 1953), daughter of Wayland Hilton Young (1923–2009), journalist and politician, and Elizabeth Ann Young (1923–2014), a writer and activist. The Youngs were early friends of Gendel's in Rome, where Wayland (later Lord Kennet) had been posted as a correspondent for *The Observer*.

†Marguerite Littman (1930–2020), Louisiana-born socialite–activist–voice coach with an interest in the contemporary arts; said to be the model for the character Holly Golightly in Truman Capote's *Breakfast at Tiffany's*.

‡Henry Geldzahler (1935–1994), art critic and longtime curator—of American art and then of twentieth-century art—at the Metropolitan Museum of Art in New York.

§Kathleen Tynan (1937–1995), journalist and screenwriter. Her husband was the theater critic Kenneth Tynan (1927–1980).

¶Pina Motzo, the cook in the Gendel home.

Kathleen Tynan, Piazza Campitelli, Rome, 1970

that they are compromised by being seen in that company. The revolutionaries feasting with the aristos, is evidently the idea. More Ken's than hers, and he took it out on her in his surly and hysterical way. Why go at all? I asked. Which appeared to alarm her. Then she got onto an evening when Pcss M horned in—she put it that way—on a little dinner with the editor of the *Black Dwarf* and some other anarchical underground publishers. Then they went to a party where everyone sat on the floor, including Pcss Margaret, and Emma Cockburn* pretended she did not know her. This was followed, the account of it, by another small dismayed disapproval when told that the Tynans were having the Snowdons to dinner. Well don't come, said Kathy. And the others protested that they hadn't seen each other in a long time—the evening before.

Rome. Tuesday, June 2, 1970

In the evening to see Antonioni's *Zabriskie Point*, which is supposed to be about the youth movement in the U.S. It's a plodding exercise in topicality. The audience was more interesting than the film. It was full of people remarking to one another, "You remember we saw that . . . we were there." A new, well-traveled Italy. But then we were at the Tiffany, a fairly new movie house on the Esquiline, where there was once a glass gallery. The movie is not only boring, in places it's ludicrous. The love scene, which multiplies itself all over the landscape, was enacted or rather acted out by a troupe like the Living Theatre. It was like coupling dogs trying to obey the laws of the Stanislavski method.

Rome. Sunday, June 7, 1970

Porta Portese with Josephine. She was trying out her movie camera harness, a homemade contraption like something out of a horror movie, contrived out of lengths of pipe with wing bolts and foam-rubber padding. I left her to it and prowled around. Bought a small plaster figure, painted, of Leo XIII, a present for Mimì† (2,000 lire), a miniature sword (1,500), which the Neapolitan vendor said he had found in a *stipetto da farmacia del*

*Emma Tennant (1937–2017), British novelist. The political journalist Alexander Cockburn (1941–2012) was her third husband.

†Anna Laetitia "Mimì" Pecci (1885–1971), art collector and art patron, and grand-niece of Pope Leo XIII. In 1919 she married Cecil Blumenthal, a wealthy New Yorker who changed his name to Blunt. Mimì Pecci-Blunt's palazzo in Rome and villa near Lucca became cultural magnets. She was one of Gendel's earliest friends in Rome.

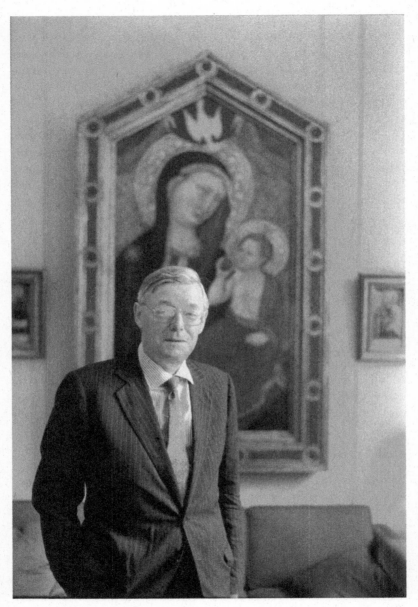

John Pope-Hennessy, New York, 1983

seicento [seventeenth-century pharmacy cabinet], and a miniature horse, as for a bracelet charm, for Jill (1,000).*

Rome. Monday, June 15, 1970

Highly scheduled day. Various chores. Meeting with plumber at Isola. On the way, I stopped to talk to the fat man at the bar. As I was taking the car up to be fixed, I offered to have the scratch in his door, caused by someone banging the door of my car against his, repaired at the same time. He had already sold the car, scratch and all, and told me—expansively—to forget it. At that point there was a snarl and a bellow. A large, lumbering red-faced man had come up close to us—we were in his path—and Crab† had taken exception to his appearance. She had leaped up and sunk her teeth into his hand. There was a puncture between the thumb and first finger, and blood was welling out of it. That is all I need, I thought—we'll be tied up now for hours.

I dragged him into the bar and washed the wound with cognac. I offered him one, too, but he refused and went rambling on about vaccination certificates and going to the hospital. If he had, Crab would have been carted off to the dog pound for observation and probably I'd have wound up with a fine for having her in the street without a muzzle.

But Pina suddenly appeared, along with Inez, the fruit lady, and Fortunata,‡ and assailed the poor victim. Telling him it was nothing, just a scratch, waving certificates, and heaping him with contumely in broadsides—"*Non gli dia retta, è un vecchio ubriaco*" [Don't pay attention to him, he is an old drunk]. The man finally turned to me and mumbled something about an "adjustment." "*Sa, se vuole aggiustare la cosa*" [You know, if you want to set things right]. I reached into my pocket for what was in it—1,500 lire—and handed this sum to him. Fearing it wouldn't be enough. But he seemed content and went rambling off. The fat man of the bar refused to be paid for the cognac.

Dinner *à deux* with Mimì on her terrace. Magical, with the Campidoglio looming in the half dark, and all the flowers out. In the middle of dinner we could hear the whooping of Viviana from across the way.

*Angela "Jill" Shipway Pratt (1921–2009), onetime model in Paris (known as Sallie) and later a breeder of horses in Italy.

†Crab, largely a terrier, was born in the *portineria* of Josephine Powell's palazzo and lived in the Gendel household from the early 1960s to the late '70s. She was fiercely loyal to the family; certain strangers could arouse antipathy.

‡Fortunata, a neighbor at the Isola.

Flea market, Porta Portese, Rome, 1982

Shouted conversation. Mimì: "*Le chieda chi c'è di là e perché non viene mai a trovarmi*" [Ask her who's there and why she never comes to see me]. Viviana and her husband; Dino[*]; and Angiolillo, the little toad who owns Tempo. Soon they went out to dinner—after 10:00 it was. Mimì very funny about Viviana. Started reminiscing about an altercation with her at Marlia[†] a couple of years ago, when she was proposing to take Gaia on a cultural tour of Tuscany. Mimì, jealous, had remarked that she didn't know enough to do that. Viviana was enraged and shouted at her that she was a praying mantis. "*Una mantide religiosa. Le ho spiegato,*" said Mimì in her full, deep, measured voice, "*Che quella era la prova della sua ignoranza. Una mantide religiosa mangia suo marito, non i suoi figli.*" [I explained to her, that shows her ignorance. A praying mantis eats her husband, not her children.] Then she tapped her head and said, You know, my brain is divided into two parts. With one I know how I ought to treat my children. With the other I treat them the way I do.

Then followed the usual complaint about her things and her books. I had returned to the library, before coming upstairs, the several books I had borrowed to do the Pyramids and Notre-Dame outlines. The footman had accompanied me through the sheeted *saloni* to the unused library, and we had got the six or seven books back in their places in two or three minutes. It is all perfectly catalogued and clear. Mimì said, you know, there is no one of the five [children] who has the slightest interest in these things. And I ask myself, What did you do it all for? It's wasted, it will all be dispersed. Then I answer myself, Well, what of it? You wouldn't have done it if you hadn't wanted to and if you hadn't enjoyed it.

Then came a lecture on the values of frustration, as a stimulus for accomplishment.

London. Saturday, June 20, 1970

Sylvia to lunch.[‡] Reminiscence about Edward Heath.[§] He used to come to Chartwell for weekends. One day when they were in the library, Winston put his hand on Heath's shoulder and said, My boy, one day you will be prime minister. A couple of years later, she ran into Heath somewhere and

[*]Ferdinando "Dino" Pecci-Blunt (1921–1997), son of Mimì and Cecil Pecci-Blunt.
[†]Villa Marlia, or Villa Reale di Marlia, Cecil and Mimì Pecci-Blunt's late Renaissance estate outside Lucca.
[‡]Sylvia Henley (1882–1980), Judy Montagu's aunt, sister of Venetia Stanley, and cousin and close friend of Clementine Churchill.
[§]Edward Heath (1916–2005), British prime minister, 1970–1974.

Flea market, Porta Portese, Rome, 1979

reminded him of the scene: "Do you remember . . . ?" Of course I remember, he said. But I am more pleased that someone else has remembered as well. Would you mind writing me a note stating that this did happen? And she did.

London. Thursday, July 2, 1970

Spoke to Pcss M. Wasn't it a lovely ball? What a good time she had had, but we never danced or talked. And Tony found it boring. Would I believe it, she was still in evening dress? What, from the ball? No, no. I'm glad we haven't a television phone because it's too funny. But we had to be up early this morning for the opening of Parliament, and I had to put on my tiara and dress for it. On the way back, we dropped in on my mum's and found her in the middle of a large party for the governor of South Carolina, who must have been amazed to see us got up this way. But he was very nice. Yes, a star. And had just been to Cambodia, so we had a long chat about Southeast Asia.

London. Monday, July 6, 1970

Dinner at Jacob and Serena Rothschild's.* They have the house that formerly belonged to the Farrells. Looked better then. Some good Rothschild pics—Gainsborough and Reynolds. Also a number of paintings by Bevan—a contemporary of Yeats. Not very interesting. Sat between Serena and Emma Rothschild. Serena had said that the smartest young couple in America would be there—the Burdens.† There is something unlikable about him, but she is very attractive and clever.

After dinner there was a boring romp in the game room, over a table game of football—in which Jacob and Sheridan Dufferin‡ were the stars. A stroll in the garden—during which we talked about the new mutual funds based on paintings. Henry McIlhenny's Seurat has just been bought by such a consortium. The young tycoons, smoking their cigars, were coolly negative about this arrangement. They didn't like the idea of art being treated as a straight commodity, leaving out the imponderables of

*Jacob Rothschild (b. 1936), financier and philanthropist; Serena Mary Rothschild (19352019), racehorse owner.
†Carter Burden (1941–1996), politician, socialite, and owner of *The Village Voice*; Amanda Burden (b. 1944), socialite and urban planner.
‡Sheridan Frederick Terence Hamilton-Temple-Blackwood (1938–1988), fifth Marquess of Dufferin and Ava; art dealer and patron, notably of David Hockney.

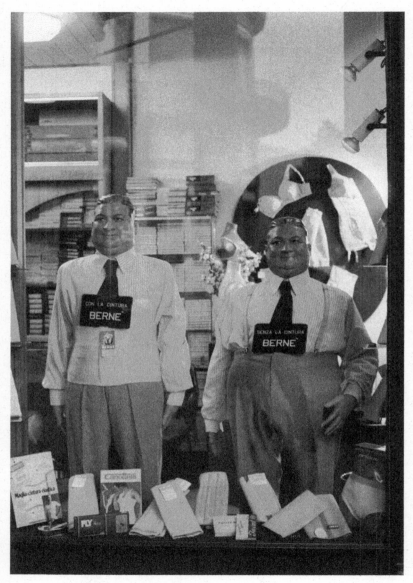

Corset display, Montecatini, Tuscany, 1980

its prestige. Then, said Jacob, it isn't a very good financial prospect, tying up large amounts of cash for as long a time as possible, so that when you do sell it, the return—discounting the interest you've lost and the depreciation in money, may not be very worthwhile.

Jacob told one of the little millionaire stories. Mrs. Oppenheimer—the South African diamond heiress—was looking out of their window at the garden. She comments on the row of trees that marks the end of it. And is that a windbreak?

Carter was insufferable about youth and the war, fulsomely repeating all the things one reads in the papers and mags every day. "Youth is dissatisfied"—youth is this and that.

J looked drawn, white & tired. On the doorstep, Jacob was talking about his trip to Paris the next day to attend a Rothschild wedding. "It's the first time in forty years that a Rothschild is marrying a Jew—for a change."

London. Wednesday, July 8, 1970

In the evening to Kensington Palace. Princess Margaret had an Indian-print dress she was pleased with. Tony arrived from Rome with a sound of thumps as his bags and cases were deposited in the hall. He had with him his assistant from *Vogue*—Derek Butler—a little fellow with long brown hair and mod clothes and a sort of Cockney accent. They were both enthusiastic about their stay in Rome. Worked all day at the Pontis.[*] Sophia Loren and Ponti they thought were fine, straight professionals. Somewhat jocular about the Crespis.[†] Consuelo? Which one was he or she? Oh she must be the one that kept saying *Dee-vine!* every time I aimed my camera. Kokoschka was ill, so he wasn't there at all. Next week Tony goes to Majorca to photograph Miró. Early in the conversation, Tony began to get at Pcss M, snubbing her enthusiastic comments about his trip. She looked as if he had hit her in the face, and when he asked whether he could have a drink—meaning, whether she would get him one—she wouldn't move. At dinner he wouldn't eat, saying that he had had dinner on the plane.

Discussion about Tony's next film. I said that I was sure the pets film

[*]The movie producer Carlo Ponti (1912–2007) and his wife, the actress Sophia Loren (b. 1934).
[†]Countess Consuelo Crespi (1928–2010), born Consuelo Pauline O'Brien O'Connor in Larchmont, New York; *Vogue* editor and fashion arbiter. Her husband, Count Rodolfo Crespi (1924–1985), known as Rudi, was a publisher and public relations executive in the fashion industry.

Tempio delle Ninfe, Rome, 1989

would make a hit in the United States. Mothers were sacred in America but not pets. The opposite of the English attitude. What would be his next one? I suggested planning and building, with emphasis on the personalities of the architects. He didn't like that one. He is too romantic for that, he said. Then got on to his careful separation of professional from personal life, and how he never took a job that anyone else couldn't have taken. Butler looked totally unconvinced. The thing that had affronted PM before dinner was her open-faced and interested question—Had he given her love to Sophia Loren and Ponti? "No, of course not," he said. "I wasn't dropping names; I was on a job." I couldn't help saying, when I saw her crushed expression, "You mean, they didn't know you were married?" He is a devil, and a couple of times in the course of the evening, to relieve the strain, I said, "He is the devil. You remember I said he was in Tuscany."

London. Friday, July 10, 1970

Three o'clock train at Waterloo, to Salisbury, where the Heads' Ah Fu met us.* No one at the house. Had tea and then found this typewriter in the office and got back to Hagia Sophia book.

Eventually Dot and Anthony [Head] arrived, and another guest—Lady Victoria Scott, called Doria.†

To dinner came Michael and Anne Tree,‡ now neighbors, and Cecil Beaton with Roy Strong, and Richard Head, who raises horses near Newbury. Dot had been deploring the state of Cecil's health. He had an operation for the removal of the prostate, which was followed by complications. Female hormones were prescribed, but he continued to complain about pains in the balls.

He looked healthy, though, and very clean, as usual. His dinner suit was deep red velvet. Roy had a most sumptuous getup, of brown and black velvet, cut in an eighteenth-century style. I sat between the two fellows. Cecil told about his complaints and how his balls ached, but then cut off, saying I reahllly can't go on this way about myself. Could I understand why the Tate wanted to put on an Andy Warhol show? Was that art?

*Anthony Head (1906–1983), Viscount Head, soldier, minister, diplomat; and Dorothea Louise Head (1907–1987).
†Lady Victoria Scott (1908–1993), daughter of Field Marshal Douglas Haig.
‡Lady Anne Tree (1927–2010), daughter of the Duke of Devonshire. She was a social reformer and prison visitor, promoting needlework by inmates. Michael Tree (1921–1999), son of Nancy Lancaster, an artist, was a partner in the interior design firm Colefax and Fowler.

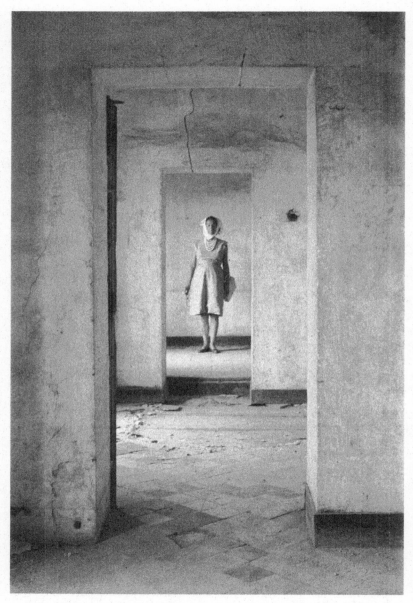

Judy Gendel, Van Gogh's Saint-Paul Asylum, Saint-Rémy-de-Provence, 1962

Roy, a friend of John Fleming and Hugh Honour,* stays with them every year near Lucca. "John is like a ventriloquist's dummy to Hugh, don't you think?" We got onto the book business. He is doing one for them on Mary Queen of Scots—"Isn't she loathsome? I hate her." Do you think she is worse than the tsarina? "Oh yes."—in a series edited by Honour and Fleming for Penguin called "The Eye of History." It is about the careers in history of well-known figures—after their lives. Roy did not make a good impression on the Heads. Dot felt he was name-dropping when he told her that he had been staying with the Buccleuchs.† He may have been doing that, as he also told me he had been staying with them. But that was in connection with a Van Dyck, now in the Fogg, that had been purloined from them. They weren't doing anything about it because it would be too embarrassing for the various people involved. Roy fighting with the National Gallery over their plans for expansion. If they take over his part— the National Portrait Gallery—he would be relegated to the parking lot. Why didn't he look for a new place to go? Yes, he should. Somerset House wouldn't be bad. Anthony found him pretentious and affected. "And those clothes!"

Amsterdam. Monday, August 17, 1970

Walked to the Stedelijk Museum, behind the Rijksmuseum, and looked at the contemporary works, the Van Goghs, the Mondrians, etc. Anna got bored with the modern paintings and asked to go on to the Rijksmuseum—no interest in geometrical abstractions or abstract expressionism. What do they mean? But delighted with Martial Raysse's plastic heart hanging at end of a curved plastic support with lights flashing along the edge, and liked the Tinguelys and Burris, but couldn't be bothered to wait her turn to feed a sheet of paper to a painting machine that turned out scribbled abstractions. That she can do herself.

In the Mondrian room, I was approached by two young American hippies. "What's this all about? Do you get it? What's he trying to do?" Gave a short lecture on ideas of clarity, continuity, and extension—trying to summarize neoplastic theory and connect it with socialist ideas. They

*Hugh Honour (1927–2016) and John Fleming (1919–2001), British art historians, were life and publishing partners. They edited art and architecture books for Penguin and produced influential books of their own (for instance, *A World History of Art*, 1982).
†The Duke and Duchess of Buccleuch, from a prominent line of Scottish peers. Boughton House, the Buccleuch home in Northamptonshire, holds a significant Van Dyck collection.

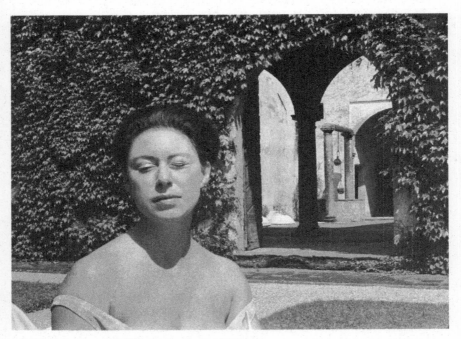

Princess Margaret, Villa Reale, Marlia, 1968

listened attentively and nodded, but I couldn't get a satisfactory answer out of them when I asked why they had reacted to Mondrian in particular. The museum is full of efforts that must also repel them. The whole thing was odd. A twisted retake of the squares in the '30s, who always wanted to know what Picasso meant and was he kidding.

Rome. Wednesday, August 19, 1970

The best of Rome. Hot with a breeze. Empty streets. Plants flourishing; two peaches on a "tree" grown from a pit. Two oranges on an orange tree in a pot.

Gore came over for a drink, and we had some rapid-fire conversation—for a change from the stolid Dutch pace. He is disappointed in the reception his book *The Two Sisters* has had. They are out to get him, he feels. I reminded him that *Myra Breckinridge* was well read, but he reluctantly refused to concede the point. When it isn't the real critics who go for him, the ones with big circulation—*Time, Newsweek*, etc.—are snide. He looked alert when I mentioned his review of David Reuben's book [*Everything You Always Wanted to Know About Sex* (*But Were Afraid to Ask)*], which was pretty hilarious. Judging from your various targets, except perhaps for Buckley, you seem to be conducting a literary pogrom—anti-Sontag, anti-Reuben . . . I think he does have a vein of Jew-baiting that reminds me of some of the German intellectuals. It's all right, because he is supposed to be immune from the charge, as he lives with Howard and broke with his mother on her referring to H as a Jew in a disparaging way. As he himself says, he was glad to have an excuse not to speak to his mother.

Villa Emo, the Veneto. Sunday, August 23, 1970

Gore picked me up at Piazza Campitelli at 2:00, and we set off, on the Autostrada del Sole, for the Veneto, where he is staying with Diana Phipps* at Villa Albrizzi, and I with Marina Emo.

Fine end-of-summer day and an enjoyable drive. Gore at his best—informed, informative, speculative, gossipy, and funny.

The drug scene has frightened him. Paul Getty now so far gone, he says, that he has told Howard to say that he's not in when Paul telephones. Convinced that the "fes," as he says (which ones?), are tailing Paul and

*Diana Phipps (b. 1936), born Countess Diana Sternberg, decorator and author.

Princess Margaret, Palazzo d'Avalos, Vasto, 1987

that if Paul comes to his apartment and wanders off to the bathroom for another dose of cocaine or whatever he is taking, the fuzz will interrupt and put them all in jail.

As we approached Florence, we began to talk about Harold Acton, and G proposed a visit to La Pietra* for a drink.

Gore cocking about Harold's book of reminiscences, in which his own name appeared. Gore is described, along with Tennessee Williams and "Victor," meaning Frederic Prokosch,† as Americans who were living in Italy but knew nothing about the country or the language. "I had been there exactly three weeks at the time he is discussing. And since then I think I have dealt with Italy about as much as he has in, what is it, sixty or seventy years?" A reference to his book *Julian*. Acton, he said, had produced only two books worthy of the effort—the one on the Bourbons, and the one on the Medicis. Otherwise it was flimsy and silly stuff. "He describes himself as an aesthete, but he is only a gossip. In fact I think 'aesthete' is just a polite old-fashioned word for 'queer.'" I was amused by Gore's assumption of a detached, butch tone. But it suits him nicely.

Telephoned Harold from service station at Florence exit. Oh, yes, he would like to see us. He had missed me in London. But he was dining with Ronnie Tree . . . Oh, yes, for a drink, that would be fine. But his butler had died. Yes, yes, a terrible blow, and "I am affrraid that I have only one servant to give us drinks." I thought that that could be adequate. Harold added, "He is all right . . . uhm . . . he was Prince Paul's . . ." Pretended to hear that he had engaged Prince Paul as his butler. Titter in response.

Gore curiously edgy, chin down and voice muffled, when Harold came into the *salone* with two dogs, the obstreperous Boxer, slobbering on my hand, and I apologized to H for offering him only half my hand, the fingers; explaining. Harold said, "I should have thought that Gore could contain himself."

Gore always treats me in a manly, comradely way, except the time he tore his new coat in my car. On the road, when part of the fender over the rear wheel was coming loose, I took a screwdriver and started to fix it. He came up and said, "You look so American doing that. Sometimes I forget how American you are."

*Renaissance villa in Florence, bought by the Acton family at the turn of the twentieth century, known for its gardens, paintings, sculpture, and furnishings; owned today by New York University.
†Frederic Prokosch (1906–1989), American writer and translator who lived most of his postwar life in Europe.

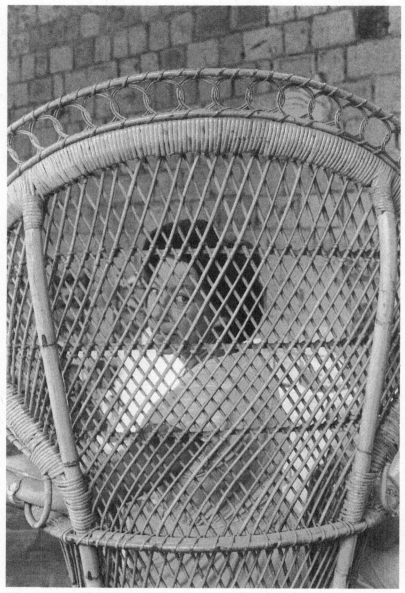

Princess Margaret, Villa Warwick, Via Appia Antica, Rome, 1985

Afterward Diana Phipps came in with a considerable party.

Diana has a wonderful seductive air, some earlier tradition of moving and reclining. Pampered court ladies of Franz Joseph's time; Mme. Récamier; Mme. du Barry; Diane de Poitiers; and so on.

George Weidenfeld* had been with her until today. He never listens, she confirmed. He was sitting next to her when she got a call from her mother to tell her that Eddie Bismarck, her uncle, was dying in Capri.† After she finished, she sat down next to George, feeling depressed. He said, noticing her, "Well, what's new, what's the news?" She told him what her mother said. "Very nice, very nice," he said vaguely, not having taken anything in.

Villa Emo, the Veneto. Tuesday, August 25, 1970

I wake up here, as if I'd been poleaxed, not knowing where I am. Then I see that I am in the corner room, nearest the house, of the *barchessa*, on the ground floor.

Late again, almost 10:00. Skipped breakfast entirely. Wrote diary. Haven't looked at the White House texts yet; I suppose I'm having a holiday, like other people. But drag everything with us like schoolboys putting a textbook under the pillow to sleep on overnight. Superstitious activities.

Bloody Marys in the *salone* and then off with Marina and Margaret Anne [Du Cane] to Este, to lunch with Diana Phipps and her guests. The more I see of Villa Albrizzi, the more I like it. Margaret Anne, when we were having a conversation *à deux*, asked me whether all of Italian country life was as formal and staid as at the Emos'. She waved a hand around to indicate the brocaded chairs and sofas: "No newspapers or books floating around, nothing casual, no games or needlework left lying, as they would in an English house." I told her to wait till she saw Villa Albrizzi. To understand that there were people who weren't like Contessa Emo in Italy, and especially in the Veneto.

Lovely Diana Phipps was sitting in a loggia by the swimming pool. A small thing, in which three small children were splashing. Evangeline Bruce there, with her long slender presence.‡ Tanned, long, shrewd, but

*George Weidenfeld (1919–2016), Vienna-born British publisher; cofounder with Nigel Nicolson, of Weidenfeld & Nicolson.
†Count Albrecht Eduard Bismarck (1903–1970), interior decorator, grandson of Otto von Bismarck.
‡Evangeline Bruce (1914–1995), novelist and hostess, wife of the American diplomat David K. E. Bruce (1898–1977).

Princess Margaret and Judy Gendel, Villa La Pietra, Florence, 1972

friendly face; long shoulder-length hair; sunglasses. Animated Pamela Hartwell (previously Berry)[*] in blue-and-white-print dress talking away at Gore, who had stayed over another day, I was glad to see. Gore a rather Hollywoodian figure—flowery shirt, reddish pants, and the inevitable dark jacket. Pamela has black-button eyes and a strong, rather handsome face. Terrible elephants' legs. But full of energy and command.

At lunch I sat between her and Diana. She had Gore on her other side and Diana had Hugh Reay.[†] Diana started out with inquiries about J and Patmos, then we got on to Holland and the sex shops. Next course I had Pamela Hartwell and Gore on the Speer diaries.[‡] She described going to Hamburg—grew out of some talk about cameras, as she and Evangeline kept leaping up and snapping the other guests as we sat and ate in the center of the eighteenth-century pavilion that stands to one side of the house, opposite the entrance gate. She had been accompanied to Hamburg by George Weidenfeld to negotiate with Albert Speer the sale of his diary for her newspaper, and while there, to make herself feel better, she said (to overcome the sliminess of dealing with This Nazi), she had bought the camera and put it down to expenses; her husband furious. Continued with the story. Why hadn't the series then come out as a book, I asked, as it was the only Nazi account since then, except for the Goebbels diaries, that had any real value, I thought. Oh yes. In fact, George Weidenfeld had planned to bring over Speer to launch the book, and there had been discussion about who would interview him for BBC. Pamela had proposed Trevor-Roper[§] as the logical person. To her amazement Speer had insisted on Balogh.[¶] General laughter.

Rome. Sunday, October 12, 1970

To Porta Portese.

[*]Pamela Margaret Elizabeth Berry, Lady Hartwell (1914–1982), journalist, museum adviser, socialite.
[†]Hugh William Mackay (1937–2013), Lord Reay, British politician.
[‡]Albert Speer (1905–1981), Hitler's armaments minister and architect, and a convicted war criminal. After his release from Berlin's Spandau prison in 1966, he published selections from his diaries and also a memoir.
[§]Hugh Trevor-Roper (1914–2003), Oxford historian and specialist on (among other things) Nazi Germany; his books include *The Last Days of Hitler* (1947). Trevor-Roper suffered an embarrassment in the 1980s when he authenticated the so-called "Hitler diaries," soon shown to be a forgery.
[¶]Thomas Balogh (1905–1985), later Baron Balogh, Hungarian-born British economist.

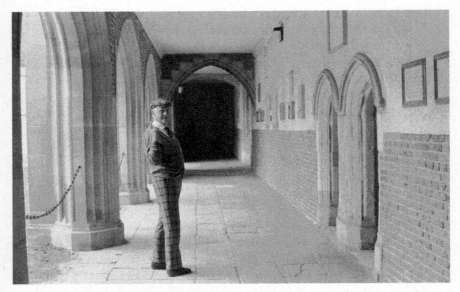

Colin Tennant, Eton College, Berkshire, 1995

Lunched with Babs,[*] who had a friend, Joyce Reynolds,[†] who is a classics professor at Cambridge—staying with her, I think. Babs gave us eggs and fennel salad to start with, then a dish she calls Babs's Panic, which is rice with odds and ends in it. Very good. They had been out looking for an inscription Joyce had seen ten years ago. Babs suspected that the slab was going to be stolen when she found one day that it had been moved from its original position. "That is something I learned in Africa. When something is going to be stolen, first it is moved away. If you notice at that point that it isn't where it used to be, it's produced again with some explanation about how it had been taken to be cleaned, or moved to protect it, and the attempt is abandoned. But if some time goes by and you do not notice, it then disappears completely. Well, I asked where the slab was. And was told that it had been moved to a safe place. Safe place, my foot. They were getting ready to move it out of the villa. So I telephoned Orietta,[‡] and she had it taken to the sheds under the aqueduct, which for some reason is fairly secure, and it is there that they keep the statuary and inscriptions that might tempt thieves." The inscription referred to an eye doctor called Ogulnius and was a fragment of his tombstone. Joyce knew of a family of that name connected with Ostia.

Rome. Friday, October 16, 1970

In evening to Luisa Spagnoli's[§] for dinner. Seated, for once. When I remarked on a large Pistoletto—a mirror with a nude woman seen from the back in the "foreground"—Luisa said, "Oh, *già*, you have never been here when there weren't a lot of people standing in front of my things." Podbielskis, Kiki Brandolini[¶] and Giovanni Urbani,[**] and Inge Feltrinelli[††]

[*]Georgina Masson (1912–1980), born Marion Johnson, known as Babs; writer, photographer, and architectural historian with a particular interest in Italian gardens and villas, and in ancient Rome. She lived in Italy for most of her life.
[†]Joyce Reynolds (b. 1918), a specialist in Roman epigraphy; spent her long career at Cambridge when not working as an archaeologist in the field. Among her students was the prominent classicist Mary Beard.
[‡]Orietta Doria Pamphilj (1922–2000). The ancient aqueduct forms part of the wall of the Villa Doria Pamphilj in Rome.
[§]Luisa Spagnoli (1925–1977), journalist, art collector, and promoter of a literary salon in Rome; granddaughter of a businesswoman of the same name who created the chocolate brand Perugina and a line of women's clothes.
[¶]Cristiana "Kiki" Brandolini d'Adda (b. 1927), socialite and fashion icon; the sister of Gianni Agnelli.
[**]Giovanni Urbani (1925–1994), art historian and conservator.
[††]Inge Feltrinelli (1930–2018), German-born Italian photographer and publisher.

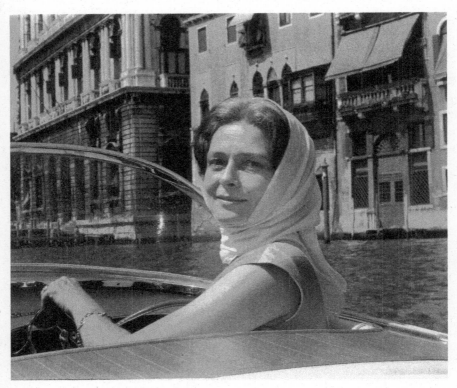

Liz von Hofmannsthal, Venice, 1962

completed the party. Except for Willy Mostyn-Owen,[*] the guest of honor. Full of his auctions. Cadaverous. At his wedding, someone said, "He must have been fairly good looking before he died."

We were going to bed and talking when Patrick[†] arrived with Harry Bailey[‡] and Monica Incisa.[§] Monica works for Merrill Lynch, a brokerage. Thought she was saying Mary Lynch, like Fanny Farmer, and couldn't imagine what sort of brokerage that might be. Previously it seems she worked for Bailey, and there was a joke about his having fired her for not typing fast enough.

Rome. Friday, October 30, 1970

Funny news. The last time I spoke to Jill, she was down in the mouth. She had had the operation for the removal of a tumor in her breast, and Carlo was acting up, and she had told him to go to hell. Today she was euphoric. She had been to the premiere of *Waterloo,* the film made by her friend Bondarchuk, the Russian director, which stars our old tenant Rod Steiger as Napoleon. And to this event she had taken her new conquest, the anesthetist at her operation. Before I went to Marlia, she was saying over the telephone that she was feeling very horny and had resolved that what she needed was a lover. Someone discreet and outside of the Roman world of horses and *saloni.* Wouldn't I help her, and for that matter wasn't it lucky that I wasn't in reach. I thought it lucky, too. Now she has balanced her books with Carlo by putting horns on him, which was one of her daydreams. "But in fact it's really much better for Carlo, too, as I'm so much nicer to him now. When he asks me to get him a gin and tonic, instead of saying, Go and get it the bloody hell yourself, I stop and think—Now if it were Milos, would I get it or not?—and as I would get it, I also go and get it for Carlo." He's called Milos? "Yes, he's Hungarian and studied in Germany and Italy, and he's only twenty-seven. It's a little embarrassing. When we take our clothes off, I make him take his glasses off, too. He's so smooth and unwrinkled. Yes, he's very pretty."

[*]William Mostyn-Owen (1929–2011), British art historian and associate of Bernard Berenson. He worked at the auction house Christie's for three decades.
[†]Patrick Lindsay (1928–1986), head of the Old Masters department at Christie's in London.
[‡]Harry Bailey (1934–1990), art historian representing Christie's in Rome; later worked for Sotheby's in New York.
[§]Monica Incisa della Rocchetta (b. 1948), writer and artist who was born, and lives, in Rome. She married Gendel in 1981.

Bill Hayter, Alba-la-Romaine, France, 1964

Flattering invitation. Gaia de Beaumont* asked me to a cocktail party in honor of another *croulant* [old man], Franco Brusati.† The only others of my generation were the Podbielskis. The rest were Gaia's contemporaries, and they were an attractive and appealing lot.

Then Monica Incisa came in and was jolly and provocative in her dry, head-down way. We had some jokes about her brokerage Merrill Lynch. Someone there called Anthony Childe telephoned me the other day and asked me to open an account. He was very fluent and high-pressure in manner. I staved him off, insisting that I had no intention of abandoning Dino. Monica said that she had told him not to bother me. She thinks I am *simpatico*, too, and stated that she was not making a pass at me but wanted to say that she enjoyed my company.

Rome. Wednesday, November 4, 1970

Holiday: anniversary of World War I armistice. Fixed four pages of Gosina's sample chapter for a book on the women's liberation movement and translated a couple of pages of Gabriella's book on De Kooning. White House outline.

In the evening, Spider‡ and Wolfgang [Reinhardt]§ came over. Colin Tennant¶ had come earlier than the others. He was jittery in a pleased way. Had I noticed that he was sweating? Because on the telephone Anne had just told him that she was going to have twins—due in ten days or so. He is here to negotiate a new deal on his hotel in Sardinia.

I like Colin's frisky, squirrel-like movements and quick gab. He is spending half the year now at Mustique but is not very confident about the future because of the unpredictability of the Black Power movement. The thing that has pleased him most was having a TV film made of himself at Mustique by an American producer.

*Gaia de Beaumont (b. 1951), Italian writer; daughter of Graziella Pecci-Blunt and grand-daughter of Mimì and Cecil Pecci-Blunt. Her father was Henri de Beaumont, diplomat and collector, and nephew of Étienne de Beaumont, patron of Picasso.

†Franco Brusati (1920–1993), Italian screenwriter and director of *Bread and Chocolate* (1974) and *To Forget Venice* (1979).

‡Sonia Geraldine Leon (1928–2014). "Spider" was a nickname given to her by her former husband, Peter Quennell.

§Wolfgang Reinhardt (1908–1979), German film producer and the son of Max Reinhardt, the Berlin theater director.

¶Colin Tennant (1926–2010), third Baron Glenconner. In 1958 he bought and developed the island of Mustique, in the Caribbean, giving Princess Margaret a parcel of land as a present when she married Antony Armstrong-Jones. In 2019 Tennant's wife Anne, Lady Glenconner (b. 1932), published a best-selling memoir, *Lady in Waiting: My Extraordinary Life in the Shadow of the Crown*.

Two chow chows, La Barcaccia, Piazza di Spagna, Rome, 1982

Rome. Monday, November 9, 1970

Saturday and Sunday spent mainly in bed, with bad cold. Picked up a paperback of *Fanny Hill* that was lying around and found that the all-around Man of Letters Peter Quennell had written the introduction, which tells the little that is known about [the author] John Cleland. An endearing novel, so good-tempered and full of good sense, as well as feeling.

Sunday went out briefly, to the Porta Portese market with Gosina. But I was in a bad mood, top heavy with my cold, and got stuck with a Neapolitan Saratoga trunk, which I didn't want. Temper worse when the Neapolitan wouldn't take it back for a 1,000-lire tip or exchange it for a small table at the same price—10,000. During the discussion, I lost Gosina. Finally I put the trunk on my shoulder and carried it to the nearest street where traffic passes and left it with a young fellow who was selling Oriental sculptures in plastic. By the time I got back with the car, the man had grown uneasy and was consulting a cop as to the possibility of the trunk containing a bomb. The cop rallied me as I was manhandling the trunk into the back seat of the car. He had two at home in even worse condition that I could buy for 1,000 lire apiece—his army footlockers.

Rome. Wednesday, November 25, 1970

White House outline. Peggy Guggenheim came to lunch. She is staying at Roloff Beny's. As she came in, she delivered a message from him—compliments on my *History of Italy*, which he had been examining. Peggy dressed in light-colored clothes—light tan coat with mink lining, soft leather boots, same color, dress printed to look like snakeskin. White hair. Poodle cut. Face rather mottled, as if she had been doing heavy drinking. But it's probably age. Did I want her to go out to see Vittoria? She would if I did. Wanted to be brought up to date on the twins. Told her that Sga. Berla* had called to tell me that she knew what the twins wanted for their birthday, besides seeing me—skis. Vittoria may have been persuaded to allow them to see me by the thought that I would shell out the 100,000 lire that two pairs of skis will probably come to.

Peggy's exhibition—that is, the exhibition of her collection at Palazzo

*Maria Teresa Berla (1902–1987), mother of Vittoria Berla (1926–1990). Vittoria, later an art patron, was briefly married to Roberto Olivetti. She and Gendel had a long affair prior to Gendel's marriage to Judy Montagu. Vittoria and Milton were the parents of the twins Sebastiano and Natalia, born in 1958.

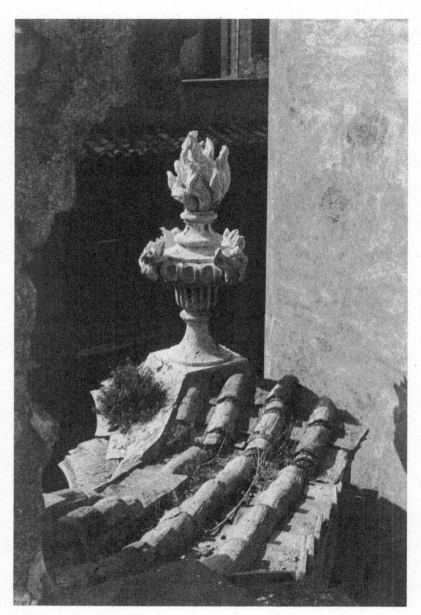

Rooftop finial, Rome, 1982

Venezia—has been put off till next year, as an appropriation couldn't be obtained till February. A spring exhibition is out of the question, as she wants her things back in the house for visitors to Venice then.

Peggy funny about Italy and the Italians. "I'm like Judy," she said. "I don't really like Italians or Italy. You're the only one I know who does like them, but I guess it's because you really speak the language and can have some relationship to them."

Rome. Saturday, November 28, 1970

On the TV news, given over mainly to the attempt to kill the pope at Manila—boring elaboration of the theme—there was a short sequence on the sale at Christie's, by Patrick Lindsay, of the Radnor Velázquez portrait of Pareja, for $5 million. Nasty effect on seeing the audience burst into applause when the deal was done. The smug petty bourgeois assurance of it. Like a scene from a Cocteau movie.

At 8:30, picked up Peggy Guggenheim at Roloff's and drove to Piazza Madama, to Fabio Mauri's.* She had brought Hong Kong, the little Lhasa terrier, with her. She claimed that she couldn't leave the dog because Roloff's office had been burgled again the night before, and she was afraid the burglars would come back and do the dog some harm. What sort of harm? Oh, poison in some meat for a kick, you know.

Rome. Saturday, December 5, 1970

Haunted by Sebastiano's face. It has a hypnotic beauty. Vittoria's blue eyes, but deeper and bigger. Some of the time it is sunk in a dream or abstracted, like a statue's look. Then it lights up with a flashing smile.

This morning I drove to Vittoria's villa on the Appia Antica, where I was well received by the new cocker spaniel, Teodoro. And by Sga. Berla and Natalia. Sga. Berla: *La Natalia è così felice di rivederla* [Natalia is so happy to see you again]. Natalia marveling over Teodoro's greeting as some sort of augury—*perché veramente in genere lui morde tutti I miei amici* [because he usually bites all my friends]. We got into the car, with two bundles of *scarponi da sci* [ski boots], and nothing happened. The car wouldn't start. Franco, the *cameriere*, came out to help, but trying and pushing and adding hot water to the radiator did nothing. Natalia ran inside and got permission from

*Fabio Mauri (1926–2009), Italian artist and writer.

Madama Lucrezia and Fiat, Piazza San Marco, Rome, 1983

Vittoria, presumably, for me to borrow a little car. Permission granted, with apology that the bigger one was needed to fetch some friends later on.

We went the back way to the Via Cristoforo Colombo and eventually got to Sebastiano's school. *Una fabbrica per l'educazione di Sebastiano* [a factory for Sebastian's education]. Big glass box. In the *segreteria* I handed over a note written by Sga. Berla asking that Sebastiano be released earlier than the usual 1:15 bell. By now it was 12:15. In the lobby of the school the decorations are sixteenth-century frescoes, stripped from an older building near the Forum, glorifying the reign of Sixtus V and his building program.

Natalia very tall and straight and narrow. Twelfth birthday today. She is attractive, with a lovely-looking face and alert brown eyes. Her manner is agreeable, quick, and interested. We talked about the paintings after having gone through the school situation—where she goes—not so big a factory—on the Via Cristoforo Colombo—and her duties and Sebastiano's.

Then Sebastiano appeared, with his unearthly face and lank brown hair. Bigger than Natalia and broader. He was wearing a camel's hair coat, a light-blue turtleneck sweater, cream-colored velvet pants, and brown brogans. And he was carrying a U.S. Army knapsack with his schoolbooks in it. Embrace. We set off in the little car for the Viale Europa and the sports shop called Europasport. The business of choosing the skis was quickly done—the man in the shop recommended the recommendable, and then brought out some attachments, which the children became enthusiastic over. While he was making out the bill, the traffic of the shop—considerable—was going on. In the middle of it stood a large round man trying out a gun in a very professional-looking way, assuming a wide-legged stance and then quickly raising the gun to shoulder level as if a starling or a sparrow had come into view. We had a joke about him when we left the shop—such a large man equipping himself to shoot such small birds.

Rome. Monday, December 7, 1970

Telephone Sarah Ambrosini to cancel trip to Prato. Don't know SA, but she got in touch last week to explain that she was organizing a trip to Prato for critics and others, to see Giorgio de Marchis's "Italian art of the last ten years" exhibition. But when I heard that she had rounded up "various cultural attachés and other people interested in art so that on the ride to Prato and back we could discuss the exhibition and currents in contempo-

Flea market, Porta Portese, Rome, 1988

rary art—you know, have a *dialogue*, a sort of 'happening' on the bus, with people talking to each other on the bus PA system"—I knew that I was not going to embark on that hell ship. She is American, married to an Italian, and has something to do with the *Rome Daily American* rag.

Dinner at the Dorias'.* Walked over at 8:30. Piazza Venezia full of riot police, in cars with grills over the windshields. Water trucks.

A palace and a half. Up the green carpet under the vaults with the *stucchi* of heraldic Doria emblems. Papal throne with its cushion hanging on the wall. Painted rail in front. Salons. And at the end, ushered in by footman, a little library with chairs all upholstered in the same chintz, floral chintz. Slipcovers, rather.

Rome. Thursday, December 17, 1970

Hugh Honour and John Fleming came to lunch at the Isola. Fleming, a former lawyer from Berwick, is white-haired and purse-mouthed. Honour is the younger mate, the odd-looking one, who does most of the talking. They are handling no less than six series for Penguin.

John asked me whether I knew Gore Vidal. "Well, he and his 'secretary' (you could hear the quotation marks as he underscored Howard's role, with pleasure) were going around to see Vernon Bartlett's† house near us, with a view to buying it. Vernon and his wife invited them to lunch and were horrified to see them lugging a large, heavy suitcase when they got out of the car. Vernon said, My God, they have come to spend the night. They must have misunderstood. But Vidal explained when they got to the doorstep. His dog had stamped off the balcony at the Excelsior, in Florence, where he had been staying, and had killed itself. They had the body in the suitcase and wanted to know whether they could bury it somewhere in one of the fields."

Rome. Wednesday, February 10, 1971

Telephoned Peggy Guggenheim. She was taking her robbery very philo-

*Lieutenant Commander Frank Pogson Doria Pamphilj (1923–1998) and Princess Orietta Pogson Doria Pamphilj (1922–2000). The British-born Pogson married into one of Rome's oldest families. In the 1960s, the couple adopted two children, Jonathan and Gesine. Late in life, Gendel maintained a studio-office in Palazzo Doria Pamphilj. The palazzo now houses a museum.

†Vernon Bartlett (1894–1983), British journalist and politician, author of several books about Italy.

San Sebastiano, Matera, 1989

sophically, to judge from her calm voice. The thieves at 2:00 or 3:00 a.m. had pried open a window on the Grand Canal landing in front of the house and had stolen thirteen small pictures—six Pollocks, two Moores, a Picasso portrait, and some other things. The police commissioner has forbidden her to offer any money to ransom the paintings. They weren't insured. He hopes to recover them. But also warns her that they might be burnt, to destroy the evidence, if he gets too close to the thieves without nabbing them in time. With all that she sounded full of hope for their recovery—and was touched by my solicitude.

Rome. Saturday, February 20, 1971

Mimì and I dined off a card table in the *salone*, as usual. She said she had been working very hard at her papers—meaning that she had been putting her diaries and old correspondence in order. I urged her to start writing, and she said, Well, for one thing, it was just writing for posterity, as she would never publish now. Because she was just plain afraid of what her old friends would do to her.

The timid lioness.

Later, she was very amusing, telling again the story of her seventeen attempts at matrimony. "You know that Cecil was the eighteenth, and I almost lost him too before I finally got him. But the other seventeen—it's a long story. To tell the truth, three of them asked me to marry them and I refused. Of these, one was a fat Bavarian who had cooled off anyway after looking in the bank and seeing that I had no money (*che io non avevo denari*); he went back to Germany—he had been in the embassy here—and married Big Bertha—yes, it was Krupp.* Another was a grandee of Spain who was very much encouraged by my aunt in Madrid. I was all over Europe, looking for a husband. Switzerland, France, Spain, even Poland and Russia—but I'll tell you about that later.

"I was only eighteen, and this Duca di Medinaceli asked me to marry him, but said that he had to explain something to me. He had a lover with whom he had lived for years, and he intended to keep her after we were married. At eighteen I was very proud—who knows if this had happened when I was twenty, I'd have known better—but I drew myself up and said, *E mai, a poi mai* [Never, and then never again]. My aunt was furious and in fact wouldn't speak to me for years until she finally wrote—after I

*Krupp was a German industrial conglomerate known for the manufacture of armaments; it supplied the German military in both world wars.

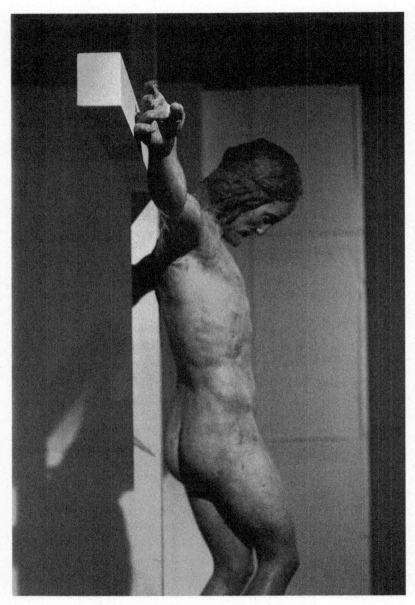

Michelangelo crucifix, Palazzo delle Esposizioni, Rome, 1964

married Cecil—and invited me to Madrid again. I wrote her back saying, *Grazie tante ma ora non ho più bisogno di te* [Thanks a lot, but I don't need you anymore].

"Well, then there was the trip to Poland. You see I had met this Princess Radziwill, who took a fancy to me and decided that I should marry a cousin of hers. So she invited me to their estate in Poland for the shooting. Yes, I shot, but not very well, and when I got there, I found that the cousin had a big beard and was not very thrilling. I don't think he liked me very much, either, but the one who did like me was the son, and we came to an understanding during the visit. To cover my poor shooting he would help me out, and when I shot a wolf, the poor beast turned out to have four holes in it instead of one. I still have the head—at Marlia—you know, where you go upstairs to Dino's rooms.

"But the mother was *furbissima* [very clever]. She did not want this marriage, because I had no dowry, so she came hastily to Rome and she told my mother she had something terrible but important to communicate to her. *E quella furba ha raccontato a mia madre che suo figlio era sifilitico. Figurati! E mia madre, grata, con le lacrime agli occhi viene a dirmi che buon'anima che persona generosa—quella che era pronta a dire che il figlio era ammalato.* [And that wily woman told my mother that her son had syphilis. Can you imagine! And my grateful mother, her eyes full of tears, told me what a good, generous person she was to admit her son was sick.]

"Oh, and then there was a very important match—but I had nothing to do with it—it was arranged by the Vatican. My great-uncle, Leo XIII, had started *trattative* [negotiations] for me to be given to the Duke of Norfolk . . . but nothing came of that.

"All the others I wanted to marry—fourteen of them, and I was always turned down in the end for lack of money. When finally I wrote to Papa [about Cecil], he couldn't take my letter seriously. He put it away in a drawer until Miss Kemp—you remember—came fresh from Paris and assured him that it was true that finally I was engaged to be married. Then he took the letter out of the drawer and wrote to me. But I almost lost Cecil, too. His mother really wanted him to marry a French girl. She herself *en secondes noces* [on second wedding] was married to the Duc de Montmorency. She sent Cecil away to Nice to forget me.

"But I promised a hundred francs to San Antonio if I would get back what I lost, and soon I was invited to dinner by a woman who took an interest in me and had a young man for me to meet. And by chance Cecil had come back from Nice that day, so she asked him, too, and I had them

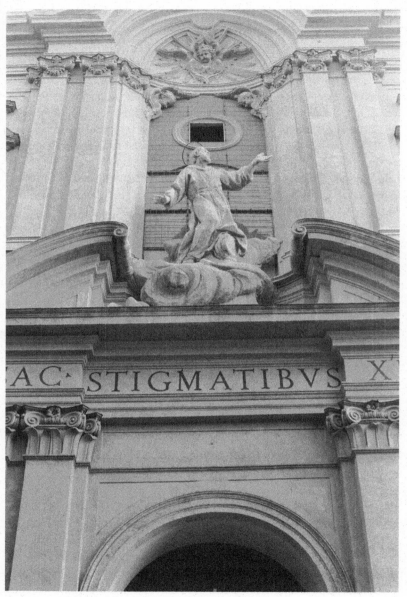

Santissime Stimmate di San Francesco, Rome, 1988

on either side. *Ma io non ho mai avuto peli sulla lingua* [But I never minced words]. So I said to Cecil, Listen, your mother doesn't want you to marry me. All right. But we can still be friends, can't we? This stung him, and he said he could marry anyone he pleased, and the very next day he went out and bought me an engagement ring at Cartier's. To this day I couldn't tell you whether I said what I did out of *furbizia* [cunning] or because it was just an impulse. So we got married—my eighteenth prospect."

Rome. Tuesday, May 25, 1971

Stopped at Palidoro for coffee, in the bar of the little settlement, and had a look at the eighteenth-century church built by Pius VI. At 11:25 in front of the castle gate at Palo Laziale, just over the RR crossing, and at 11:30— after driving slowly along the avenue of low overhanging trees and going past the entrance to the castle proper—I was going in the wrought iron gates of J. Paul Getty's* country mansion. New parterres in front, with some carefully laid-bare Roman ruins—a few courses of brickwork. Decent regular facade painted the Roman ochre color. A line of orange trees in pots standing along the terrace. Four huge wrought iron lanterns, with a sort of crown device on top, lying on ground, waiting to be put up somewhere.

I was ushered into the hall, where the most prominent feature is a vast porphyry basin on an inverted capital. The usher was the man who had opened the gate—dressed in ordinary clothes. A smoother servant appeared after a moment and asked me to go into a *salone* that was furnished with sofas, in front of a large travertine fireplace, and had seventeenth-century Italian tapestries on the walls.

Old Paul himself could be heard slip-slopshing down a narrow inner stairway, and then he appeared, with a rather nice welcoming smile on his dead-horse face. He's not very steady on his pins for a seventy-nine-year-old (compared to Mimì and Sylvia), and his hands shake.

I commented on the porphyry basin. He looked at it fondly and stroked the side. "I bought it in Florence, from a dealer. It's from Mount Porphyrites, in Egypt. The stone was imported for the use of the Roman emperors. The dealer says there are only a few of these, at least of this size, in existence."

*J. Paul Getty (1892–1976), founder of Getty Oil; once deemed the richest private citizen in the world (but with a reputation for stinginess). Much of his art collection is held today by the Getty Museum and the Getty Villa in Los Angeles.

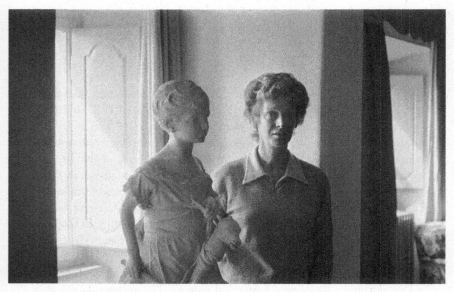

Marella Caracciolo Agnelli, Garavicchio, 1975

We sat down in the *salone*. He had an oracular look, sitting erect in his chair with arms extended on the armrests. What was the biggest thrill you ever got out of collecting?

"The most exciting moment I can remember was on June 20, 1938, when the Raphael came up at Sotheby's. It's known as the *Loreto Raphael*. In the catalogue it was listed as a copy, and I got it for £40."

Were you following a hunch or did you have good advice as well?

"I've always had close relations with the experts, and good advice from them—Berenson, Duveen, Julius Held . . . Zeri has been very helpful."

When did you begin to think of your collection as involving a responsibility to the public?

"Some time before I founded the museum at Malibu, in 1954. You don't want to be a dog in the manger with these things. To take an extreme example—Rembrandt's *Night Watch*. You couldn't imagine that in a private house, where the public has no opportunity to see it."

Do you mind being photographed, with some favorite possession? "Not at all. Let's go out to the porphyry basin, if that's the sort of thing you'd like."

There are good reflections in and around the basin. Now could we have another, perhaps with one of those seventeenth-century Roman busts?

"Oh, they're not good enough."

What sort of things would you like to add to your collection?

"Some more good Greco-Roman objects. Paintings have become very scarce and expensive. It's all changed. Buying pictures used to be a sign that a man had more money than he knew how to deal with, or was crazy. Throwing money away. That reminds me of a story about J. Pierpont Morgan, who was bringing a suit over a set of teacups. The lawyer pleading his case addressed the court, saying: Your Honor, put yourself in my client's place . . . and before he could get any further, the judge broke in to say, 'How can I put myself in the place of someone who would pay 4,000 pounds for a set of teacups?'"

Rome. Saturday, May 29, 1971

Lunched at Isola alone and then drove out to Palo. I had asked to have a session with Paul's *The Joys of Collecting* before talking to him [again], and he had said, Certainly, you can take it off in a quiet place and read it. The butler showed me into "*lo studio del Signor Ghetti*," which, like the rest of the

Marella Caracciolo Chia, Garavicchio, 1979

house, has the anonymous and somewhat bleak atmosphere of a *pensione*, though an expensive one. No portable objects lying around, not even ashtrays, and only a few insignificant books in the shelves.

After about a half hour, a comely blond woman with a small blond child appeared and assured me that Sig. Ghetti would be with me presently. I said I hoped not before a quarter of an hour, as I was still taking notes from his book. Then five minutes later Paul came shuffling in—with a serious, unsmiling expression—and when I said I'd like to go on reading for a while, he offered to come back in twenty minutes.

His statements in the book answered most of my remaining questions, so when he came back and sat down, I asked him mainly about the house, La Posta Vecchia, and his other houses. He had his hands clasped under his chin, his elbows on the armrests, and occasionally he would put his hands in front of his mouth, as if to stanch the flow—which, as usual, was rather sluggish. He started to smile when I remembered to give him a copy of *The Tower of London*, which I'd brought with me. A "help the rich" gesture that was for me a reverse compensation for my slow-wittedness in not having asked him to lend me *The Joys of Collecting* overnight. I didn't do so in response to the reluctance I thought he felt to give or lend anything, and it was silly on my part to respond to it. His reality is in being totally true to himself, so he didn't need any help from me.

"I own two houses in Naples."

Are they equipped, can you go there and stay whenever you like?

"Yes, they're fully equipped. Small houses, by the sea. Then I own this one, and my home in Malibu."

And Sutton Place?

"Sutton Place does not belong to me."

I thought of J's theory that if you asked Paul any question whatsoever, he would feel compelled to give a straight answer.

I said I had read that we were in the area of the ancient Etruscan city of Alsium and its port. Had he found any traces of it? I had seen what looked like Roman foundations exposed in the garden in front of the house.

"Haven't you seen the museum? I'll show it to you." He heaved himself up and tottered through the series of rooms to the one with the railing that shows a Roman mosaic pavement, patterned in colors, down below. We peered down for a moment, then he opened a door to the side and said, "It's down here." He pressed rows of buttons, and lights began flickering on down below—neon. As we went down, he commented, "All this was

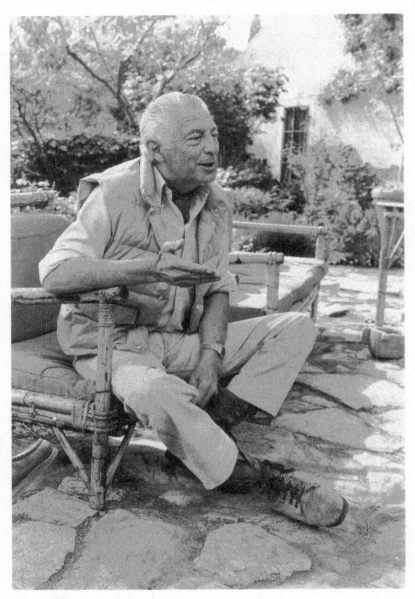

Gianni Agnelli, Garavicchio, 1983

found and preserved during the restoration of the house." The walls, most of them in *opus reticulatum*, came up to the knees in some places and up to the elbow in others. Everything carefully barbered, and walls tricked out with panels of dark-brown synthetic.

Some more mosaic pavements, then two "rooms" with vitrines full of Roman pots, pitchers, lamps, and dishes. All around first century B.C. to first century A.D., and all found here. Paul seemed distracted and kept looking back from where we had come. But he willingly or obediently posed for a photo standing in front of one of the cases. Then he headed back to the part of the basement by the wall on the seaside. And bent down to peer out through a slit window. Outside there was the beating of a boat's engine. I peered through another slit but couldn't see anything. Paul continued to look out anxiously. Then he straightened and started up the stairs but kept looking back toward the windows. "Do you think anyone could force one of those windows and get in?"

It would have to be someone the size of an organ-grinder monkey, I said.

Rome. Wednesday, June 2, 1971

Twenty-fifth anniversary of the republic. How young it was when I first came here, twenty years ago or so, and how uncertain its future is after only one generation. A couple of men standing beside me in the crowd under the pine trees of Piazza d'Aracoeli pronounced the current bromides to each other as the parade came around in front of the Altar of the Nation, from Via dei Fori Imperiali, where the reviewing stand was. *È una situazione proprio grave . . . La costituzione garantisce il diritto di scioperare ma non lo limita.* [It's really a dire situation . . . The constitution guarantees the right to go on strike, but it doesn't establish any limits]. The crowd, which included all ages, including tots—a few of whom were holding little tri-color flags—proved to have a connoisseurship of weaponry and applauded some of the tanks and armored cars, especially the speed-devil Leopards, newly acquired from Germany. A few years ago, all these displays of military might—the tanks, cannons, missiles, and jets—would have seemed like a parade of old toys. Tiny ineffectual Italy putting on its little display while the nuclear powers arranged its fate and the fate of the rest of the world. Since the Vietnam War and urban guerrilla warfare, the hardware has reacquired some meaning.

Still toylike, though, are the contingents of specialized troops—Alpini

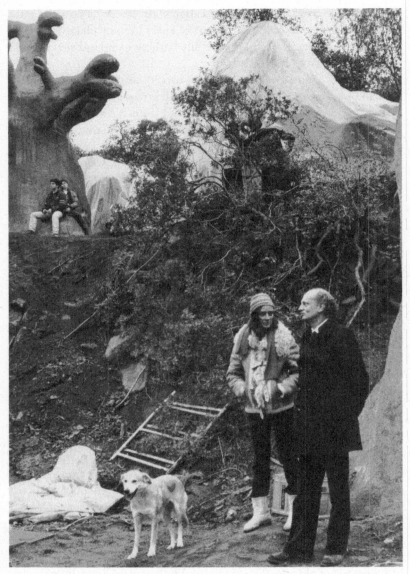

Niki de Saint Phalle and Nicola Caracciolo, Tarot Garden, Garavicchio, 1982

in white overalls, skis crossed on their backs; frogmen in frog suits; a few squadrons of mounted cavalry drawing caissons after them—like a scene out of World War I—reminding one of the eighteenth-century rulers playing with their troops, dressing them in fanciful uniforms, deploying them on the parade ground—Frederick of Prussia, Paul I . . .

Rome. Monday, June 21, 1971

Met Gioia and Miele Torlonia* at corner of Via del Mare. Miele driving a dark-green Mercedes sedan. To SS Giovanni e Paolo, to the enclave of film studios where I was once an extra in—what was the movie called?— *Teresa*. A GI. In '50 or '51. Five thousand lire was the pay for a day's hanging around in uniform. It's been slicked up, with natty brickwork, and there's a bar. Consuelo and Rudi [Crespi] arrived, looking like the spirit of happiness in consumer goods. Consuelo remarkably attractive-looking despite lack of sex appeal. Rudi wearing a slinky jump-suit caught at waist by a belt with large silver buckle.

Large brown blue-eyed face of Valentino,[†] the dressmaker. Talking to Gioia about the lack of helicopter service to Capri. Gioia complaining about iniquity of the Hotel Quisisana, which now charges 4,000 lire a day for a dog, Papa. In the wake of Consuelo and Rudi, the old elf Arnaud de Borchgrave,[‡] with tanned bald head. Very pretty dark wife. Also a little crowd of young heroes with bare chests and Louis XIV hairdos, with girls who had their eyes almost entirely shut. Friends of Franco Rossellini,[§] producer of the film we were to see, which was directed by Pier Paolo Pasolini.[¶] He's there, as well as Lanfranco** with Muriel Spark, and Marina Cicogna with her mate, Florinda Bolkan,[††] an actress.

Film unspeakable and not at all saved by close-ups of sexual parts,

*Emanuele "Miele" Torlonia (1929–1994) and his wife Gioia Missiroli Torlonia (b. 1928), Roman socialites. Historically, the aristocratic Torlonia family administered the finances of the papacy.
†Valentino Garavani (b. 1932), Italian fashion designer.
‡Arnaud de Borchgrave (1926–2015), Brussels-born American journalist associated chiefly with *Newsweek*.
§Franco Rossellini (1935–1992), Italian actor, director, and producer.
¶Pier Paolo Pasolini (1922–1975), Italian writer and film director; murdered in Ostia under circumstances that remain unclear.
**Lanfranco Rasponi (1914–1983), Italian writer and scandal-tinged publicist; owner of the Sagittarius Gallery in Manhattan.
††Marina Cicogna (b. 1934), Italian photographer and producer of *Belle de Jour*, (1967) and *Once Upon a Time in the West* (1968); Florinda Bolkan (b. 1941), Brazilian-born model and actress.

Tarot Garden, Garavicchio, 1983

mainly men's. It's called *Il Decameron*, based on Boccaccio, but can't be clumsier or more heavy-handed. Worst is a sequence featuring Pasolini himself—once one director gets in front of the camera, like Fellini, they all want to do it. Pasolini acts the part of a pupil of Giotto, who comes to southern Italy to fresco a church. Every cliché of the artist on the screen is faithfully repeated—intensity, dedication, soulful look.

After thanking Rossellini for this treat, the Torlonias took Muriel, Lanfranco, and me to that restaurant just off Santa Maria in Trastevere— the one I don't like, which has been considered smart the last several years.

When we broke up, I walked Muriel home—just a few blocks to the Lungotevere. She has strange working habits. In the home stretch of a novel, she commits herself to a hospital. The last one was finished in Salvatore Mundi. She is a bag fumbler and had to sit down on the front doorstep and empty her purse to find the right key.

Rome. Tuesday, September. 14, 1971

Tony arrived at the Isola at midnight with Derek, his assistant. Consuelo had sent her car and chauffeur for them, and the chauffeur lurked in the piazza, saying that it was a rough neighborhood and he was worried about the cameras in the car.

I was delighted to see Tony. He is very attractive in an improbable way. The upper part of his face is pretty—curly blond hair, round blue eyes, pretty nose; the lower is big-jawed and masculine. His body is slight, but he has great muscular blond hairy forearms. And his character is also a curious mixture of masculine firmness and straightforwardness and feminine coquetry and occasional deviousness. All his charm comes out when he is away from Princess M.

We had drinks, then Tony lighted on the proofs of the pictures I took in England, and he sat down with them, peering at each with a thread counter and, apologizing for it, began marking them for printing. He was pleased with a very glamorous one of him sitting at the wheel of his car. He said, jokingly, that it was as good as a Bellisario.[*]

When he was going through the pictures taken at Glen,[†] he launched a diatribe against Colin Tennant. He has it in for him because years before he married Pcss M, Tony was approached by Colin, who was about to

[*]Ray Bellisario (1936–2018), paparazzo who specialized in the British royal family.
[†]The Glen, estate and country house owned by the Tennant family near Peebles, in the Scottish Borders.

Margaret Koons and Orcus, Sacro Bosco, Bomarzo, 1950

be married himself. Colin wanted him to take the pics of his wedding—which was to take place at Holkham. He stressed this point, then added that the Queen Mother would be one of the guests. Tony nodded. Colin then said that under the circumstances—it would be such good publicity for Tony—he wouldn't expect to be paid anything. According to his account, he refused but got the job anyway and his usual fee.

I said that I had known only the amiable and generous side of Colin. But Tony wouldn't have even that—it was all calculation. He would be using PM for publicizing his miserable island, which was a blot anyway, as who needed nowadays an enclave of white pleasure-seekers in a sea of black misery. He also implied that if Colin had given us tickets to come to see him in Scotland, it was because he was putting together his snobbish little house party and knew that PM liked us. But all this is rather petty spleen—the smaller, irrational side of Tony.

We drove to Piazza Campitelli and installed ourselves. I put Tony in the bedroom, Derek in the toolroom, and I slept in the little study by the door.

Rome. Sunday, March 19, 1972

These spring days, one wants to be out. Josephine picked me up at 9:00 and we drove to Porta Portese to see Alessandro as soon as possible. He had mentioned that he would have the upper part of the sarcophagus this Sunday. He didn't have it, but he did have a chest full of *pasta italica* ware, including a very large jug with raised ornament. He asked 50,000 for it. A few years ago, when he didn't put much importance on this ware, he would have asked 10,000. A man came along and bought the largest pieces—200,000 lire worth. I bought an ostrich egg in some leather trappings—an African souvenir—for 2,000. At the other end of the market, a Neapolitan had two large Roman two-handled jars in plain earthenware. I bought the two for 15,000. One of them had a broken blackware dish with single handle inside. All the pieces there, though.

Rome. Tuesday, March 21, 1972

Lunch for the Sitwells,* back from Bari and Lecce and on their way now to Vienna. Went up in elevator with a man I recognized from having heard

*Sacheverell Sitwell (1897–1988), known as Sachy, brother of Edith and Osbert, was a traveler, poet, and writer on music, art, and architecture; and Georgia Doble Sitwell (1905–1980).

Cesare d'Onofrio, Ospedale di Santo Spirito in Sassia, Rome, 1983

about him from Kathleen—Munthe—the neurasthenic son of the more robust Axel, who lives at Lunghezza.* Strong resemblance to Uncle Roderick, or is it cousin?—in *The Old Dark House.* "Have a potato?" Also the Howards[†]—the landlords—and Benedetta Lysy. Sat between Benedetta, a very handsome young woman, and Lelia Howard. Last saw Benedetta at her coming-out party at Teatro di Marcello. Daughter of Iris Origo.[‡] Now married to the Russo-Argentine violinist Lysy, who studied with Menuhin.[§] I liked her on sight, and we talked about the moon and the cypresses the night of her ball. After that, Iris felt that the Roman prince's world was bad for her, and she was sent to St. Timothy's, near Baltimore, where she felt that everyone was much younger than herself, in education at least, and couldn't get interested in cheerleading and the other popular activities. With Lelia, had some reminiscences about Ninfa, and her mother baking nut bread and the Graves children tearing some plants off trees. Lelia described them as epiphytes—they live on air. Not parasites but *epiphytes.* I said, Think what the Fabians could have done with that in an attack on the aesthetes.

Rome. Tuesday, April 24, 1972

Liberation Day.

Last week, one morning early, I had gone to a bar in Via Arenula for a cup of coffee, and on the way back to Piazza Mattei thought of San Carlo ai Catinari, which I hadn't gone into in many years. I went to have a look, and in the nave just inside the doors a section of pavement had been taken up. Benches had been arranged around the hole to prevent people from stumbling in. Hanging over one of the benches was a middle-aged woman looking down. I looked down too and saw steps that led to a crypt, and this was lighted up by a bulb in a cage at the end of an extension wire, the bulb being held aloft by a workman in a blue *tuta.*

*Axel Munthe (1857–1949), Swedish physician and author of *The Story of San Michele* (1929). His son Malcolm (1910–1995), wartime spy and writer, lived part of the year in a castle outside Rome.

†Hubert Howard (1907–1987) and Lelia Caetani Howard (1913–1977) were responsible for bringing the renowned gardens at Ninfa, a former Caetani estate outside Rome, to their present form.

‡Iris Cutting Origo (1902–1988), Anglo-American historian, biographer, and diarist, author of *War in Val d'Orcia* (1947), *The Merchant of Prato* (1957), and *A Chill in the Air* (2017). She was raised in Italy, where she and her husband, Marchese Antonio Origo, restored and developed La Foce, an estate near Montepulciano in Tuscany.

§Alberto Lysy (1935–2009). Benedetta Lysy (b. 1940), continues to oversee La Foce, known for its gardens and its music festival.

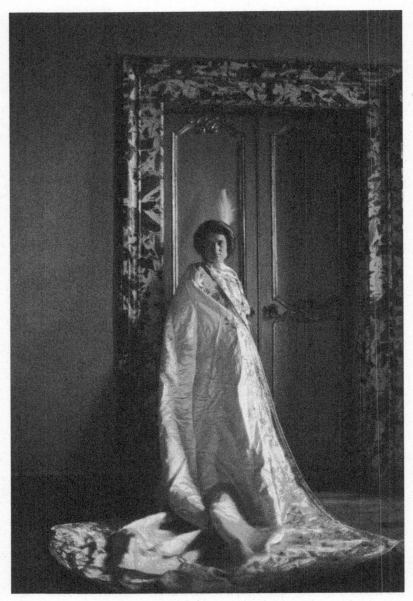

Costanza Afan de Rivera, Palazzo Costaguti, Rome, 1983

The gray-haired woman looked at me and said, I'd like to go down and see what they're doing. What do you say we both go down and have a look? All they can do is throw us out if they don't want us down there. *Che ne dice?*

I nodded and stepped over the bench at the head of the stairs. She followed me, and in a few steps we were in the crypt. I was surprised to see Nicola Afan de Rivera* standing in the middle of it with a Leica in his hands. He was just as surprised to see the two intruders. One of his hands went up and he said, *No no . . .* but stopped when he saw that it was me. *"E lei, come mai qua"* [What are *you* doing here?].

I explained. Around us was a devastation of broken splintered and rotten coffins in the niches along the walls. Skulls and bits of bone were mixed in with the debris. On the floor were the remains of a lead casket embossed with the Costaguti arms, crumpled and flaccid as an old bedsheet. Nicola said something about putting things in order.

The woman remarked, *"Si vede che era gente ricca sepolta qua"* [Obviously, the people buried here were rich], as she looked at the important lead casket.

You see what it comes to, said Nicola, with a promptness of spirit that didn't sound at all defensive.

But, said the woman, Haven't you found anything interesting—gold, jewels, money?

Only this, said Nicola, pointing out a terra-cotta jug with a lid. A pot used to store oil for the lamps that were lighted whenever there was a burial. There hadn't been one at least since 1870, the year of the unification, when burial within the walls was forbidden.

Rome. Wednesday, April 25—Tuesday May 1, 1972

Dinner with Liz [von Hofmannsthal] and Wolfgang Reinhardt. C They had Sir Alec Guinness and Lady Guinness with them. Sir Alec is to play Hitler in Wolfgang's movie.† Lady G smiles but doesn't say much. He has the gravity of an Anglican bishop. (He is a member of the Athenaeum Club.) We got on to childhood, and he remarked that he thought he must have been illegitimate. An "uncle" used to come to see his mother and

*Nicola Afan de Rivera Costaguti (b. 1944), architect in Rome. His family owns Palazzo Costaguti, in Piazza Mattei, where Gendel kept an apartment and studio.
†The movie referred to is *Hitler: The Last Ten Days*, released in 1973; shot in part at the De Laurentiis Studios in Rome.

Sandro d'Urso, Piazza Mattei, Rome, 1989

him in Bournemouth, and when he left, he would always reach into his waistcoat pocket with a peculiar round gesture of his fingers and pull out a gold sovereign. One day Guinness complained to his mother about having to go down to the station to see "uncle" off, and that was the day when the gesture produced a half crown instead of a sovereign. AG enjoyed showing the gesture, which he used to accompany his story.

Venice. Thursday, June 8, 1972

From Piazzale Roma, I went directly to the Biennale on the vaporetto. It was still being put together. Milling around among the press and the workmen were the familiar . . . Carandente, Liverani, Giorgio de Marchis[*] . . . Everyone, except Carandente, saying that this was certainly the worst Biennale to date. (Something said at each Biennale.) It looked pretty bad, though. Full of *trovate* [tricks], the central pavilion. Silliest and most presumptuous was a room at the end, by the bar, where Gino De Dominicis[†] had a tape with loud, insistent laughter going, in a bare room—in which were displayed a small girl sitting in a corner, with a sign at her feet saying something about "kinds of immortality" (a reference I suppose to the idea of having children as a way of projecting yourself into the future). On seats attached to the wall about twenty feet up were two men, with their feet dangling in space—the two seats faced each other from opposite ends of the room. Another exhibit with a tape going—recitations from Shakespeare in Italian—was Alik Cavaliere's,[‡] with dummies of a woman and a man, with pubic hair, and the man's head split in two, a platform with a chair and uniform hats on a hatstand, a freewheeling doorway with closed doors, etc. More tapes in some rooms where you could see a film, for instance, of De Dominicis giving himself flying lessons by flapping his arms.

London. Saturday, November 11, 1972

On Wednesday, Judy became a fixed star, complete and perfect. At least nothing could be added. I was at Piazza Mattei when John Stefanidis

[*]Giovanni Carandente (1920–2009), critic, scholar, and museum administrator; Gian Tomaso Liverani (1919–2000), proprietor of the La Salita Gallery in Rome; Giorgio de Marchis (1930–2009), historian, critic, author, and arts administrator.
[†]Gino De Dominicis (1947–1998), painter, sculptor, and provocateur.
[‡]Alik Cavaliere (1926–1998), Italian sculptor.

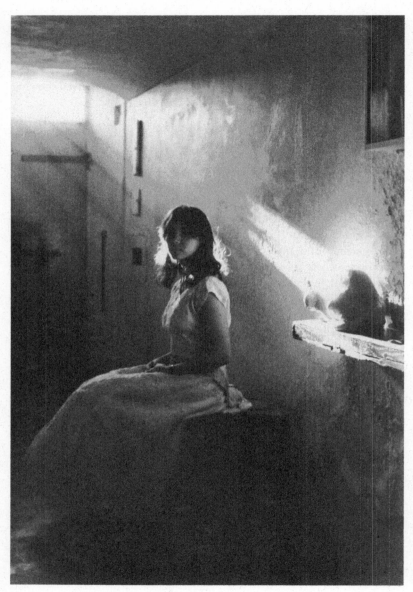

Anna Gendel, Isola Tiberina, Rome, 1980

telephoned from London. He had very bad news, he said, the worst in fact. Judy had died a little while before. How? Why? Her prophetic soul. I asked for the details. On Friday she had been euphoric—having been reassured about her health. She did not have cancer. But she was to go on having treatment for metabolic disorders. The weekend she had spent at Cornwell.

What should they do now? Was I coming over, what did I want? A funeral? Cremation, I thought, but I couldn't think straight. I would call back later. Called Josephine—quick comfort. It was a fatality. I had done everything I could do. But no one could really do anything. Those knots had been tied in childhood. Her lifelong struggle with her mother had killed her.

I asked Josephine to come over and keep me company. Anita took me aback with her classical Mediterranean reaction. She literally howled on the telephone: *Non me lo dire! Non è vero. O no, Signor Gendel, o no. Mi sento colpevole, o non posso più. O come faccio, è colpa mia. O Dio, come posso vivere. Quella lite! È colpa mia. Signor Gendel non mi lasci sola, la prego di venire qua.* [Don't tell me! It's not true! Oh no, Mr. Gendel, no! I feel guilty, I can't stand it! What can I do, it's my fault! Oh God, how can I live! That quarrel! It's my fault! Mr. Gendel, don't leave me alone, please come here!] I asked whether she could come to Piazza Mattei, but she could not. I had already rushed out to the bank and [withdrew money] for tickets. So I went to quiet down Anita. The crying and sobbing tapered off, and I sent her to collect Anna at her school. She was only to tell Anna that Judy was very ill and we had to go to London at once.

Josephine kept me company while I packed, and we talked about J's troubles and whether she could have been saved.

When Anna arrived, I took her into the bedroom and told her what had happened. She cried, and so did I. Then she said, Oh, Daddy, let's not cry anymore, it just makes us feel worse. So we dried our tears, and Anna asked, Now that Mummy is dead, are we going to lead a normal life? Meaning, was her world crashing around her?

We all drove out to Fiumicino—Jos, Anita, and Crab, and soon Anna and I were in the air on the way to London. I had called John S. back and had spoken to Peter Ward,[*] who had offered to meet us at the airport. On the plane, Anna asked what would happen—would she go on at the Over-

[*] Peter Alistair Ward (1926–2008), the youngest son of William Humble Eric Ward, Earl of Dudley (1894–1969), and a close friend of Judy Montagu's, indeed, a half-sibling, it would later be established. Ward, or "Wardie," was the trustee of her estate.

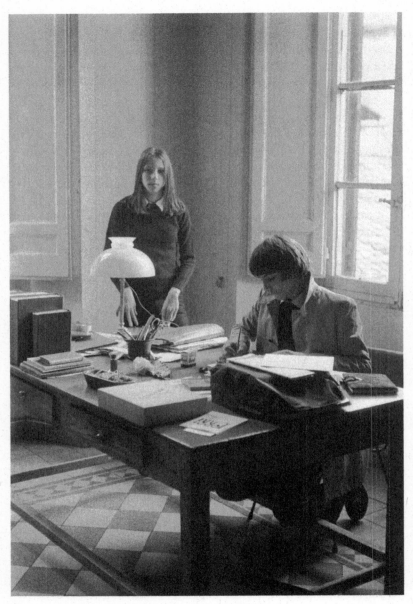

Natalia and Sebastiano, Piazza Mattei, Rome, 1972

seas School? Would she be going to Francis Holland school in London in
'74? She thought I wasn't as enthusiastic about that plan as Mummy. I ex-
plained that it had always been the practical living problems about which
I had doubts. If she liked she could probably go on at school in Rome. Her
face lit up. She wants what she knows.

At Heathrow, on the gangway from the plane, we were met very cer-
emoniously by a splendidly uniformed BOAC man with sideburns, who
I later discovered had been sent by Princess Margaret's secretary.* I had
called the palace to ask whether Anna and I could go there. PM was out
the two times I had called. But Arabella Hoyer Miller and an aide-de-
camp insisted that it would be all right. BOAC man walked us through—
no lines and no waiting. Outside there was Wardie and next to him the
fine old sad face of ninety-year-old Sylvia [Henley]. It was touching and
comforting to see them. Embraces. Princess Margaret had also sent a car
for us, which I sent back.

In the car we talked about the funeral. Grace† was arriving from NY
Friday and had suggested Witley, where some of the Wards are buried.
Anna remembered that Judy had said once she wanted to be buried at
Himley, where most of the Wards lay. But Judy had so often said she'd
as soon have her body go to some laboratory for dissection. If there was
going to be a funeral, then cremation was pointless, I thought. Especially
as Wardie offered a plot at Cornwell. That struck me as an ideal solution.‡

I included Anna in the discussion as much as possible. She has clarity,
and I thought it better to talk everything out so as not to leave any pock-
ets of uncertainty. If that is possible. At Kensington Palace we found PM
dressed very beautifully in a yellow satin bouffant dress and jewels. I knew
she had an official dinner.

Anna had been gathered up by the royal nanny and Sarah.§ PM and
I went to say goodnight to them in the nursery. The servants—Alberto,
Mrs. Foley, and so on, expressed their sympathy. PM lingered upstairs—
talking to me about J. I could see that she was hit very hard. She made

*British Overseas Airways Corporation (BOAC), which merged with British European Air-
ways in 1974 to become the current British Airways.
†Grace Dudley (1923–2016), wife of Eric, Earl of Dudley. After her husband's death, she lived
for more than four decades with Robert Silvers, a cofounder and coeditor of *The New York
Review of Books*.
‡Himley Hall in Dudley and Witley Court in Great Witley are ancestral homes of the
Ward-Dudley family. Judy Montagu was buried at Cornwell Manor, in Oxfordshire, the home
of Peter Ward.
§Lady Sarah Armstrong-Jones (b. 1964), now Lady Sarah Chatto, daughter of Princess Mar-
garet and Antony Armstrong-Jones.

Arno River statue, Villa Reale, Marlia, 1970

me promise to be back by 11:00. She did secretarial chores to those she likes—calling John Stefanidis for me on her little Swedish telephone. I said I would dine with Wardie, as I had to decide about the funeral.

Wardie at his best, rising to an occasion. Susie* at the house, which she is redoing completely in a more modish style—with little Oriental touches and Bryan Organ paintings. They told me what they knew about J's death and the account was the same as all the others later who knew anything. She had arrived in London telling everyone very brightly that she was "on the die." Or that she was for "the knacker's yard." At Cornwell on the weekend, she had spasms and aches and vomited up everything she ate. Monday she was too ill to dine with PM as planned. Tuesday she lunched very brightly with Sylvia but in the evening was sick, and that night John heard her being sick but didn't go up because he thought it would embarrass her. Wednesday— that's in the morning—she spoke to Anne Tennant. This wrenched my heart: she told her she couldn't go to the theater with her that evening because she felt she was dying. She wept and begged Anne not to forget her.

Aubrey, John's butler, called in a doctor in the morning, who prescribed something. He gave her a relaxant injection for her spasms on Monday. At 10:30 or so, Aubrey heard a thump and found her on the floor of the little bathroom off the guest room. He and the maid put her on the bed and went to tell John he thought she had died. And she had.

London. Tuesday, November 14, 1972

Goodbye Judy.

So many themes ending. So many problems that no longer exist. It was always her pathos that got me, and it runs in my head. Woke at 8:00. A brilliant blue sky, à la Canaletto. Frost on the ground. Quintessential English landscape.

And J's pathos the running theme. How in the car on the way to the airport the day she left she held up her hand pathetically and said, Look, pigmentation has started. I'm sure its Addison's disease that I've got.

It wrings my heart to think of her inner torments. The idea of her weeping on the telephone to Anne Tennant and asking her, "You won't forget me, will you? You won't forget me."

The funeral couldn't have been better organized or more aesthetically satisfying.

*Susie Allfrey (b. 1942), fashion model and friend of Peter Ward.

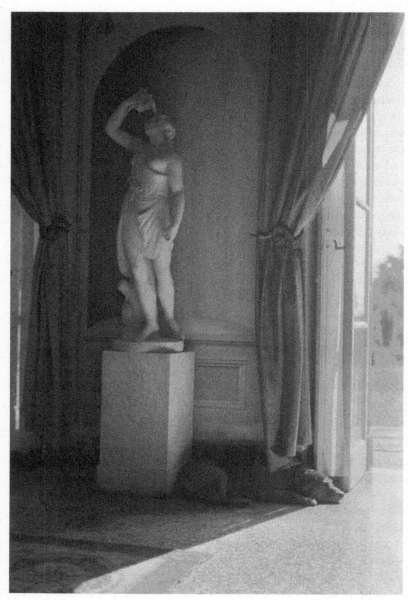

Villa Reale, Marlia, 1977

At 11:45, the bus arrived from Kingham Station with most of the guests. A car had picked up Princess Margaret and Anne Tennant, off the same train. PM very trim in black fur coat. Colin had already arrived, a cheering presence. Anna had a new outfit bought for her by PM—she told me that Grace had asked her to send the bill, but of course she would do no such thing.

A choir of five or six boys in white surplices and the padre in black and white were waiting at the door.

Everyone filed in and took places. I followed, holding Anna's hand. We had the first two places in the first row of pews on the right. After Anna came Sylvia and then Mary Soames.* Across the way were Princess M, Anne, Grace, Wardie.

The coffin lay a few feet ahead of us in the aisle, covered with flowers. Oak with burnished silver handles. Plain shaped. I thought of Judy lying inside, eyes closed, very white nobly carved nose and features. At rest. And wondered what she was wearing and who had decided about it. (Later, Grace told me that it was a white gown like a nightgown or simple evening dress, provided by the funeral parlor. I did not go to the funeral chapel to see her laid out, partly because I didn't want Anna to go and thought she might want to if she knew I had.) Which brought on tears. The hymns triggered them, too, especially lines about passing and inevitability. I saw that tears were running down Anna's cheeks. I gave her my handkerchief, and she snuggled against me.

Anna took my hand, and we walked out behind the coffin—which had been shouldered by six stout locals. Behind came Wardie, Princess Margaret, Sylvia, and the others. Anna and I went to stand by the vicar and all the others who lined the path alongside the church door.

When the vicar had finished, the undertaker dropped a handful of earth into the grave after the coffin was lowered. Anna threw in a little bunch of flowers.

Earlier that morning, when we were lying on Grace's bed, I had thought of a way of sparing Anna the distress of seeing the coffin go into the ground. I said that as PM was very sensitive to funerals, perhaps Anna would peel off as we left the church and take PM up to the house. Anna said thoughtfully, "Daddy I would like to say goodbye to Mummy . . . but as soon as I have I'll rush back to the house and keep Princess Margaret company." So that was that.

*Mary Soames (1922–2014), youngest child of Winston and Clementine Churchill; served with her cousin Judy Montagu during the war in the Auxiliary Territorial Service.

Fountain, Villa Farnesina, Rome, 1985

PM took Anna's hand when we came away from the grave and walked up the path. Sylvia took my arm. There was a tear-blurred line of familiar faces. Just beyond the graveyard, a photographer appeared and snapped PM and Anna. Sylvia spluttered, and I wondered how he had gotten past everyone onto the property. He probably came across the pasture.

We stood around on the terrace in the sun until lunch was laid out inside—a buffet—and most of the guests went in to feed. Embraces and handshakes.

One of the most endearing was Arnold Goodman's. He held my hand and said that he would like to be of any help he might be—including practical matters—and would I please call on him to do what he could.

A funeral is a good idea. All that friendly solidarity did something—for Anna, I'm sure, and certainly for me.

Wardie came along with his hands in his pockets looking whimsically annoyed: Colin had officiously ordered all the wreaths to be brought down here and put out on the lawn around the statue.

It looked nice, though—an instant garden in the winter.

Everyone produced phrases of devotion and offers of help of any sort. Bindy [Lambton] was smashed in two senses. She had been drinking heavily, and she had an enormous black and blue shiner from a door that Alec Douglas-Home* had opened suddenly. The most emotional outburst, though, came from Maureen Dudley,† who came in looking very white and stiff. When I spoke to her, she broke up and sobbed and wept and shook all over. "I'm so sorry . . . I can't help it . . . but I've never been to a funeral before . . . and oh, I didn't mean to do this to you." I took her out into the hall, and it was a distraction for me to comfort her.

Billy [Ward] made me a solemn speech about being at my disposal. I had wanted a good sprinkling of the young that Judy loved—and there were Rose and Anne Lambton, Anne Somerset, Jonathan Hope, Jasper Guinness, and some others. Isaiah Berlin and John Sparrow were there from Oxford. Later, when the bus left with most of the guests—to catch a train around 3:00—Ingrid‡ and I walked up to the grave to get away and talk over the memorial service. The grave had a sea of flowers in all colors, like the multicolored beds J loved to plant at Maida Vale. Princess Margaret made Anna a present—a bracelet with a turquoise bauble in

*Alec Douglas-Home (1903–1995), British prime minister 1963–1964.
†Maureen Dudley (1932–2011), British actress. She was the second wife of William "Billy" Humble David Ward, Peter's older brother.
‡Ingrid Channon (1931–2009), wife of Paul Channon.

Marble swan, Villa Reale, Marlia, 1985

a little Florentine leather box. She drove off with Anne in a car to the station at Banbury. When we kissed goodbye, she said, Keep in touch by all means, won't you, and do come and stay whenever you like. The little Rock of Gibraltar.

Grace, Anna, Betty de Robilant, and I got into another large car and drove off to Heathrow. Grace, sure-footed in the ways of privilege, rallied the Alitalia people into putting us in the front row of seats on the plane, and they took us on board first. Five in a row on both sides of the aisle. At disreputable Fiumicino, there was a great ragged crowd at the police controls—Grace got us through in a moment.

Anita and Pina and Crab were waiting for us.

Rome, Sunday, March 4, 1973

To Porta Portese with Anna and Bindy. The latter like a terrier, tearing around, examining, buying—combs, toys, odds and ends. Terrier? A very large-sized one.

Then to Palo to eat our sandwiches on Paul Getty's beach. I had telephoned the housekeeper in the morning and was to call back to tell her when we would be arriving so that the gate could be opened for us. It is a long way from the house. But there was no telephone in working order to be found, and we went on to Palo, trusting in inspiration. The Odescalchi gamekeeper helped; we promised a reluctant young boy a tip to go over the fence and alert the housekeeper. Her husband appeared after a few minutes—behind us was an audience at the windows of a rural tenement of relatives of the boy, and the stationmaster of Palo, who did not have an outside telephone at his disposal, was parking his magnificent silver car in a "box"—but did us no good. The *geometra* [surveyor] whom he had consulted about our visit had instructed him to let no one in, as he had had no orders from Getty.

I antipathetically threatened the man by saying darkly that Mr. Getty would not be at all pleased that Lady Lambton, his cherished guest of last summer and lifelong friend, had been turned away from his gate. I thought he might give in at this, but it didn't work. So we proceeded to our main goal, Cerveteri, and had our picnic among some tombs along the back road from the official area to the part I had driven to behind it. The back road being the Etruscan one. What a fine spring day. Bindy companionable rather than raucous and hilarious. Naming plants and flowers and asking questions about the Etruscans. Anna climbing around and exclaiming over lizards.

Mars, Villa Carlotta, Tremezzo, 1991

Fellow ramblers frequent and almost a crowd at the official fenced-in part, where we went after picnicking.

At home, found a cellarful of kids—Sebastiano, Natalia, and half a dozen pals in a cloud of plaster dust. Anna immediately put on a smock and tied a rag around her head and set to scraping the walls, too. The twins' friends seemed to me to be on the nondescript side. One girl and the rest boys. But I didn't really take them in.

When Sebastiano was excitedly telling one of them on the telephone the other day about his great find—a meeting place for the pals—he explained, "È la casa di mio padre" [It's my father's house]. In this gravelly Roman voice. I had a thrill of pleasure at the expression, not out of parental pride—I mean the pride of being a parent—but at being claimed as a father by this wonderful youth.

They all flew off on their motor bicycles at 6:00.

For dinner, took Bindy to the Podbielskis'. An entertainment I had arranged for her. Pod had produced the Avedons,[*] Gore, Marina [Emo], and Barry Fifield.[†] Luciana Avedon asked me after we sat down whether Judy was in London or NY. Somehow she hadn't heard that she had gone to another world. Luciana curious in appearance, with yellow and black hair and a Stuart-revival rig, as if she were dressed up as Bonnie Prince Charlie. Her husband Burt is a solemn fellow—long graying hair, sharp executive clothes, and quite a bit of jewelry—cuff links, bracelets, and rings.

Gore at his name-dropping worst; scarcely a sentence of his began without some well-known name. He started on Bindy with his set piece about his funereal communion with Judy—[about how, the last time they met] they both knew they'd never meet again. I had told her about this piece of vulgarity, and she had her revenge. When he finished, his little curtain lowered, she said, Milton took me to the flea market yesterday and several of the peddlers there came up to him and said that the last time they saw Judy they knew that it was the last time.

Rome. Tuesday, April 10, 1973

Bleak windy rainy day. Lunch solo at Isola. What a pleasure. At 4:00,

[*]Burt Simms Avedon (1924–2018), aviator, cosmetics executive, manufacturer of adventure wear, big game hunter, and Formula One driver; and Luciana Avedon (1935–2008), jewelry designer, socialite, and author of books on beauty.
[†]Barringer Fifield (b. 1942), American travel writer.

Goddess and pomegranate, Villa Borghese, Rome, 1984

picked up Anna at the bus stop and went shopping at Standa—for a comb, a brush, shampoo, and bubble bath. She had requested this—Anita gave me the message in the morning. What a delightful, appreciative creature she is. "Daddy, I do hope you don't mind my chattering. I know I keep going on and on, and perhaps it distracts you." On the contrary, I love it.

Botero* exhibit at Marlborough. Carla had invited me to the dinner, which is given de rigueur for artists after openings. Was busy and anyway do not admire Botero at all, a caricatural painter of pig-eyed blimp figures. He is very bad. But had said I'd meet Norman Reid† there, and understood that Gabriella was anxious to be in touch with him—on general principles, as a good painter's moll. Carla greeted me, shouting, *Vieni a pranzo* [Come for dinner]. No. *Perché no?* [Why not?] *Non voglio* [I don't want to], I said, and then found that the artist was standing at her elbow. And tried to turn it into a pleasantry.

Rudi [Crespi] came up and said, I must give you a kiss. It is transmitted from Monica Incisa, who said that I was to give it to you.

Rome. Wednesday, April 11, 1973

Daisy, a bouncy little photographer, took my passport photos, as she had done for the previous ones five years ago. With many jokes and lots of good humor.

While the photos were being developed, Tom [Hess] and I walked up through the Villa Borghese, stopping to have a look at the miserable Byron statue and the stupendous monument to Umberto I, with its great Medusas in porphyry and its mourning woman, cloaked. Tour of the Galleria Borghese to look at the gardens, which have been fixed up.

Picked up photos and took them to the consulate, where I received my new passport in a matter of minutes. The consul or vice-consul is a blond woman in her fifties, dressed in beige. When she administered the oath, she told me that it was no longer necessary to raise the right hand, as formerly. A court ruling had it that the signature on the application blanks was enough of an oath, really.

We got on to Anna, and she thought Anna might become a U.S. citizen at once—the old rule about spending three years in the U.S. before your twenty-first birthday, for people of mixed parentage born abroad, has

*Fernando Botero (b. 1932), Colombian painter and sculptor noted for renderings of oversize people and animals.
†Norman Reid (1915–2007), director of the Tate Gallery in London.

Princess Margaret and hatstands, Villa La Pietra, Florence, 1982

apparently been abrogated. There is even a chance of the twins getting U.S. citizenship, though it is different when the father is American and the mother not, rather than the other way around.

Tom and I wandered down Via Tritone, and Tom bought Anna a paschal lamb* in sugar and some candied violets and cherries. We parted.

With Anna on foot to Passetto's, where she had a huge meal of smoked salmon and rare roast beef and a dessert of candied violets and marzipan cherries. She was very pretty and sweet. I find that I love my children.

Rome. Thursday, April 12, 1973

Italo Faldi[†] lives almost opposite the Isola, at Via Ripense 4, in one of the 1930s houses. Shiny stone, little rooms. He was in a lavender polo-necked shirt and slacks. A Louis Philippe face with a little mustache. Rather ceremonious in manner and orotund, occasionally facetious in phrase. But a mine of information on the Cavaliere d'Arpino show. Was not aware that the Cav was an ardent and accomplished climber, who had made it in Rome in a big way. Another Prince of Painters. He got the two biggest commissions in the Rome of his day—the Sala del Consiglio, on the Campidoglio (lay), and the inside of Michelangelo's dome, at St. Peter's (religious). Also a big clientele for little paintings of mythological and sensual subjects. Counter-Reformation ambiguities. *"Però devo farle un rimprovero"* [But I must reproach you], said Faldi, who had been fussing about, offering me a drink. The "reproach" was that I had not covered his show in '72, where the recently acquired Caravaggio of *Judith and Holofernes* had been exhibited. He presented me with the catalogue. And then another, remarking that I might find the text a little obscure. When I opened the book, I saw that it had been printed in Japanese.

Rome. Wednesday, May 30, 1973

Went to the Dunns'[‡] and enjoyed myself thoroughly. I had a long conversation with Iris Origo, whom I haven't seen in a very long time. Anna she had seen more recently, when Anna was spending the night with her granddaughter. They had come in in their nightgowns and sat on her bed.

*Agnelli pasquale, an Easter sweet made of marzipan.
†Italo Faldi (1917–2012), Italian art historian and arts administrator.
‡James Clement Dunn (1890–1979), former U.S. ambassador to Italy, and Mary Augusta Armour Dunn (1893–1988).

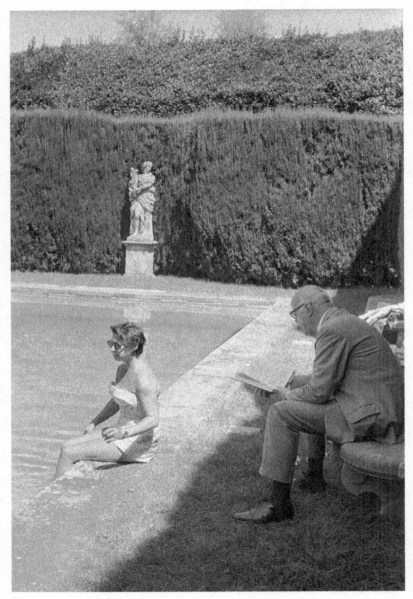

Princess Margaret and Harold Acton, Villa La Pietra, Florence, 1968

"Oh, I liked the bedtime scene," I said. She agreed and went on to praise Anna for her mind and her looks.

We had a rattling conversation, which included some nostalgic bits. I remembered the ball she gave for Benedetta, the romantic night with the blue-velvet sky and the cypresses. Palewski[*] that evening said to her, she remembered, *"Pour une femme qui dit qu'elle n'est pas mondaine ce n'est pas mal du tout"* [Not bad at all for a woman who says she's not a socialite]. She also remembered the ball as exceptional. And did I remember going with her to the Pincio to look for a site for the Byron statue? We couldn't have chosen very well—under those tall pine trees it looked so miserable and dwarfed. We as the site committee might have put it among flowers, where it would have had a chance to look imposing, instead of overshadowed by those umbrella pines. I made a joke about training ivy over it.

She spoke about her shyness, how she always felt out of things when she was a girl, especially as she had to change among three different cultures, American, Italian, and English. Bernard Berenson[†] dismayed her once, when she was seventeen, and he hurled a challenging question at her across his *salotto*, which was full of people. She mustered her courage and answered—something about what she wanted out of life. That's what I mean, he said with disdain, addressing the others—that is conventional thinking. She spoke about his diaries and his self-dissatisfaction. I said that it was a pity he had been born too soon; he was a generation or two out of line. Nowadays there would be very little conflict over his commercial operations and his scholarship. He didn't have enough balance to see that he had gotten out of life the most that he was capable of. He was a worldling with dreams of monastic cloistered scholarship.

Rome. Friday, June 8, 1973

Lunch solo at Isola. Took some clothes and things over to Piazza Mattei, as I'm giving up my bedroom to Princess Margaret, and the guest room goes to Colin [Tennant].

At 4:00 the white Jaguar from the embassy turned up. Giulio, the driver, as we coursed toward Fiumicino airport, told me that he had

*Gaston Palewski (1901–1984), French politician; associate of Charles de Gaulle and for a time France's ambassador to Italy. He appears as a character, under a different name, in two novels by Nancy Mitford (with whom he had a long affair).

†Bernard Berenson (1865–1959), Russian-born American art historian, collector, connoisseur, and adviser to wealthy patrons. Today his villa, I Tatti, near Florence, is owned by Harvard University, his alma mater.

Harold Acton and Princess Margaret, Villa La Pietra, Florence, 1968

driven the princess several times before, the first time in 1949, no less, on her first visit to Rome. He was in the tank corps in Russia during the war. He promoted himself to the job of collecting some spare parts in Italy and was prudently doing that when his division was wiped out in front of Stalingrad. A man's destiny is written beforehand, he said, but there is also no use in tempting fate.

Went to find Colin, who was arriving separately, from Paris, where he had been at a wedding. It wasn't hard to find him in the crowd, as he was wearing a furry felt hat with a wide brim—and no one else was. After watching from a distance his altercation with the customs man (they wanted him to open a box, which contained a new suit, which he said indignantly even *he* hadn't yet seen), I joined him, and he emerged red-faced from behind the barrier, followed by a porter wheeling a heap of suitcases and boxes on a handcart. Giulio put the bags in the back of the Jaguar. A Mr. Weburn had arrived with a luggage van, from the embassy, to collect PM's bags.

BEA* had made a point of arriving on time.

PM was suddenly there, with a row of photographers walking backward in front of her. We kissed on both cheeks, I bowed my head, Colin hung back and bowed from a distance. I asked him whether I had committed a gaffe by kissing in front of the photographers. Oh no, he said, you are a respectable widower.

Garavicchio. Monday, August 6, 1973

Another very clumsy-looking boat came in, the *Jumbo II*, which belonged to Queen Juliana.† Alongside swimming—or rather towed by a new gadget, a kind of encased outboard motor that you hang on to and that drags you along; if it escapes, it makes a circle and comes back to you—was Prince Bernhard.‡ Tony started muttering against him to me. He is awful, pinching bottoms and going after girls in the most embarrassing way. I call him "Sir" twice a day and then don't go near him. Behind this figure in the water came a very large woman in a bathing suit. Her broad white face had green eyeshades on it. She clambered out

*British European Airways.
†Juliana (1909–2004) reigned as queen of the Netherlands from 1948 until her abdication in 1980.
‡Prince Bernhard of Lippe-Biesterfeld (1911–2004) married Juliana in 1937, eventually becoming prince consort of the Netherlands.

Monica Incisa and Antony Armstrong-Jones, Lord Snowdon, Piazza Campitelli, Rome, 1971

of the water up the ladder, and PM went and kissed her. She screwed up her eyes and said, Hello. I am without my glasses. I haven't a clue. PM said who she was and introduced everyone. Tony went and skulked in the rear and drew me with him. I saw PM glaring at us and went back. Prince Bernhard was talking about eating caterpillars. He has to go officially to Zaire and was told he would be offered this. "The sauce they wouldn't explain to me because the man said it would make me sick." He has an appraising eye. Round and blue. Seamed leather face and the gone-slack body of a man who had muscles. Around one shoulder blade is a very deep scar from an operation.

He and the queen refer to each other as Mammi and Pappi, and their dialogue is like soap opera. "Mammi, don't dive in." "Why not, Pappi?" "Because you'll make the sea come up." He started to tell a story about a dish offered in a restaurant in Brussels to some African officials. She protested that he wasn't developing it well enough. "Oh, you tell it, Mammi, and goodbye everybody. I'll go back to the boat now." But he stayed and she told how they protested against the dish being called—it was raw meat—Le cannibale. *Écoutez messieurs,* was the punch line, *ici à Bruxelles quand on dit le cannibale c'est l'américain* [Listen gentlemen, when in Brussels we say cannibal, we mean the American]. Tough on you, said PM, turning to me and laughing.

Much waterskiing and late return to Garavicchio.* Just the four at dinner on the terrace. PM appeared in her dressing gown, an elaborate American creation with a jabot. She asked Tony how he liked it, and he said it reminded him of the queen of Holland. PM said, Why were you so rude to the queen of the Netherlands, not coming to say hello to her, and now why are you rude to me? I am not as vast as she is. Oh-oh, stammered Tony, uh-uh . . . He fumbled for a cigarette and tried to edge away. There was some playful pushing back and forth and raillery. I had been teasing Tony about eating up some scrambled eggs that had been sent up for PM. He looked at bay and suddenly snarled out, You sycophantic courtier. I said something sharp and started to leave in anger. Changed my mind and came charging back: You shit ass, I shouted. You can't talk to me like that. I was glad that I hadn't gone off in injured dignity.

We had a long talk, which evidently affected him very much, for there were tears in his eyes. We spoke about our relationships. Judy and PM. He sees his wife as his salvation and has gradually cut out the weekends

*The Caracciolo family estate in the Maremma, a stretch of the Italian coast on the border of Lazio and Tuscany.

Tony Snowdon and Sebastiano, Piazza Mattei, Rome, 1981

and the grouse shooting. To the Family I am completely dispensable, he said, with a note of bitterness. And then said that he adored the Queen and the Queen Mother. I would die for the Queen, he said. Now a modus vivendi had been established. PM had her life, Mustique, and "her various deals"—and we get along much better. Nothing like the terrible rows with screaming of several years ago. She would get very angry and threaten to cut off my telephone. I don't react anymore. If you must cut it off, I say, then do it, and nothing happens . . .

In the night I dreamed that I was talking to PM in her drawing room at Kensington Palace and pointed out the window at a huge building that had risen beyond Millionaires' Row—a sort of squared-off Guggenheim Museum. What is that? I asked. Oh it's Tony's. It's where he keeps all his things—papers, notes . . .

Rome. Thursday, August 23, 1973

To Carla Panicali's to give her the transparency from Tom [Hess] for his article on Ad Reinhardt* and to hear the story of the pope's museum of modern art. Monsignor Pasquale Macchi, a polished little fellow, was the man behind the effort. He is a promoter and saw it as a good thing for the Vatican image. He succeeded in getting presents from artists and patrons. For instance, Gianni Agnelli† has given a Francis Bacon, worth 150 million lire, and a Marino Marini worth 50. Carla had no plausible explanation as to why Gianni should have been so munificent. In secret, she told me that Macchi had bought some things from her directly—about 50 million lire worth—and she expected him to buy much more. This was not to be known publicly, as the Vatican preferred to play poor-mouth. In fact, at the opening the pope had referred to the generosity of friends of the Vatican who had made the museum possible "*senza intaccare le finanze traballanti del Vaticano*" [without affecting the shaky finances of the Vatican]. There was a suspicion of general suppressed laughter, said Carla. Even Frank Lloyd had thrown in a Feininger, worth quite a bit. But that was to make up for a bad gaffe. In an interview in *Time*, he had said that the idea for the museum had come from him when the pope received him in a private audience some years ago in Rome.

*Ad Reinhardt (1913–1967), abstract painter and graphic artist.
†Gianni Agnelli (1921–2003), president of Fiat and its largest shareholder. Some of his extensive art collection was given to the city of Turin.

Tony Snowdon and André Leon Talley, Palazzo Ruspoli, Rome, 1987

Rome. November [undated] 1973

Betsy Baker* had arrived, at the Hotel de la Ville, and I asked her to lunch. We had two hours of conversation about *ARTnews*, Tom, Esterow,† and her new job, which she is pleased with—as editor of *Art in America*, replacing Brian O'Dougherty. I asked her directly whether it was possible for her to use me as a correspondent and put my name on the masthead. She seemed more definite about putting my name in her mag than about using me. She is very personable. Not as pretty as I remembered her, and much bigger. With her rather dippy-looking oversize glasses on, she has a demure, little-girl look. She took them off for a moment and revealed two cool appraising blue marble eyes. I like her despite a few annoying little NY stigmata—like the use of *like* as an expletive. How mere can a detail of personality get!

Rome. Tuesday, November 27, 1973

Vittoria called me at 6:00. She had rung the bell at the Isola but hadn't found anyone in. So I went back and fetched her from the bar, and we had an hour's conversation. I said I was concerned about the tensions between her and Sebastiano, and if it would ease them, perhaps I could take him to stay at the Isola for a couple of weeks. It would also give me a chance to get to know him better, which might be helpful for the future.

(I had mentioned the possibility of S's coming here to Anna, and asked her whether she would be pleased or would just as soon not have him in the house. "Oh I would like it," she said. "But I'm not so sure how Anita would take it.")

Vittoria said very reasonably that she would ask him. I also mentioned the possibility of taking him to England over Christmas—if the tensions were very bad—though it would be difficult to arrange. And finally I asked how she felt about my recognizing the children. About S's coming to stay with me, she had second thoughts and said rather shrewishly, "You know I don't see you as such a champion of ethical behavior, setting yourself up as an example for the young."

London, Thursday, January 3, 1974

Jacob Rothschild arrived for a drink. Susie [Allfrey] came in after, and

*Elizabeth C. Baker (b. 1934), editor of the magazine *Art in America* for more than thirty years.
†Milton Esterow (b. 1928), longtime publisher and editor of *ARTnews*.

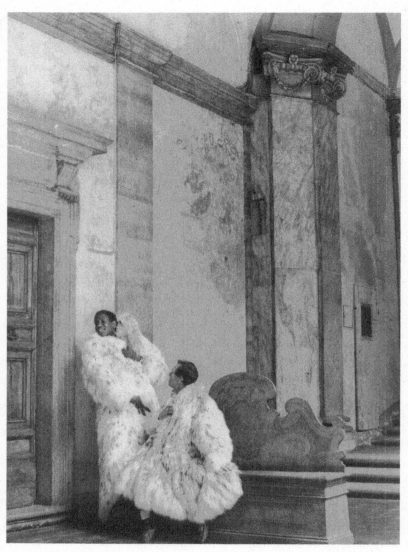

André Leon Talley and Tony Snowdon, Palazzo Ruspoli, Rome, 1987

there was a rout of cross conversations and children pullulating. Jacob was amused by the setting. He had never seen Mario's* pad before. He exclaimed over a signed photograph of Señora Marcos, the wife of the president of the Philippines. Now how did he get that? asked Jacob. She never gave me one. And he wrote a note saying, "I give up, she's all yours. J," and stuck it in the frame of the photo.

He liked Stanley Moss† and thought he might do business with him—but the million dollars he wanted as half share in the Tiepolo was a lot of money. Especially now that the market and in fact all markets were sagging. Did I think that when he said a million dollars he meant just that, or was it discussable? I didn't know (hoping for the million, and my cut), he usually played an open hand . . . since he got into the art business at least . . . as far as I knew. Yes, he had been a full-time poet before he was analyzed and released into the world of business and deals. Jacob amused.

Then there was some talk about the crisis and the Arabs. Jacob laughingly reported that his bank had just organized a large Arab loan. There was only one condition put by the Saudis and Kuwaitis and others who were in on it, that there must be no photographs of the signing of the agreements, and Jacob and his associates were smuggled into the office where things were concluded by a side door.

What did I think of Harry Bailey, or rather, more obliquely, did I know Harry Bailey? I wouldn't get between a man and his job even if I had strong feelings about him, so I said I knew him slightly, but friends who knew him well had a good opinion of him and his work.

John Craxton came in, dressed in black leather, with great black gauntlets. We all left. Jacob in a sober car and I and John, helmeted and scarved, on the huge new motorcycle whose nose was at the front door.

Up to Kidderpore Avenue, where we had a snug dinner at a card table in the sitting room by the fire—John, his mother, and I. John was the cook and butler. Mrs. Craxton got on to the disloyalty and iniquity of Lucian Freud, who has brought down a lawsuit on John's head. Lucian over the years had sold off paintings John had given him when they lived together (and were lovers, I believe). Recently John had sold some of Lucian's drawings. When Lucian was asked to authenticate them, he said simply that they were forgeries.

*Mario d'Urso (1940–2015), son of Sandro; international banker and Italian politician.
†Stanley Moss (b. 1925), American poet and private art dealer; founder of Sheep Meadow Press.

Tony Snowdon and André Leon Talley, Palazzo Ruspoli, Rome, 1987

Rome. Friday, January 11, 1974

Reading Kenneth Clark's *Romantic Rebellion*. An eminently civilized performance. The plain elegance of the writing, like Marcus Aurelius.

Anna and Marella* came up to say goodnight—in their pretty flowered pajamas. Anna was taking a good look at what I was typing. I snapped at her, Don't look at what I'm working on! Marella said, *"Anche papà si secca quando guardo quello che sta facendo"* [Daddy gets annoyed, too, when I watch what he's doing].

I had been meaning to tell Anna that it bothers me to have anyone look over my shoulder while I'm writing something, but had not done so. So instead of explaining it reasonably I burst out. That is not very grown-up for fifty-five.

To bed early with Clark's book.

Rome. Saturday, January 19, 1974

The conversation [with George and Anne d'Almeida][†] took an interesting turn. We got on to the case of Paul Getty III's kidnapping, and it turned out that George had been very much involved at one point.[‡] Gail Getty[§] had asked him whether he wouldn't go to London and try to persuade Paul Jr. to ask his father for the $3 million ransom. George reluctantly agreed and took Jack Zajac[¶] along for moral support and also to help threaten Paul with the prospect that if he did not do what he should do, he would lose the only two friends he had in the world.

When they arrived at Cheyne Walk, they found a Mrs. Smith in residence. Sister Smith, as she is known by the English, and Anne said that Judy had known her or knew about her. She is called in to wean people from drugs. Besides Mrs. Smith, there was a secretary and a Portuguese couple.

Paul on the telephone had been entirely lucid and had offered to send

*Marella Caracciolo Chia (b. 1964), journalist and lifelong friend of Anna Gendel's and the Gendel family. Coauthor, with her aunt Marella Agnelli, of *Marella Agnelli: The Last Swan* (2014).
†George d'Almeida (b. 1934), a French-Argentine-American painter, and his wife Anne (1934–2014); they lived in Tuscany.
‡J. Paul Getty III (1956–2011), grandson of the billionaire, was kidnapped in Piazza Farnese in July 1973. He was released five months later, after a ransom was paid.
§Abigail "Gail" Harris Getty (b. 1932), first wife of John Paul Getty Jr. and mother of J. Paul Getty III.
¶Jack Zajac (b. 1929), American painter and sculptor who lived periodically in Rome.

Pope Innocent X and David Linley, Palazzo Doria Pamphilj, Rome, 1987

a car to the airport. This George had refused: "There wasn't any point, as he would have forgotten or thought better of the expense . . . so I just said no."

They found that Paul was living entirely in one room, a library that he had built where he listened to records and read and took drugs and ate his peanut butter sandwiches and milkshakes. "Probably prescribed by some doctor to keep him supplied with proteins and things in an acceptable form."

They put the case to him. George had been to the Italian police, to Paul Sr.'s agent, Fletcher Chase (who was living in the Contessa Paolozzi's house, where the king and queen of Greece had stayed), and to the FBI agent in Rome. "If you ever need our FBI man here, his name is Tom Biamonte . . . I talked to him on the telephone on Thanksgiving Day . . . I started having to talk to the police at the time of Talitha's death. They knew I was a friend and they asked me a lot of questions. Presumably I am in the clear. I told them that I was a very old—a prehistoric—friend of Paul's and was not in on the more recent doings."

Paul argued very vehemently that his father would never let him have all that money. They urged him to write a letter requesting it. (Paul Sr. has not spoken to his son since the death of Talitha.)

They had prepared a draft—all he had to do was sign it. He got angry and arbitrary. "You know, he kept trying to get us to watch *Ali Baba and the Forty Thieves* on his videocassette recorder he had just acquired . . . anything to get away from the subject of Paul's kidnapping."

George was most outraged that Paul should argue that paying the ransom would put him on the same moral level as the kidnappers. When George said it was a matter of conscience to do everything he could for his son, he replied, "I know all about having things on my conscience," a reference to the death of Talitha, presumably.

George reported these conversations to Gail, who firmly assured him that she knew that the father was disposed to shell out if Paul asked him for the money and if it was all arranged so that he, Paul Sr., did not figure as the source. His great fear was that all the hoods in the world would get after his thirteen other grandchildren if they saw the money that could be made by putting the screws on the Gettys.

The police had delivered an envelope to George at 5:00 the morning of his departure for London. It contained large grisly photos of Paul III's severed ear.

Anne put in that when the ear arrived, the police called in Gail for the

Papal inscription, near Palazzo Carpegna, Rome, 1988

identification. The bystanders were taken aback when she picked up the ear and examined it closely. But as she explained to Anne, I could see at once that it was Paul's—it had the freckles, and after all, it was like a part of myself—so why would I feel that I couldn't touch it?

The day after George and Jack were installed at Paul's in London, they saw the photos spread on a table in the living room. He seemed more convinced that the kidnapping wasn't a phony. But he argued that, if they paid the ransom, Paul would probably be killed anyway.

He lunched the same day with Penelope Kitson, a former lover and present aide of Paul Sr.* It was a policy conference. George had seen her and another employee of Paul Sr.'s, McNoe, and both had taken the line that Paul Sr. wouldn't budge on the question of paying the ransom. They were so convinced that George called Gail again in Rome and reported this, but she was sure of her information. She knew that the old man would provide the money.

George had another interview with Mrs. Kitson after the lunch with Paul. She was bland. Nothing had changed. The only comment that struck George was "The boy has always caused trouble. What would they do with him if they got him back?" He said her understanding smile was sickening.

The next morning Mrs. Smith informed George that the papers were out with a statement from Paul Jr. He offered $1 million if the kidnappers would guarantee that Paul would be returned at the same moment as the money was delivered.

George and Jack were fed up. They left at once, writing a short, curt note to say goodbye to Paul. In the three days, they had seen him twice or three times.

In their conversations, George had repeated several times what the Italian police had urged on him. They said, Try to get him to do exactly what the kidnappers say. In our experience it is the only way to handle such cases. Give them what they want and then try to get it back.

Perhaps his visit did some good after all, because a few days later Paul did ask his father for the money. Or his father realized that the matter was becoming urgent—the kidnappers had threatened to cut off the other ear—and simply gave instructions for the ransom to be paid. The latter more likely. I was fascinated by this saga and George's angry contempt for his former best friend. "Yes, he is a basket case. He lives there shut up

*Penelope Kitson (1923–2014). Upon his death in 1976, Paul Sr. left Kitson five thousand shares of Getty Oil.

Street musician, Rome, 1998

without ever going out, except perhaps to his bookdealer. Mooning over his old books and his videotapes."

Rome. Sunday, January 20, 1974

George d'Almeida was at Gail Getty's the evening that the kidnappers telephoned their instructions about delivering the ransom. She was entirely collected during the conversation and had only a moment, afterward, when her face sagged and tears appeared in her eyes. Then she pulled herself together again and was off to tell the police. George, though, was overcome by the shakes. He had never realized that when people spoke about having the shakes, it was literally a physical thing. He explained his shivering body and shaking hands to himself as tension in sympathy with what Gail must be going through, and fear of coming even that close to the evil of the kidnappers.*

This morning to Porta Portese on foot. A hasty tour, in the course of which I bought three Japanese prints, an eighteenth-century daub of the head of a bird dog with a duck in its mouth, and a collection of Neapolitan prints in good reproduction—for the d'Ursos. (Twenty thousand lire all told, which I regretted after I had spent it.)

Lunch at Isola. Anna, and Marella with her—the whole weekend, and both of them were taken off by Anita at three to Babs's to learn how to make apple pie.

Rome. Saturday, January 26, 1974

Monica arrived at the Isola at 10:30, and we drove off to Viterbo on the Via Cassia. It was a beautiful sunny day, and not driving on the autostrada was like the old days. Monica is a little frightened at the prospect of moving to London. Her bank is transferring her there for several years, and she leaves next week. On the telephone the other day, her mother was bemoaning the departure and then got on to the subject of Nicola Afan de Rivera. *"E quel Nicolino, perché non si decide?"* [Why doesn't that Nicolino make up his mind?] She was talking about Monica's report that N had asked her to marry him and then had disappeared, without calling up or repeating the offer. I thought it was a joke, but evidently the mother took it seriously enough.

*After the ransom was paid, J. Paul Getty III was found alive at a gas station in southern Italy on December 15, 1973. The kidnappers were members of the organized crime group known as the 'Ndrangheta.

Archangel Gabriel, Pantheon, Rome, 1988

She seemed to think I might be in a position to stimulate N and get him to declare himself more earnestly. Then she began to run, saying hastily, Of course we were grown-ups, she and I, and wouldn't bandy about things of that sort, and naturally I wouldn't say anything to Monica, would I? Monica herself sounded half serious in the car but kept coming back to the point that he doesn't appeal to her physically, whereas, she said, I do.

Rome. Tuesday, February 5, 1974

Splitting headache before dinner. Full of Veganin, but tempted to call off Gore, who was coming to dine *à deux*. I had asked Josephine to find something to do, as I didn't want the Gore who plays to an audience.

He looked rather bulging when he came in, commenting on how Crab barks lying down on her chair. He is well upholstered, he is aware, and remarked later on that he was planning to "shed about two hundred pounds of flab for March first," when he is scheduled to appear on BBC with Lord Longford to discuss sex and pornography. He has a friend, he said, a Czech who came out during the [Alexander] Dubček government and works here in a nightclub, who is in close touch with the Questura. He plans to emigrate as soon as possible because his police friends have been saying that there will be big changes here within a few months. There will be a government like the Greek one, made and supported by the police and the army. I said that I had been having intimations of that sort, and not only for Italy, but for England, even the U.S. If Nixon feels himself threatened, why wouldn't he "in the interests of the country" make a deal with the Pentagon? Gore was worried about having put so much money into a house in Italy if there was going to be a colonels' regime here. I thought he didn't have much to worry about. But what if they confiscated his property? On what grounds? It wasn't likely that Italy and the U.S. would be going to war; in fact we'd probably be the first to recognize a right-wing Italian government. And most of the Italo-Americans would be pleased. Perhaps he was worried about being known as queer and as a spokesman for sexual permissiveness. The first thing these regimes do is "moralize." Probably we would not have gotten on to this if he had not already started on his second bottle of Ficino.

Gore considered this dispassionately and the conversation veered off sex, though not quite, to Anaïs Nin. He had come to loathe that "old chicken queen," he said. What is that? "Oh it's homosexual talk for an older woman who likes to have young boys." Anaïs, he said, had taken

Piazza Mattei, Rome, 2001

him over when he was twenty-two, and at that age "you go off like a rocket with anyone after all." But last year he had had a chance to make it with Garbo. His eyes lit up. She is really a boy, you know, even at sixty-eight. "I remember when Tennessee Williams offered to write a film for her twenty years ago—he was on the crest, having just done *Streetcar*. She told him how it should be—not a woman and not a man. That is one of the great personalities of our time. Well, when it came to my chance, I couldn't face it. It was too much. I got shy . . . I see her all the time. We have become friends . . . at Klosters."

We got onto the Roman scene. "I can't take those Roman parties anymore. I used to like the background, the beauty of the women . . . the houses and pictures . . . moving around among the palazzi . . . But they are all scared now and don't do much, and the parties there are very depressing. Now if I come into a room and see Dino Pecci-Blunt, I turn around and leave. Not that I have anything against him personally, you understand. The only good reasons for going to parties are to find someone for sex, or to further your career. Well, all I'm interested in are fourteen-year-olds just up from Messina, and those you find at Circo Massimo and not in Roman *saloni*. As for my career, I don't think it depends on my circulating around Rome."

We talked about the movies for a moment. "The only decent painters today—I hate abstract art, I really do—are the movie directors who think they still owe us a story because of their literary notions . . . but *The Holy Mountain* of Jodorowsky's, you ought to see it . . . but close your ears and just watch the pictures . . . Otherwise it's only cock that interests man, woman, and child," said he, recklessly. "And the only one to dish it up, really, is Pasolini, who gives me what I want, which is fully frontal male nudes. Adolescents with big cocks. Did you see *Canterbury Tales*? No? Well he has an English boy in it, large blonde, who is supposed to be making love to a girl, and he had a big hard-on in his tights, but later on you see that it was a fake. You can't fool an expert like me. He is lying on a bed later on, with the thing out, and it's a tiny thing, you know one of those little English acorns."

In this stream of stories, perhaps the most outlandish was his account of having a face-lift in New York. Several years ago he decided that it was too much when the bags under his eyes became triple, as he said, rather than double. And his Nordic Fold (there was a short lecture on this phenomenon, concerning Eddie Bismarck, who had it naturally, and I, who had developed it with age) was so pronounced that when he looked down, he couldn't see anything. So he had the operation and was kept conscious because the surgeon was intelligent and had taste and wanted him to be

Roma children, Largo Argentina, Rome, 1988

able to open his eyes and glance around in order to determine what to do to the upper lids. The lower were easy, he said, they slit the skin by the eyelashes and squeezed out the accumulated fat. He could hear the surgeon and his assistant working away. "Oh, they were a couple of fags, you know, and my old friend Blair would say, 'That's right, get it out over there. Squeeze a little harder,' and then go on to discuss some dancer they had seen the evening before. I chimed in at one point, half out with the local anesthetic, pronouncing the word *ballet*! I had identified the subject of their conversation. Anyway, the upper lids were more complicated, and if you get those wrong, you can come out with the wide-open stare of a girl. Like Rudi Crespi. He didn't go to a good man, and that's what he looks like." Gore acted out a staring Rudi. Then he smoothed his face around his eyes and said, Nobody seemed to notice that I had had it done. But friends said how rested I looked.

Rome. Saturday, February 9, 1974

Josephine drove out with me to some junkyards she knew about. The best was a large area off the Via Appia Nuova, on the Raccordo Anulare, to the left. A monumental woman who looked like a gypsy dominated the yard from a snug furnished hut. Outside was a colossal wrought iron lantern with colored glass—something from a turn-of-the-century theater or department store. I priced a spiral staircase (180,000 lire), a straight iron ladder (50,000), some marble—white—about 25,000 for enough to make a fireplace. Josephine priced a four-wheeled cart of silvery old wood—70,000 lire.

But the prize of the junkyard was a group of toilet fixtures—a vast porcelain bath—oval—and another smaller one, a sink on a pedestal and a neoclassic toilet bowl. The woman owner made an impressed face when I asked the price. *Quella è roba buona . . . la vasca più grande era del Duce* [That's good stuff . . . the bigger tub was Mussolini's]. Really, I said. *A sì . . . l'abbiamo presa appena in tempo che I messicani stavano per portarla via.* [Yep. We got it just in time. The Mexicans were going to take it] *Messicani* [Mexicans]? *Sì, sì, l'avevano già avvolta in materassi.* [Yes, yes, they had wrapped it up in some mattresses already]. It wasn't clear when this happened. After the war? At Villa Torlonia?*

*Villa Torlonia, in Rome, was built by the Torlonia family in the early nineteenth century and was used as a residence by Benito Mussolini from 1925 to 1943. During the war, bunkers were built on the property.

Boy and fox, Palinuro, Campania, 1973

On the way back to Rome, we stopped at a stone yard to price slate and *peperino*. A man with a mustache gave me the various prices—a beautiful dark *pietra serena* came to 9,000 lire a square meter; green marble, 16,000 . . . He also had *rosa di Francia*, a pretty pink marble, and many kinds of travertine. He asked me whether I was an artist, [and] when he heard that I was a *giornalista*, he said that he hoped I did not pay attention to the clothes a person wore—*che non bada ai panni* [doesn't pay attention to clothes]—and got me into his field house, where he showed me a book with a reproduction of a confused surrealist painting he had done. His name is Pasqua Pierini, and he was eager to have a conversation about art. I was not and tried to show that I was really an undereducated American and wasn't up to a metaphysical conversation. He became more animated, though, and pronounced in a D'Annuzian way on the burning fires of creativity.

Rome. Monday, February 18, 1974

In the afternoon, Natalia, to whom I had spoken on the telephone in the course of unraveling this morning's nonsense, came to Piazza Mattei on her motorbike. She had stayed home from a school excursion and required a written excuse from a parent. She had told the *preside* that her mother and grandmother were away and that her father had a different surname, but any assorted parent would do. So I wrote out an explanation of her absence. She lit on the two red albums with the Olivetti company monogram in which I keep the photos of the twins that I took between 1958 and 1962. Among other things, I wanted them to take in that I had not abandoned Vittoria at their birth, as she maintains, but saw them regularly for some years after the birth. (In fact, until I was banned from the house.) This came out in our conversation about the photos.

Craigs to dinner, with Josephine.* Peggy had a cold and was silent most of the time. Harry and I did the jabbering. I had a conversational euphoria. The pair is not in harmony. He has a vein of self-deprecation, and when he gets on it, she helps him. One that recurred was lack of money and the need to take jobs as they presented themselves. Hence his work on what he called the *Son of Airport*. A follow-up to the big box office hit I remember Judy talking about—in the same way that she spoke about her women's magazines. A kind of guilty enjoyment.

*H. A. L. Craig (1921–1978), known as Harry, Irish-born editor and screenwriter, and his wife, Peggy Anthony Craig. Harry Craig's films include *Anzio* (1968), *Waterloo* (1970), *The Message* (1976), and *Airport '77* (1977).

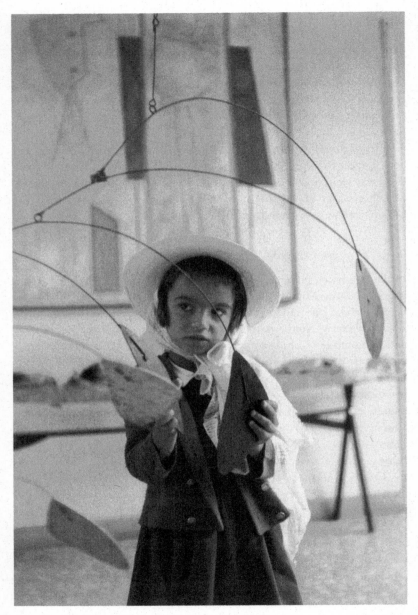

Anna Gendel, Palazzo Venier dei Leoni, Venice, 1967

We reminisced about Marlon Brando's tenancy at the Isola, and Harry described a scene here when Marlon was commenting on the Polynesians and went on about their bad teeth. His Tahitian wife got fed up and gave him a great clout across the face. He remained impassive. We agreed on the disgusting character of Rod Steiger, another tenant. Harry had almost come to blows with him over some scene-hogging he had witnessed, but at the last moment Steiger backed down. The years since I last saw Harry—in Rome—have not dealt very kindly with him. He is gray-faced, paunchy, and tired-looking.

During *Waterloo*, for which he did the script, he was approached by some officials of Egypt, Kuwait, and Morocco and asked to do a script for the life of Muhammad, a great spectacular the three countries had decided to back. They liked his radio play on Savonarola and thought he was the man for the job. The script was finished and shooting is beginning this spring. He had been pro-Israeli before the 1967 war, he said, and then had turned toward the Arabs. In the ensuing discussion he managed to throw in that, now the Israelis might be in a bad way, he was turning back to them. I got a whiff of conversational trimming, as if he were tailoring his views to suit the company.

Rome. Friday, February 22, 1974

To Gabinetto Fotografico Nazionale to pick up Caravaggeschi photos. There is a new atmosphere in this place. It is all efficiency and busywork. Perhaps Ferrari, the new director, is responsible. Looked up some Isola Tiberina photos as well. In the hall, framed, there is half of a stereopticon photo, taken in 1916, of an old woman sitting by some laundry in front of a half-open door on the Isola. It is either our door or number twenty. Must get a print of this.

Peggy Guggenheim to lunch. You live well, she said, looking around. As usual, she wanted a report on the children and was dismayed to hear that Vittoria was being a pain again.

Sebastiano was on the telephone about lawyer's business. Peggy and I talked about Anaïs Nin and reminisced on what a joke she was at the time. I found a copy of the volume of her diary from the 1940s that Gore had given me and read some passages about Peggy and her silver bed that shook and creaked. The preamble said that Peggy Guggenheim looked like W. C. Fields—I skipped this as I read, because I found it too embarrassing to pronounce. I also read a passage about a vernissage for a book

Anna Gendel and Ned Lambton, Sutton Place, Surrey, 1968

of Max Ernst's, where I was mentioned as being present along with André Breton, Peggy, the Tanguys,* and some others. Peggy also had no recollection of this event and said shrewdly, I don't think we were there; she must have made it up.

Peggy has gout and finds it very difficult to walk. She asked me to drive her to Piazza Sonnino, so that she could get to the hairdresser. It is all of one hundred yards. I drove her there, putting a chair out to defend the parking space in front of the door, and left her at the newsstand to get a copy of *Time* for her to read under the drier.

Rome. Tuesday, March 12, 1974

Harold Acton appeared at 9:00 with his sidekick, Alexander Zielcke.† He was spending the night at the Hilton and leaving very early the next morning to meet Anne and Michael Rosse‡ at Sintra for a Portuguese holiday. I was touched that he brought me a book of his *Old Lamps for New* with a more effusive dedication than I would have expected. "For the Milton I love best—the one of Paradise Regained," and so on. Of course, the sentiment was forced by warping me toward my namesake, but still. Conversation rattles with Harold. Alexander can't play the game; he is heavy and literal; in fact, physically he has also become so—eventually he'll be a gross burgher, with a round face and a red mouth. But he is well-meaning enough and evidently responsive to Harold and his needs. It is not the Italian pattern.

Harold had had messages from Princess Margaret and Tony on the occasion of his being sirred. He commented on their unhappy situation. Tony is his godson, but he condemns him for bad behavior. The Annenbergs§ had been to see him in Florence. "I could see them eyeing all my dusty, decrepit things and thinking that if they could get their hands on them, they would make them all like new."

We looked at some photographs I took when we were all staying with Harold in Florence. Alexander was very appreciative and full of praise about

*Yves Tanguy (1900–1955), French surrealist painter, and his second wife, Kay Sage (1898–1963), painter and poet.
†Alexander Zielcke, German photographer and artist. He lived at La Pietra for the last twenty-five years of Acton's life.
‡Anne Rosse (1902–1992), by her first marriage, to Ronald Armstrong-Jones, was the mother of Antony Snowdon. Michael (1906–1979) was the sixth Earl of Rosse.
§Walter Annenberg (1908–2002), publisher, investor, diplomat, philanthropist; and Leonore "Lee" Annenberg (1918–2009), businesswoman, philanthropist, and White House chief of protocol under President Ronald Reagan.

Queen Elizabeth, Balmoral Castle, Aberdeenshire, Scotland, 1976

the liveliness of the snaps. Harold commented, on seeing some photos of Sebastiano and Natalia, that he looked most poetic. Yes, I said, he has always had something Tolstoyan about him. Harold asked what they were interested in. Nothing but records and parties and movies and running around on motorbikes with their friends, as far as I can make out, I said. Harold was reminded of a moment in a restaurant with Bernard Berenson and his wife. Mrs. B. remarked on the poetic expression of the waiter. "I wonder what he can be reflecting on," she said admiringly. BB put in: "Undoubtedly all that is occupying his mind is how much of a tip he can count on."

Harold, as we went off—they stayed until midnight—said that we saw all too little of each other. After Easter, when he was back in Florence, would I be sure to call up and come and stay? I was pleased to be asked, but suddenly had an intimation of last words being pronounced.

Rome. Saturday, June 22, 1974

Joan Buck and Harald Baumgartner to dinner.* Harald has asked whether he could watch the West German vs. East German soccer match on TV. Joan and I remained tête-a-tête upstairs.

Bits of the story of her life so far. Being a speed freak in NY. Living in a minute studio apartment in Paris. Making herself the "adopted" daughter of Ricki and John Huston. At St. Clair, Huston's house in Ireland, she met Timmy Grimes,† whom she described as "a damp Airedale." Her ménage with Harald is her first; previously she has had less connected lovers.

She doesn't think much of Rome compared to London. She is rather shamefaced about her job with *Women's Wear Daily*.

Harald is driving off to Varna on July 10. It will be his ninth or tenth summer in Bulgaria. Why didn't I come, too? I'd like nothing better but must keep the Hesses company. [Harald's] mother just before the war fell in love with an Austrian—his father—and when the war started, was amazed to see him suddenly in uniform, like all the Austrians and Germans who had been ostensibly visiting or studying in Bulgaria. Eventually she left with him for Vienna, where she broadcast to Bulgaria for the Nazis. After the war, they went to live in a village, where mama had nothing

*Joan Juliet Buck (b. 1948), American writer, editor, and actress; Harald Baumgartner (1945–1974), Austrian-Bulgarian fabric designer and onetime weight lifter.
†Tim Grimes (b. 1947), now a production designer; son of Stephen B. Grimes (1927–1988), production designer who worked closely with John Huston and rented an apartment next to the Gendels on the Isola.

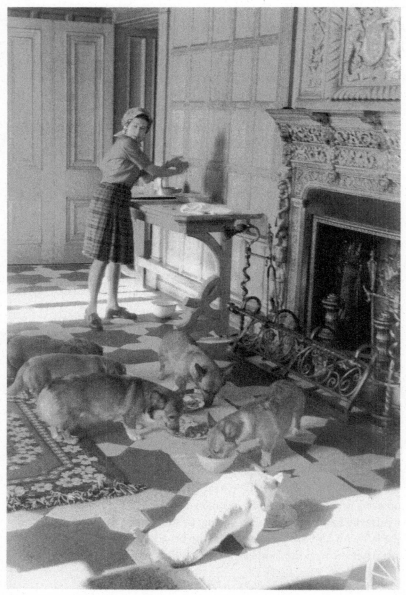

Queen and corgis, Balmoral Castle, Aberdeenshire, Scotland, 1976

to do but play the piano. She got fed up and left her husband. "And like a good Bulgarian she didn't ask for any money." Subsequently he remarried. "Of course, my father and I love each other, but we have nothing in common." I don't see any "of course" about it.

Harald was a swimmer and then a champion weight lifter. That accounts for his notable shoulders and muscles. He looks like a good animal, but his soul is not easy, I think.

Joan also seems on edge. She feels responsible for Harald's feelings and reactions, especially when they are in company. I said that I found this unusual; couples usually, after they have declared their solidarity, face the world side by side or back to back. Anyway they face out together.

Rome. Tuesday, June 25, 1974

Harold Acton: "How pleased I am to hear your voice. Mine, alas, has been gone and is only now returning . . . It is tonsillitis, although my tonsils were removed when I was a child. They grew again, it seems . . . And this week I am to have many visitors. All the dignitaries of Detroit who have come for the opening of the 'Later Medici' exhibition . . . a period much neglected . . . Oh well, my book was written so many years ago. At that time, the subject was not popular. The Italians preferred not to dwell on their decadent moments. The Fascists, you know, liked to believe that they were an example of health and strength . . . Oh, Princess Margaret is always welcome here . . . Perhaps it is for the better that they should have separate vacations . . . Within the limits of my household I shall do everything I can for her . . . Yes, it would help if your housekeeper could come with you and Anna . . . Of course, *ferragosto* is the worst possible time for a visit . . . The Florentines, like all the Italians, go away . . . to the sea . . . and other places. I'm afraid the entertainment would be limited . . . or nonexistent . . . If Princess Margaret chose to bring a friend of courage, he would also be most welcome . . . I was not enthusiastic about the young man I saw at Kensington Palace, but it is another thing if he makes her happy. The last time we met, on my return from Portugal, she looked radiant, and if that is a result of his attentions, I think well of him . . . On your way to Venice, do stop and spend the night if it suits you . . ."

Supper with Anna, who was full of little accounts of her activities with Clem and Giulia.* What a charming creature she is. When I look at her

*Clementina Cusani-Visconti and Giulia Salvatori, childhood friends of Anna Gendel.

Queen Elizabeth, Balmoral Castle, Aberdeenshire, Scotland, 1976

pretty, lively face, I feel how wrong it is to be dispirited, as I am, and this helps to correct the downward course for the time.

Rome. Wednesday, June 26, 1974

At 7:00 took Anna by taxi to the Via dell'Oca libreria. Upstairs, parents and children had gathered for Toti Scialoja's reading of his new book of poetry. Some were not parents, like Luisa Spagnoli. And some parents [were] without their children.

The children sat on the floor in several concentric circles. Toti was at a desk in a corner. His preparations fascinated the audience, as well they might. He took off his broad black tie and replaced it with a long green ribbon, in which he had one of the children tie a bow. Then he worked his hands into a pair of bright pink gloves. And finally he took a curly wig out of a bag and put it on his head. He looked like a mannish Mother Goose. But by then there was no question that he had his audience with him.

He made an intelligent introduction to poetry and nonsense rhymes— citing Lear and Lewis Carroll—and explained such devices as portman-teau words. Then he read his poems. When they failed to get a good laugh or a ripple or comment, he adroitly covered this by launching into an explanation, and went on to the next. Most of the children were so young that they were more befuddled by the verbal pyrotechnics than amused. But the adults carried the day by laughing uproariously.

Rome. Sunday, July 7, 1974

Porta Portese in the morning. Bought from a Neapolitan a little brass shovel with a handle in shape of a feather. For a very small fireplace or stove?

Muriel Spark to lunch. She has been convalescing from an operation for hernia. There was a great swelling along the scar for some days. "It was awe-inspiring. It looked as if I was wearing some lesbian appliance under my dress. I expected people to ask me whether I dressed left or right." She likes Rome. "I have as many friends here." They include Lanfranco Rasponi and Brian de Breffny.* She is not that loyal to them. About De

*Brian de Breffny (1931–1989), or Baron de Breffny; born Brian Michael Lees in London. Married briefly to Princess Jyotsna, the daughter of Sir Uday Chand Mahtab, Maharajadhira-ja Bahadur of Burdwan, then to Ulli Castrén (1919–2011), Finnish-born widow of the wealthy Bahamian fixer Sir Stafford Lofthouse Sands. The couple restored Castletown Cox, a Palladi-an country house in County Kilkenny, Ireland.

Princess Margaret and Anna Gendel, Balmoral Castle, Aberdeenshire, Scotland, 1976

Breffny she said, after explaining how much she liked him and how much she enjoyed going to see India with him: You know he wasn't always called the Baron de Breffny. When I first knew him, he was Brian Lees.

She is off to Edinburgh to see her son. He works in land or forest development. He is Jewish and piously so. Her father, Kamburg or Camberg, was Jewish, but she was raised in the Church of England by her Anglican mother and then became a Catholic. The Cambergs and the three hundred Scottish Jewish families of Edinburgh have been there since the eighteenth century. She married a Jew—Spark. He is mad and has spent "most of his life in bins." Her son has argued that *she* should have been in the bin. He had trouble accepting her best-seller fame. When she goes to Edinburgh, he doesn't allow her to eat bacon and eggs, she said with a smile, a rueful smile. She has a quaint old-fashioned backstairs snobbery in the way she says "Brian married an Indian *princess*." But there is a similar note when she mentions her two Swiss companies into which her name and works have been incorporated.

She has a very wet kiss when she kisses you goodbye.

Met Gore by the Pasquino movie house, in Trastevere. I watched the Trastevere world go by during the ten minutes I waited for him. A troupe of *pazzarielli* came drumming and jagging into Piazza Santa Maria in Trastevere. People sat around the edge of the fountain, some of the boys horsing around. The neighborhood has changed enormously. It is Greenwich Village in the old days. More foreigners, it seemed, than locals. Many of them English-speaking, with little children, heading for the English-language service. Gore appeared and led the way through some alleys, and we were at the tarted-up door of a little "improved" Trastevere house. George Armstrong opened the door.* We went up steep stairs through two or three floors to a small terrace crowded with plants. Gore plunged at once into a review of *Burr* and a profile of himself in *Books*, which George had. George is in his late forties, like Gore, but white and puffy, with haunted blue eyes. It is a decent face, and intelligent looking, but he is running scared.

Gore, unfortunately, started on the high connection bit—the Agnellis and the Italian situation, and although George, as correspondent of *The Guardian*, is better informed than both of us put together, somehow he was left behind. [Then] Gore was off on Stalin and Lady Astor. When are you going to stop killing people? she asked him. "Lady Astor, you know the un-

*George Armstrong (1924–2006), born George Armstrong Leiper IV, in Little Rock, Arkansas. Rome correspondent for *The Guardian*.

Queen Elizabeth the Queen Mother, Clarence House, London, 1982

desirable classes are reluctant to liquidate themselves." Which reminded him of Mrs. Kennedy. "Jackie was at the Élysée, sitting next to de Gaulle, of course. She was bent on making interesting conversation. 'Who was the most amusing prime minister you ever met?' she asked him. 'Stalin,' he replied, without batting an eye."

London. Thursday, August 1, 1974

Shopping with Anna and then lunch at Violet Wyndham's.* She now lives near the Portobello Road. "It's rather slummy . . . and difficult to find." We found it and some other guests—Diana Cooper, Fulco,† and the star of the proceedings: Rod Llewellyn.‡ Violet has the pride of the pander in her protégé. She supplied him as an extra man when the Tennants were fretting about having some youth at Glen for a visit by PM. He belonged to a circle of fond young men she cultivates, and he was Nicky Haslam's mate, it seems.§

At 7:00 to Clarence House in black tie. The taxi driver was timid about driving in. In front of the door was a little crowd of Queen Mother devotees with cameras, waiting for her appearance. She draws a crowd wherever she goes. PM was in the drawing room. She pointed out the paintings to me—a Monet that her mother calls *The First Drive*. A very nice Fantin-Latour still life with pansies. A brilliant pencil portrait of Queen Elizabeth [the Queen Mother] as a girl, by Sargent.

Tony came in, looking very sparkling and blue-eyed. Then the Glendevons¶—she was Somerset Maugham's daughter and is the mother of Jonathan Hope—she reminded me. Also Derek Hart,** Elizabeth Cavendish,†† and then the Queen Mother. She said it was nice to see me again when we shook hands. There was some buffet supper—bacon and eggs and smoked salmon and drinks. Tony suggested that the QM show me the

*Violet Wyndham (1890–1979), biographer and formidable cultural presence. Daughter of the novelist Ada Leverson—Oscar Wilde's loyal friend and supporter—and mother of the writer Francis Wyndham.
†Fulco di Verdura (1898–1978), prominent designer of jewelry, first for Coco Chanel (to whom he was introduced by Cole Porter) and eventually through his own salon.
‡Sir Roderic Victor Llewellyn (b. 1947), landscape designer and author. His relationship with Princess Margaret was widely publicized; they would remain close friends.
§Nicky Haslam (b. 1939), British interior designer, photographer, writer, and socialite.
¶John Hope (1912–1996), first Baron Glendevon, and his wife, Elizabeth Paravicini Hope (1915–1998), the daughter of Somerset Maugham.
**Derek Osborne Hart (1925–1986), journalist and broadcaster.
††Elizabeth Cavendish (1926–2018), daughter of the tenth Duke of Devonshire and a lady-in-waiting to Princess Margaret. A devout Anglican, she was nicknamed "the Deacon."

Monica Incisa, Kensington Palace, London, 1982

Pipers.* She took me inside, and we looked at the rows of them, and then she said I must come back in the day and see them at leisure. I asked what Sargent had been like. "Oh, it was so long ago. He was red-faced and quite charming."

We went in the Rolls-Royces to the theater and sat in the dress circle. I was to the left of the QM and Derek to the right. Beyond him, Elizabeth, Tony, and PM. On my left were Lady and Lord G. The play was an English *pochade* called *The Norman Conquests*. Middle-class drawing-room comedy. The acting was brilliant, and there were a lot of laughs. The QM is always in her starring role, though, and the audience rose whenever she appeared and applauded her.

Florence. Saturday, August 10, 1974

PM, Anna, and I, just ourselves, on the terrace with chairs and mattresses and books, to take the sun. I've had a talk with Harold in his study, about plans. He is a little put out that PM doesn't want to go to the Palio [di Siena]: she had had such a memorable time on the last visit that she doesn't want to overlap it. But Marlia is all right for Sunday, which was a *journée creuse* [an off-peak day], and anyway he wanted to give his cook a rest. He complained about staff problems, as always. The butler is a good diligent man, but the footman is slow, thick, and unresponsive.

Queen Helen to lunch.† She is quick and agile, though in her late seventies. "Margaret, I did want you to come to Villa Sparta, but I must give my staff a holiday and I leave tomorrow for Lausanne. Paul and Olga are coming. We stay at a *tiny* hotel, the Carlton. You run the lift yourself and the doorman is such a good fellow that I have told him, 'If ever we go back to Romania, you shall be my prime minister.'"

She tells PM that she follows her news in the scandal mags. She's sure they get things wrong, but it's a way of keeping up nevertheless. She seems touched when PM suggests that she come and stay in London. They talk about the prospects King Constantine has for returning to Greece under the Karamanlis regime. Queen Helen says they are 50–50 but weighted

*During the Second World War, Queen Elizabeth (later the Queen Mother) commissioned John Piper (1903–1992) to paint an ambitious series of watercolors of Windsor Castle. Many hang in the Lancaster Room and the Dining Room at Clarence House.

†Helen of Greece and Denmark (1896–1982), second wife of Crown Prince Carol of Romania, who would become King Carol II; mother of King Michael I. She lived much of her life at a villa in Fiesole, outside Florence. Yad Vashem posthumously named her one of the Righteous Among the Nations for her efforts to save Romania's Jews during the Second World War.

Swimming pool, Windsor Castle, Berkshire, 1990

negatively. He should never have left. They criticize Queen Frederica in a jocular way.[*]

Queen Helen says, My father told us never to get mixed up in Balkan politics, and I always followed his advice. Unlike my mother-in-law. She played a starring role, Queen Marie, I said.[†] I remember seeing her name in the papers all the time when I was a child. Oh yes, much too much so . . . for a woman in that position. She should have left it to her men.

Harold refers to Queen Marie's mother-in-law's poetry—Queen Carmen Sylva. Queen Helen says that she never looked at any of the poems. One of her grandchildren, daughter of King Michael, is brilliant at the university. QH remembers that we met last two years ago here—she looks down sadly: And your wife was here at that time. Since then her sister—the Duchess of Aosta—has also died.

She, QH, has to leave us to see a lawyer in town. A Greek music teacher in her fifties has started a suit to prove that she was the daughter of King Carol and the Duchess of Aosta. "But Carol and she disliked each other. It's quite ridiculous. Of course, she is after the millions that Carol put away in America. For years we tried to find out where. Only that woman in Portugal knows. Magda Lupescu."[‡]

Florence. Sunday, August 11, 1974

Dinner. We are like a hard knot of guests in a remote hotel. The conversation doesn't flag, though. Reminiscences, personalities, the news. After dinner Harold and I go up with PM to her vast bedroom, and she eggs H into looking into the drawers and boxes of the sixteenth-century chests of drawers. A treasure hunt. They find binoculars, a grand old Fielding Kodak, a stereopticon camera, and many pairs of lady's gloves. Also family photographs—even some daguerreotypes of H's American great-grandfather with muttonchop whiskers. PM criticizes the way the *Madonna* of the Master of the Castello Nativity is hung, against a sixteenth-century tapestry. It should have a plain ground, she maintains. H says mildly that he has left everything the way his father arranged it. Filial piety.

[*]Frederica of Hanover (1917–1981), wife of the future King Paul I of Greece. She was the mother of Spain's Queen Sofía and of Constantine II of Greece (forced into exile in 1967).
[†]Marie of Romania (1875–1938), British-born wife of King Ferdinand I; Romania's last queen. She made a triumphant tour of the U.S. in 1926.
[‡]Magda Lupescu (1899–1977), the mistress and, later, third wife of Romania's King Carol II. After Carol's abdication in 1940, the couple eventually found refuge in Estoril, Portugal.

Tortoise Fountain restoration, Piazza Mattei, Rome, 1979

Florence. Sunday, August 12, 1974

After lunch we drove to the Pitti Palace, the party in a hired car and the two detectives following in mine. *Gli ultimi Medici* exhibition, with Harold providing the comments. We were joined by a loose-limbed fellow with high demi head covered with long black hair, Chiarini, the director. He is married to a daughter of Pouncey.* I was struck by the three decorated jars from Guadalajara—Chiarini couldn't explain their provenance. Also by Cosimo III's fruit paintings—figs and cherries—showing a great variety—twenty or more of each—which brought thoughts about the reduction of these varieties dictated by the market. The portraits—Cosimo III and his fleshy lips. Vittoria della Rovere with glassy eyes, very white flesh, and black shiny robe and mantle.

We had a drink at a soft drink stand in Piazza Michelangelo. PM and I laughed at the street scene. An old man sat down at our table with a glass of yellow-green liquid and was totally oblivious to us and everything else. A fat man carried a fat baby across the street—it stuck out unyieldingly like a badly articulated doll. An overdressed little boy wore a red-and-white polka dot suit and red shoes. Up to San Miniato. The tomb of the cardinal of Portugal.

To dinner at Villa Clifford. Lady Bird Johnson the hostess. Flowing drapery flowed in the entry. Welcome Your Royal Highness. And Sir Harold. And you're Mr. Gendel? Harsh but not disagreeable Texas twang. Narrowly constructed daughter—Luci—with black hair like one of Velázquez's infants. Upholstered blond husband Pat Nugent. Inside everything looked slicked up since I last saw it when staying with the Trees. (Harold: Oh, Ronnie won't come back anymore. They were robbed, he said. By both. The landlords, the Cliffords, and their staff. Eleven thousand dollars a month!) Brighter bulbs in the lamps, perhaps. Large shapeless woman with coarse face and white hair—Mrs. [Liz] Carpenter, who was Mrs. J's press secretary. Count Tadini, a neighbor of the Nunesses near Pisa. A man about the countryside, according to Harold. Mr. and Mrs. [Robert] Gordon, the U.S. consul and wife.

At dinner, Harold was on Mrs. J's right and I on her left. Over drinks we had had some caviar, but it wasn't very good. The food was mediocre, although made by H's former chef as he ruefully remarked several times.

*Marco Chiarini (1933–2015), art historian and for three decades the director of the Galleria Palatina, in the Palazzo Pitti in Florence. His wife, Françoise Pouncey (1938–2014), was the daughter of the British connoisseur Philip Pouncey.

Tortoise Fountain restoration, Piazza Mattei, Rome, 1979

Mrs. J wanted to talk about Florence and Venice, where they are going for a couple of days. I preferred to hear something about Nixon, but their line on that was discreet deploration. It was all so sad. I told her that the Italian press had quoted President Johnson as having said of President Ford—our New Leader—that he can't chew gum and walk at the same time. She laughed. Oh they knew the Fords very well—she had been a friend of Mrs. Ford in the 1948 Club—the wives of congressmen and senators of the same year would meet and keep up relations. It helped everyone . . . Well, they were friends and they were very nice . . . Of course, Mr. Ford wasn't very *quick.*

Teasing session with Mrs. Johnson, the Nugents, PM, and Mrs. Gordon—on the lateness of Texas's entry into the Union. (The subject was the bicentennial of the republic.)

She is a nice straightforward, interested, active woman—Mrs. Johnson. But as Harold said, she is tinged with melancholy.

Florence. Tuesday, August 13, 1974

Dinner at La Pietra, with the addition of John Pope-Hennessy.* PM and Harold had been going on about his preposterous voice and how afraid they were that they would get lost in a *fou rire* once he started, but when PM caught my eye during dinner, I had forgotten about this gag. In fact he doesn't sound particularly ridiculous to me. I didn't want to tell them that they all sound pretty much alike to me—the upper-crust English. John P-H is magisterial and to the point and has a nice, sly humor. When asked about how the V&A would fare now that he has taken over the British Museum—how it would fare under Roy Strong—he said drily that he couldn't foresee any changes at all, as he had left a program covering the next seven years.

Anna's comment to PM on John P-H was, "Well, he was a little too intellectual for me." PM laughed and said she had had the rare privilege of sitting in with three of the most cultivated men in the world today. I appreciated being included. After John left, Harold remarked that he had been rather patronizing about the Last Medici exhibition. Harold feels that he is the godfather of the exhibition, as he was the first to write about

*Sir John Pope-Hennessy (1913–1994), art historian; director of the Victoria and Albert Museum (1967–1973), then of the British Museum (1974–1976). His influential books include the three-volume *Introduction to Italian Sculpture* (1955–1963) and *Donatello: Sculptor* (1993). Known to colleagues as "the Pope."

Tortoise Fountain, Piazza Mattei, Rome, 1985

the later Medici. John's view was that the show had been better arranged in Detroit.

Harold and PM had a little frisson discussing the horrible death of James Pope-Hennessy.* John must have suffered from all points of view, as he is very buttoned-up and "correct." James was beaten to death by rough trade he had been cultivating, who thought that the reports of his earning a vast amount of money on a book meant that he had the cash in his house.

Rome. Wednesday, September 11, 1974

To Gore's for drinks and dinner. An aged, pale, shambling Tom Driberg[†] was there. He had been staying with Gore at Ravello, working on his memoirs, which G says are brilliant. "He's telling *everything.* People will leave England in regiments when the book comes out. But mostly it's about himself. There's one line which I think ought to be the title of the book: '"Only for pity" will do.' It was what he said to some boy he was trying to get into bed who objected that only pity could induce him to do such a thing."

We walked over to the Archimede for dinner. (Howard had gone out with some pals.) Gore had read in the *Herald Tribune* that the Archimede was a good restaurant. (It is an excellent restaurant with nice service, as it is run as a family affair.) We had some very good *fiori di zucchine* and *lombatina* with herbs.

He had with him a little golden-haired terrier that he calls Rat. It is an Australian terrier and supposed to be a good ratter. The animal would be picked up at intervals and put on G's knee. It would reach its head up and lick him on the lips. When he was asked whether he didn't fear worms, he denied that worms were common and insisted that a dog's saliva was a powerful antiseptic. In fact, when he had gingivitis, he had the dog lick his mouth to cure it. I asked what happened to the dog's gums.

We closed the restaurant—the ladies hadn't arrived until 10:30—and it was after one when I left Gore and Tom at their door. I felt sorry for the old hulk and asked him to lunch tomorrow. It won't come under the head of pleasure. Only for pity will do, except there won't be any recompense for me.

*James Pope-Hennessy (1916–1974), brother of John, British travel writer and biographer. He was at work on a biography of Noël Coward when he was murdered at his home in Notting Hill.
†Thomas Driberg (1905–1976), British journalist and Labour politician.

Iris Origo, Palazzo Orsini, Rome, 1979

Rome. Thursday, September 12, 1974

I didn't regret my charitable invitation to Tom Driberg. The conversation at lunch was interesting and enjoyable, and he was obviously very pleased to be wanted. He carries an aureole of loneliness, but the gray-chess face lighted up over reminiscences. He brought me a copy of the *Sunday Times* supplement—August 25—in which there was an interview with him, a sort of preview of the memoirs he is working on. He had been careful, he explained, not to give away any of the interesting bits that he hoped would make the book salable. If it goes well, he plans to buy a house in Italy or France. I tried to get him on his contemporaries—he is seventy—and asked whether he had been at school with Harold Acton. "Oh, Acton says he is seventy, but he must be a few years more." Tom did not go to Eton but met Harold at Oxford. "He seduced me at Oxford. I don't mean that I hadn't been seduced before."

He described his working methods on the autobiography. He lives now at the Barbican and has a young man who comes in to help him. They have destroyed forty thousand papers so far, he estimates. (This statistic appealed to me.)

Rome. Saturday, October 5, 1974

Monica Incisa, in Rome on a two-day excursion, came to see me at Piazza Mattei. Very trim. Brown knee-high boots, sweeping dark-brown skirt, sky-blue sweater, brown shirt, cap of brown hair. Pleased with herself for wearing a skirt. Big hugs, kisses. "Oh you are more beautiful than ever," she said to me, and launched into an account of London life. She goes out a good deal but has no real friends yet. Many of the women she has met annoy her. They keep saying that things are "super."

Monica went off on her brother's Bravo—a moped.

Rome. Friday, December 6, 1974

Harold Acton's knelling voice: Henry Clifford is dead; Cyril Connolly is dead; Cecil Beaton had a stroke; Ronnie Tree had a stroke. What a trunkful of bad news.

He is finishing his book on Nancy Mitford after facing problems like mentioning, without discussing, her long love affair with Palewski. At the last minute, pages of information came in from Debo and Paddy Leigh Fermor.

Iris Origo, Palazzo Orsini, Rome, 1979

Rome. Tuesday, December 17, 1974

Made an omelet for myself and was settling down for an evening with the files when I turned on the TV for the news and got hooked by an old western—though I'm not fond of the genre—called *Johnny Guitar*. An old meatball of cross-starred love, gunplay, hate, and lynching, with the ludicrously dignified, big-mouthed, huge-eyed Joan Crawford. Who are the ancestresses of these screen ladies? Imaginary English noblewomen? Mary, Queen of Scots? Florence Nightingale? It would be interesting to trace the spiritual bloodline.

Rome. Friday, December 20, 1974

Anna, hectic from a party at the boy Klatsky's, arrived home with Clementina, who is spending the weekend; Klatsky himself; Kirk Treacle, the boy she loves; Marjorie Shaw; and a boy new to me except in Anna's conversation, John Crowe.* A forthright fellow with such assurance who addressed me as Dad. I told him I was not his dad, whereupon he called me Brother.

Much noise from below. We are now going through the varieties of subteenage life. It seems to exhaust Anna; she is green and mauve in the face. I asked her to get to bed by 9:30 and not to stay up talking with Clem.

La Pietra, Florence. Saturday, September 2, 1974

Harold on Vittorio Emanuele, the pretender, who is in jail in Corsica for shooting up an innocent bystander, a young German who was sleeping aboard a yacht and got hit by a bullet from a rifle he let off in a brawl with some Italian tourists. "What do you expect? He has some of that mad Wittelsbach blood. His grandmother was the Red Queen.† Her son Charles Theodore was at school with me. But you know, I believe in cases like this that there should be capital punishment. There is that poor boy who lost his testicles and a leg. Why should Victor Emmanuel go unpunished?"

*David Klatsky, Clementina Cusani-Visconti, Kirk Treacle, Marjorie Shaw, and John Crowe, friends of Anna Gendel's.

†Elisabeth von Wittelsbach (1876–1965), Bavarian duchess, became the wife of King Albert I of Belgium and thus queen of the Belgians. A branch of the Wittelsbach family produced "Mad King Ludwig" of Bavaria. Elisabeth earned the "Red Queen" sobriquet after visiting Russia and other Communist countries in the 1950s. Her daughter Marie-José married Umberto II, the last king of Italy.

Iris Origo, Palazzo Orsini, Rome, 1979

La Pietra, Florence. Sunday, September 3, 1974

Ate so much at lunch that I fell asleep afterward and woke up an hour later feeling logy. Went around the garden snapping, and then came across Harold taking his constitutional. The talk rambled on—Loeser, Horne, Berenson . . . the rivalries among the experts. John Pope-Hennessy's intolerable airs. As if he had done the art he was studying.

He had no regrets about not having channeled his writing. He was pleased to be a poet, novelist, and historian. His writings had been praised by everyone except his own friends, who had had taken every opportunity to snipe and attack. Peter Quennell, Cyril Connolly. He felt there was jealousy there, that they thought anyone who lived as he did, in a villa with gardens and art all around, was cheating and shouldn't be writing at all.

Rome. Friday, September 8, 1978

Rolling back through the years to the many bedrooms I've come awake in. Bohemian, at home, my own, hotels, friends' and lovers'. My lover's bedroom has her drawing table at the foot of the improvised "matrimonials" made by shoving two single beds together.

Monica stirs. I'm glad she is young and nice-looking. She doesn't see me as an old man or an aging one. What does she see? Company, moral support, fascination, talk, mysterious processes of the mind that leaps unexpectedly.

She rouses herself to let me out of the apartment. The locks are complicated. I slip out the door as she opens it and take the stairs down to the street.

Rome. Friday, October 6, 1978

Isaac Bashevis Singer has received the Nobel Prize for literature. Graham Greene had been mentioned as a likely candidate. I think Singer is a much greater writer than Greene, one who deals with a whole world, a universe. Whereas Greene is a brilliant tightrope walker edging between God and his grubby little creatures.

Rome. Sunday, June 1, 1980

At Porta Portese, found a leather box useful for keeping secure my zoom

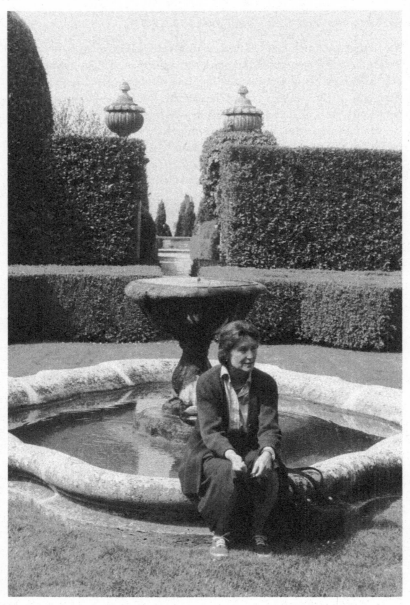

Benedetta Origo, La Foce, the Origo family home, Val d'Orcia, 1994

lens, for traveling. Russian coins: a Catherine the Great five-kopeck piece, a ten-ruble copper of 1833, and some smaller coppers. Books: a Bible concordance in Latin, eighteenth century; *Jones on Asia*, an eighteenth-century collection of essays on the Far East, including one on the treatment of snakebites and another on elephantiasis. Travel books on Tibet and Guatemala, and a volume of eighteenth-century *orazioni*.

Rome. Tuesday, June 3, 1980

The crispness is going, and spring has set in. I walked through it to the Vatican, where I found a toothy Esterow [of *ARTnews*] waiting at the entrance to the museums. He must have a set of false teeth; they are very even and very white.

We were taken upstairs by a guard and led to the office of Walter Persegati, secretary general of the museums. An efficiency man. Small, most composed, with white hair *en brosse* and blue eyes and an executive manner. Must have been educated by the Jesuits. Esterow explained that he wanted to do an issue of *ARTnews* on the Vatican and then bring out a book with the same material. "I want to give the public an idea of how things work here. The man behind the scenes. I want to *humanize* the Vatican." The sec gen didn't look displeased, then proceeded to talk for an hour and a half on his functions. Policing, prevention of theft and vandalism, and crowd control. There hadn't been much damage recently. The guards find plaster dust on the floors of the galleries occasionally, and that means that one of the restored fingers of a Roman statue has been broken off. Sometimes there are pickpockets. The guards find empty wallets and purses in the toilets.

No, they don't arrest anyone. Their aim is to make them feel that they are under observation and that the Vatican is not a good place to go and pick pockets.

He arranged a series of appointments for Esterow over the next few days. Pietrangeli, former head of the municipal museums, is now the director, having taken the place of Redig de Campos. Then took us to the command room where twenty or more closed-circuit TV sets follow the movements of visitors in the museums. You can follow individuals from hall to hall. On one screen they go downstairs, on the next they come out in the Sistine Chapel. If the crowd gangs up at some bottleneck, the guards close the doors, and a dulcet voice is sent over the PA system to explain that they'll have to wait a few minutes, and meanwhile they will be told some facts about the wall decorations around them.

Benedetta and Donata Origo, La Foce, 1994

Esterow saw Claudio Bruni's dinner party as a Cage aux Folles.* Not so far off. The dinner table was opulent to the point of grotesquerie. Outsize wine glasses on stems. A vast still life of out-of-season fruit. Lace tablecloth. Gold-bordered dishes. The star of the evening, Irene Papas.† Larger than life. Handsome dark woman with a strong face and powerful body. In a green satin dress. Black hair. Very. And eyebrows. With a forthright manner. When she remarked that she was alone, I asked why. "Oh, they all leave me," she said largely. And why do they do that? "Because they never want the truth, and I do." You mean you refuse to enter into their fantasies? "Oh, you are sharp and hard. Why do you want to be that way?" She put a big hand on my arm.

Claudio told more anecdotes—one about Picasso choosing Matisse's brush rag as the work he would take in exchange for one of his paintings. Because he realized that Matisse had laid out his worst efforts. Matisse then hastily produced some good things.

London. Thursday, June 26, 1980

To the Natural History Museum. What a splendid pile, and how fine it looks after the cleaning with the different hues of the bricks clear now, and all the carving, colonnettes, and details in clean golden stone. Inside is very handsome, too. Stained glass. Painted panels in the vaults, of flowering plants.

At Campden Hill Square, Antonia‡ introduced me to her mate, Harold Pinter, the playwright. Anna was out skating with Natasha,§ but presently they came in and joined the drinking party in the parlor. Pinter is a stocky man with dark, curly hair. Somehow we got on to children at once, and Antonia happened to remark that his son had given up his name. He had two surnames and dropped the Pinter. And I described the trouble I'd been to [in order to] give Sebastiano my name.

But the main subject was the pope. Here Pinter was critical of him. Why didn't he speak for the poor and the disinherited in Latin America?

*Claudio Bruni-Sakraischik (1926–1991), art dealer and proprietor of Galleria La Medusa in Rome.

†Irene Papas (b. 1926), Greek-born actress. She won an international audience with films such as *The Guns of Navarone* (1961), *Zorba the Greek* (1964), and *Z* (1969).

‡Lady Antonia Fraser (b. 1932), daughter of the seventh Earl of Longford; noted biographer of *Mary, Queen of Scots* (1969) and *Cromwell* (1973). Her second husband was the playwright and Nobel laureate Harold Pinter (1930–2008).

§Natasha Fraser-Cavassoni (b. 1963), writer and biographer; daughter of Antonia Fraser and her first husband, Sir Hugh Fraser.

Marcus Aurelius restoration, Rome, 1981

Antonia and I had a more detached and worldly view of the pope as the head of an institution. Antonia: "People who aren't Catholic seem to expect the pope to be like God. It is an organization, an institution, and of course I wish they wouldn't insist on things they shouldn't bother with, like sex and abortion. They could just as well leave that to the individual." Like suicide, I suggested. "Yes, exactly, that has simply been accepted, instead of being censured and punished."

London. Monday, June 30, 1980

Next door at No. 23 Old Church Street, Sybille Bedford's apartment and garden were at the opposite of the Birkins'.* Neat, with spaces. Sybille moved by seeing me again, as I brought up the Evelyn tragedy. I was unchanged, she insisted, so I said politely that I didn't find her much changed. And didn't. She still had that powdery look I never liked. Pale and powdery. But much came back to me as she reminisced about Rome. Those evening rambles through the empty streets. Evelyn feeding the cats.

Detailed account of Evelyn's last year and her illness and operations. I didn't know that after E's return from Europe—in '54?—they hadn't met for six or seven years. But you weren't in touch. Oh, we were, we wrote three or four times a week.

Martha Gellhorn's rage over Evelyn's "perfidy" in telling me about her miserable novel where she described Judy, Vittoria, and me.

I was tempted to ask some direct questions about her relations with Evelyn but didn't. Then she went into a sort of apology. It wasn't her idea that Evelyn should come away with her. In fact, she was appalled when E. one evening arrived with her suitcases. She was broke and embarrassed by the prospect of being responsible for someone she considered . . . well, not a child, but quite young, even if there was only five or six years' difference in their ages. She seemed relieved when I said that the separation, though it enraged me, was also an immense relief, after all the quarreling.

Novel picture of Evelyn, after she became a success in publishing, as a big spender, taking them to hotels and meals.

I gather that this was the relationship of S's life, and she had imagined spending her old age with E. She seemed weepy to me, but she does have watery eyes.

*Sybille Bedford (1911–2006), German-born British novelist, memoirist, and traveler. Milton and Evelyn Gendel had met her in Rome in 1950; Evelyn's affair with Bedford began soon afterward.

Marcus Aurelius restoration, Rome, 1981

Rome. Tuesday, November 25, 1980

Alex and Tatiana Liberman expansive at the Rally Room of the Grand Hotel.* The fashion shows were over, and you could breathe again, said Alex. Why, yesterday this room was packed with fashion people, and now they've all gone. I ate *gamberetti* and *spigola* and raspberries. Delicious food. Alex sailed into Balthus. He was a phony painter, just as he was a phony aristocrat and phony everything. Tatiana liked his work but found it limited. Why was it so "frozen"? I cited Chardin, Poussin, Piero, Vermeer, putting Balthus in company that's really a bit too good for him. Alex declared that he couldn't stand the "literary" character of the work. He liked only abstract art. He sounded like an old manual of the old avant-garde. Caught rapid glances from Monica, who was consciously remaining neutral.

And what explained the grandiosity of Roman buildings? They had been to see the Palazzo Spada, at my suggestion. It was power, wasn't it? Imperial power. But that collection of paintings was pathetic, said Alex. All second-rate. Rome was second-rate in its art, wasn't it? There wasn't a Louvre. I composed them a Louvre by imagining the Barberini and Corsini collections thrown together with the addition of the Galleria Borghese and the Doria Pamphilj and the Vatican and the Sistine Chapel and Raphael's *Stanze*. They didn't seem to get the point, and I felt that they would go away repeating that art in Rome was mediocre. Despite my citation of the Masolino and Pinturicchio wall paintings and the Rubenses and other notable works in the churches. Caravaggio.

Monica shyly pleased that I had mentioned her new drawings, and Alex had asked her to bring them. We went into the salon to look at them, and Alex was so impressed he asked to buy some. She is to get them to NY—by hand probably of Harry Bailey, who is due here tomorrow. And just then the editor of German *Vogue* went by. Alex hailed her, introduced her to M., and had her look at the drawings. She wants M. to work for her, too. Alex pleased at his quick strategy.

He and Tatiana look as well as any seventy-year-olds could. Clean, neat, well-groomed, beautifully dressed.

*Alexander Liberman (1912–1999), longtime editorial director at Condé Nast Publications, and a painter and sculptor; and Tatiana Yakovleva Liberman (1906–1991), a designer. Tatiana's daughter and Alexander's stepdaughter was Francine du Plessix Gray, who captured the Libermans' lives in *Them: A Memoir of Parents* (2005).

Marcus Aurelius returns, the route from Via di San Michele, Rome, 1981

Villa Reale di Marlia, Lucca. Thursday–Friday, September 25–26, 1980

The usual stir of memories and feelings as the house came into view, and then there were drinks in front under the remaining magnolia tree. Four sisters and some guests—Peter Wilson,* Alvise Robilant, one John Winter and one Jonathan,† an Empire specialist, with a beard. They were there to make estimates of the Empire furniture for the insurance. The Pecci-Blunts are trying to rationalize their insurance coverage. As rates have gone up dizzily, they are no longer insuring big bookcases and pieces you would need a truck to get away with, as they doubt that thieves equipped with trucks could get in within the walls.

Peter Wilson wanted to talk about Judy, whom he knew all through their childhood, as his father was a friend of Venetia's. (That was Scatters Wilson, so called because he spent his time scattering his seed about.) And then his brother Martin and Iris Tree.

Laetitia‡ was pumping out charm like a squashed barrel of molasses.

They all went off to pore over the possessions.

I went to see the widower swan. His mate had been killed by a fox. He daydreams about zeroing in on someone's shin. But I was quicker than he.

The grounds are saddening. In January, a tornado uprooted dozens of trees. The hedges that are an interlace of tree boughs, by the fountain that leads to the Teatro di Verdura, are mangled and denuded. Elsewhere the cypresses are a sorry sight, as they have been attacked by a virus disease that is epidemic in Tuscany.

But the overall view from my window on the top floor in the center of the house is splendid. Through the haze it is just possible to make out the roofs of Lucca. The vast lawn slopes down, between lines of two-story hedges and those beds of dahlias, to the lake, which is now like a mouth that has shrunk to reveal stretches of gum. The water level is down and the banks show.

The lanterns at the corner of the house have had their glass smashed. There is a general air of dereliction. Cornices are crumbling and plaster has fallen away from the walls in patches.

*Peter Cecil Wilson (1913–1984), auctioneer and chairman of Sotheby's.
†John Winter (1944–2014), president of Sotheby's Italy, later director of Sotheby's London; and Jonathan Mennell (b. 1954). They, together with Jock Palmer, would establish Trinity Fine Art.
‡Laetitia Boncompagni (1920–2007), daughter of Mimì Pecci-Blunt, was the wife of Prince Alberico Boncompagni-Ludovisi (1918–2005).

Tomb of Devereux Plantagenet Cockburn, Cimitero Acattolico (Protestant Cemetery), Rome, 1976

Rome. Tuesday, October 14, 1980

Iris Origo herself answered the telephone when I called to inquire about her state. Very jaunty. Oh, she had been operated on and it was all over, unbeknownst to her in fact, as she thought it was tomorrow. They had tricked her, and it was just as well, having saved her all that worry. What a curious feeling, though, to have lost a whole day. She rambled on and was so hard to understand because of the mumbling that I wasn't sure that she wasn't making sense.

New York. Tuesday, October 21, 1980

Reluctantly to upper Riverside Drive, pausing in the taxi to pick up Danny Berger* at Madison and 80th. He went easy on the nervous slapstick and so was better than in the past. The Kellehers† gave us dinner in their apt on 105th St. Nice decent things—Emerson's desk, a Duncan Phyfe seat-bench sofa. Chinese paintings. Dolphin candlesticks. Delicious dinner of pure white corn—eaten without butter, as it is so good—and chicken with some Chinese sauce and cheese. Soul of goodness kind of people. She nervous and drawn and a little trying, but not much. He stalwart and right. Judicious about [Thomas] Hoving. Scathing about [Joseph] Noble, now director of the Museum of the City of NY. Formerly the archetypical executive-type administrator—Brad Kelleher: the sort of man who would fit in anywhere, a museum, Wall Street, running a gas chamber. A trendy fellow, which accounts for the plastic Big Apple theme at the museum.

Monica had to go back and finish the last of the spots for the *Book Review*, to deliver in the morning. Dropped her at 56th St. and took the taxi on to Columbia Heights, sparkling in the crisp night. Norman Mailer's high, stooped house was all dark, and I almost went back thinking the party was over. It was 11:30. But the front doors were open. At the top of the house one light was on, and I could hear voices from behind a red door.

The large studio room had a spectacular view of a myriad of lights in looming towers across the water. People were sitting—fifty or sixty—on chairs and sofas—and on his feet with his back to the view was Abbie

*Daniel Berger (b. 1938), responsible for merchandising, publications, and marketing at the Metropolitan Museum of Art in New York; longtime consultant to Italy's Ministry of Culture.
†Bradford Kelleher (1920–2007) and Mary Kelleher (1921–2008). Bradford created the museum store at the Metropolitan Museum of Art.

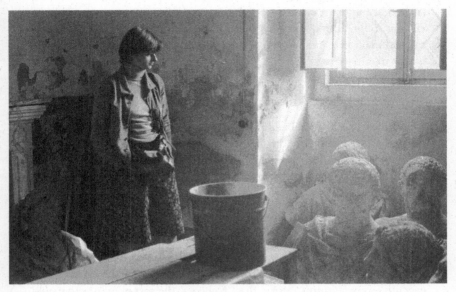

Monica Incisa, Villa Cetinale, Sienna, 1978

Hoffman, the '68 war protester—haranguing the company. He was saying that he wasn't convinced that cocaine was innocuous as a drug and mentioned someone, polemically rising voice, as the pusher for Joe McCarthy. Lally Weymouth* flung her arms around me, and there was Alexander Cockburn alongside. We sat together. A butler brought me a drink. The women all looked stylish. Most of them. Atmosphere of knowingness and well-being. A blond woman wearing black boots asked a question. Poised stance with one booted foot advanced. She wasn't clear what the drugs had to do with [Hoffman's] claims of political persecution. He looked and sounded anguished, and his voice rose. In the vestige of a Yiddish accent, he said, What am I supposed to do, lie down and die?

What a bazaar, said Lally. Isn't it awful? I thought it was going to be one of Norman's regular parties or I'd never have asked you to come, or come myself. I was delighted, though. The very last gasp of radical chic, the apostle of which fifteen years ago had been Lennie Bernstein and his advocacy of the Black Panthers.

Donald Ogden Stewart† was stretched out on the floor looking very earnest.

People started to leave as Hoffman had finished his talk. (It had gone on for more than an hour, and I was very glad that the Kellehers' dinner had made me miss most of it.)

We found a taxi and jammed in and bumped across the Brooklyn Bridge. Lovely in the night as we talked about cocaine and the end of the protest movement. No one has much sympathy for the protagonists anymore. You know Jerry Rubin is a stock analyst in Wall Street, said Alexander.

London. Sunday, November 9, 1980

PM asked tentatively if I wanted to come to church—at St. George's Chapel. "I don't know . . . if you're bored, the architecture and the details are worth studying, and sometimes the music is good." I said I'd go. Another aspect of tourism.

PM and Anna dressed for church in the drawing room, watching the

*Elizabeth Morris "Lally" Graham Weymouth (b. 1943), American journalist; daughter of *The Washington Post*'s Philip and Katharine Graham.
†Donald Ogden Stewart Jr. (1932–2015), a writer for *The New Yorker* and *Playboy*; son of the American screenwriter of the same name who won an Oscar for *The Philadelphia Story* (1940). He lived in Rome for more than fifty years.

Monica Incisa, Palazzo Fortuny, Venice, 1979

royal family laying a wreath at the Cenotaph. Lutyens, the polymathic imperial and country-house architect had done the design after WWI. It was meant to have smoke or an eternal flame spurting from the top. *"Le phallus de l'état en jouissance"* [the phallus of the state in ecstasy], as that clunk Marcellin would put it. We were all soberly dressed, in front of the TV set and on the screen. Picking out people we knew. PM of course knew the most. The great bulk of Christopher Soames.

The three of us, attended by Wellbeloved and Geoffrey* in their semimilitary bumfreezer livery (medals on chest), got into the little blue car and were driven to Windsor by the detective. The usual small crowd of tourists aimed cameras at PM. The governor of the castle, a military bigwig, was there to shake hands. And then the priest in charge of the chapel. A worldly fellow with an easy phrase and convinced handshake. He escorted PM to the upper row of choir stalls. She indicated that Anna and I should go in first.

Hymns and kneelings and sittings and the service under splendid fan vaults, sitting in the stalls of the Knights of the Garter. Their arms surmount the Gothic pinnacles of the stalls. Headdresses in cloth, one with a pair of arms extended, another with a turban, a helmet, and so on. In the flat apse a great stained glass window celebrating Prince Albert. Gilbert Scott.

Wonderful choir. A Schubert number toward the end of the service sounded like an opera aria, carried on a high soprano boy's voice. It made one feel like getting up and waltzing. Princess Margaret met my eye and we had to restrain ourselves from laughing.

At communion time, the entire congregation, except for me and an old woman opposite, who also had not been kneeling, went to the altar rail. Two priests distributed wafers and wine. I noticed that an elderly priest with white hair carefully wiped the chalice after each sip of wine. The other, who was much younger, did not. I thought that he must be closer to the generation of communal joints passed from mouth to mouth—along with hepatitis. PM and Anna went up and communed.

At the end of the service, the priest in charge escorted PM back to her car. Handshakes and goodbyes. Laughing in the car over the lace-collared and scarlet-surpliced choirboy who had taken off in such a spectacular way.

Queen Elizabeth [the Queen Mother] was back from London. PM

*Members of the Queen Mother's staff at Royal Lodge in Windsor Great Park.

Monica Incisa, Via di Sant'Eustachio, Rome, 1978

was giving her an account of my reactions to the Remembrance Day ceremonies at the Albert Hall as seen on TV. I gathered that PM had been carrying on a long campaign against the form of this ceremony, as she had said, "There's nothing to be done with the Queen. I don't know if she loves it, but she doesn't see anything wrong in that mixture of the religious and all those numbers." And I thought, the Queen has the common touch and knows what she's doing. Queen Elizabeth had a patient look on her face as she listened to PM. "Milton agrees that a simple mass prayer would do instead of that procession with the bishop. After all, there is the Cenotaph the next day, when it *is* appropriate."

She was interrupted by the arrival of Bryan Forbes, who came as if bounding in, with his wife Nanette Newman and his daughter Emma, a pretty sixteen-year-old who wants to be a ballerina.*

Bryan talked all the way through lunch almost nonstop. Reminiscences, anecdotes, appeals to Nanette to confirm what he was saying. A tireless routine. Amiable enough and aiming to please. But it reminded me of the Peppers at their most striving, when they batted the ball back and forth and the ball was always some triumph of the Peppers or their children or, it must be said, their friends. Smearing success magic over everything.

Most of his anecdotes were of course about the theater, with some minor asides for Nanette's books. "I don't know how she manages to do *everything*, including writing books." (I do—the books are children's books and rather simpleminded.) His best was about Peter O'Toole in *Macbeth* and how he had decided to drench everything in stage blood, including his leading lady. (That *Macbeth* went down in theatrical history as the worst ever put on.)

Queen Elizabeth was radiating her melting charm in all directions, turning to me occasionally after Bryan had had the floor nonstop for a little too long and putting in a comment or a question. Somehow the war and the Germans came up. It was in connection with the Dutch paintings that had not been sent from Buckingham Palace and Windsor to the salt mines in Wales. She had them with her in the air raid shelter and got to know them intimately. This I suppose in connection with her polite interest in our visit yesterday to Windsor—and there she told how George VI had found Gainsborough's letters on the royal portraits and rehung them

*Bryan Forbes (1926–2013), British writer, director, and producer, and Nanette Newman (b. 1934), British actress and author. Their daughter Emma became a radio and TV host, not a ballerina.

Monica Incisa, St. Mark's Basilica, Venice, 1977

according to his plan. Anyway, her conclusion concerning the war and its threats was to raise her glass of wine and then lower it below the level of the table as she ducked down playfully, saying "Down with the Germans!" Princess Margaret looked amazed and disapproving. "Mummy! Really, you know that's wrong. I've always taught my children not to say things like that. It should be 'Down with the Nazis.'" Queen Elizabeth looked charmingly devilish, lowered her glass again below the table, and said, "Down with the Germans."

If things didn't work out for Anna at Romana's*—Romana was sometimes odd, she was so scatty in Scotland you know—said PM, she must come to Kensington Palace. No, it wouldn't be any trouble. She could use it like a hotel. Like you, said PM roguishly.

London. Monday, November 10, 1980

Second dinner with Princess Margaret. Oh, she was so glad I could come back. Somehow she had assumed I was dining with her. John, the butler, had said I would be in. Roddy [Llewellyn] was away in Sark, to visit an uncle he liked. Had I ever been? She had, and met the then dame, Mrs. Hathaway.†

She was pleased with David and his cabinetmaking school. Just right. Sarah was now a problem, because she had outgrown Bedales but didn't want to leave. She would have to be persuaded. Oh yes, everyone likes Sarah, she is so *agreeable.*

Repeated the invitation to Anna to come and stay with her. And praised Anna. Her mother had remarked after the weekend that Anna spoke when she had something to say and was silent when she didn't.

She took a nice brown-and-blue-striped sweater out of a package and asked if I would like it for Christmas. I tried it on and capered about in it. She was pleased that I liked it.

I went and got another couple of drinks for us out of the drawing room.

Oh dear, it's *midnight,* said Princess Margaret. We must go to bed. So she put her wrapping paper away and turned out the lights, and we went up to the bedroom floor in the elevator and kissed and said goodnight.

*Romana McEwen (1935–2014), daughter of Raimund von Hofmannsthal (1906–1974) and his first wife, Ava Alice Muriel Astor (1902–1956).
†Sibyl Hathaway (1884–1974), the feudal Dame of Sark from 1927 until her death. Sark, one of the British Channel Islands, is a royal fief.

Flea market, Porta Portese, Rome, 1988

Rome. Friday, November 28, 1980

Gaia de Beaumont asking me why I didn't marry Monica when I went back to New York. Monica on the telephone had also returned to the theme. *Vuoi sposarmi?* [Do you want to marry me?] If you'd like it, sure. Then bring my birth certificate when you come to NY. Irrationally, *oramai* [by now], the prospect still makes me uneasy. As if I had an indefinite future that was still full of novelty and surprises and I would certainly live till 95 or 105. Well, who knows that that isn't my destiny.

Lucia Campione, Fabio Borelli, Roberto Levi, and Elena and Vieri and Alessio Vlad came in, to eat a buffet dinner and watch *Ombre rosse* on TV.* That turns out to be *Stagecoach*, which I hadn't seen since it first came out. How thin and creaky it is, and how absurd the inappropriate musical accompaniment. Gaia and I were the only irreverent ones laughing at the violin that came in whenever the film dealt with human intimacy—love scenes, the birth of a child.

Vieri was the authority. He knew the names of all the actors. The others were completely absorbed in it and asked Vieri questions about the dates and other roles of the actors. John Wayne looking like a future presidential candidate.

The Mexicans absurd as they always were in westerns. Like Poles and Germans in Russian novels. More so.

Rome. Sunday, December 14, 1980

Splurged with Raucci, a rough fellow with a mustache, who had a large Pliny, *Natural History,* and a Plato. Quartos bound in vellum. Sixteenth century. Prices marked in back came to 470,000 lire—270 for the Pliny and 200 for the Plato. I started to haggle by offering him 120,000 for the two. He said he wouldn't even listen to me. So I suggested that he make a counteroffer. He reflected for a while, retreating under his vast beach umbrella that was to shelter the books in case it rained. *"Ma se sono segnate 470,000 non posso fare meno di 250,000."* [But if they are marked 470,000, I can't ask less than 250,000.] "All right," I said, "I'll meet you—let's make it 200,000." He said, "220,000." No, I said. He conceded at last, and I wrote him a check and bore the two heavy volumes away with me.

*Lucia Campione (who worked at RAI, Italian television), Fabio Borelli (who also worked at RAI), Roberto Levi (film producer), Elena Levi (antique store owner), Vieri Razzini (film producer), and Alessio Vlad (composer and conductor).

Lion of St. Mark, Venice, 1986

New York. Thursday, April 16, 1981

Collected Anna and Monica at Grace's lobby, having walked up with my bag and Monica's from 56th Street. Taxi to 42nd Street bus terminal and got American lunch at 1:00 p.m. at a joint of hamburger and hot dogs with exceptionally quick and pleasant Hispanic counterman. The 1:15 bus to Kent. Sat with Anna. Monica dozing behind us. "Daddy, this is the furthest north I've ever been in America." Spring in Connecticut. A beautiful day—for a wedding. Francine* was waiting for us, and at Town Hall two merry Santa Claus ladies collected the blood certificates and rubella test and handed over the license, while Monica and Anna in the back seat read with giggles as we drove to the house.

Changed into dark clothes. Alan Perkins, the JP, a gray-haired man in a light-blue suit, arrived. Could he wait until the Libermans came in? They were driving from NY. He could. We fraternized over relationships and where we lived. The Perkinses had been here for centuries. Next Tatiana appeared, with Gennady, the Russian pal of Brodsky, who is opinionated and gets his nose into everything. Where would we stand? Monica chose a place with our back to the window. Perkins took his stance and read the service. The preamble about the "sea of matrimony" had a nineteenth-century ring and produced smiles. I put a ring on Monica's finger, and we repeated the traditional words and were married. Anna had asked Francine for a copy of Shakespeare and asked to read something—it was the sonnet about the marriage of the minds. I was touched by her wanting to have an active part in the ceremony.

Rome. Friday, March 4, 1983

Diana Cooper's pathos, expressed on the back of a uniform Christmas card:

"Lovely to have a word about you tho' not of you—((must refer to the announcement of my photo show))

Do come to London before I die which being ninety can't be long now. I never—alas!—see Anna

Love to anyone who remembers me.

Diana"

*Francine du Plessix Gray (1930–2019), writer and critic. She and her husband, the painter Cleve Gray (1918–2004), offered their home in Warren, Connecticut, for the Gendels' wedding.

Piazza Mattei, 2001

Rome. Thursday, March 17, 1983

Persegati [of the Vatican Museums] received us in a meeting room with a round table surrounded by high-backed brown-leather chairs. More managerial than ever. Leo* explained that he wanted to see the Casino of Pius IV and the gardens and the Sistine Chapel and the Fototeca of the Vatican Pinacoteca. P. arranged on the telephone for the garden visit tomorrow morning. We had a talk. Leo criticized the lighting of the exhibits in the Vatican show that is traveling in the U.S., and P. defended it by saying those objects were on a starring tour and had a right to the limelight. I said I had heard the attendance was less than expected. Oh no, in the beginning there weren't as many sales of tickets for the inauguration as they had expected, but then they had picked up and now the exhibition was drawing crowds. Seven thousand every half hour, he specified. Neat, self-possessed little man, something priestly and something executive about him.

Then he insisted on showing us his first love, which was the closed-circuit television command post, so we solemnly repaired there and admired his organization.

We were turned over to a young man who escorted us to the Fototeca, where my old friend Bandiera, after cordial greetings, complained about the work that was *massacrante e lui tutto solo perché i suoi due aiuti erano in vacanza* [backbreaking work he had to do by himself because his two helpers were on vacation]. But he undertook Leo's request and soon found the bits of the tomb of Paul II that Bramante had dismantled and that are to be reconstructed—according to Persegati, in the hall over the portico of St. Peter's. The reliefs are by Mino da Fiesole, and in particular Leo wanted the one showing Eve being drawn from Adam's rib. After the forms were made out, we were again escorted back to where Persegati sits, to pay the bill. We looked out of the window onto the Cortile delle Corazze, where the base of the Antonine column has been set up. Leo remarked that it was a sarcophagus; he didn't seem to mind being corrected.

The cleaned Michelangelo frescoes in the Sistine Chapel are spectacular. What a transformation. The three of us commented enthusiastically on the sixteenth-century palette becoming visible again. Basis for all the later Mannerist color. And the high relief of the figures and of the architectural elements when they are not flattened by accumulated grime.

Leo spotted [Fabrizio] Mancinelli, the curator of Renaissance art, who

*Leo Steinberg (1920–2011), art critic and art historian. In *The Painted Word*, Tom Wolfe named him as one of the "kings of Cultureburg."

was standing with John Shearman* and Kathleen Weil-Garris[†] observing the display of Raphael tapestries. Shearman had figured out the sequence of the tapestries that were made for Leo X and were full of Medici iconography and found where they were meant to go. He said, humorously triumphant, They fit!

A guard with a fierce manner but a twinkling expression was routing well-groomed elderly American ladies who were flashing away at the walls. Using flashes is not allowed in the chapel.

Leo was very interesting on *The Last Judgment*. Michelangelo had rebuilt the wall so that it sloped in 30 cm. from the top to the bottom. Vasari, ridiculously pragmatic, according to Leo, said that this was done so that the dust wouldn't gather on the surface of the wall. But it was to emphasize the invasion of the chapel's space by *The Last Judgment*. The Church Triumphant replaces the Church Militant, and Christ himself takes the place of the popes. Hence there was no coat of arms of Paul III to replace the one of Sixtus IV corresponding to the one on the opposite wall that had been there. Michelangelo had progressively stepped up the scale of his figures toward the end wall. And the great moldings, for instance defining the corner lunettes, had been narrowed to the maximum. And look at the cross that the stocky figure is planting—where is he setting it? On the cornice itself. That is Simon of Cyrene, according to Leo, and the painting is the first example in art history of the painted invading the real space.

Rome. Monday, May 13, 1985

Long talk [by telephone] with Monica. Her news and mine. She had been to see the Raphael drawing at Princeton that Mrs. Johnson, the pharmaceutical heiress, had bought from the Chatsworth drawings auction. We had gone to see the exhibition together in London. At dinner at Princeton, she had sat next to John Hale, the English art historian, who had claimed acquaintanceship with "Grendel" in Rome. "And I am Mrs. Grendel," said Monica. "Except we say Gendel." "But your husband must be much older than you; I believe he is older than *I* am." Monica looked at his white

*John Shearman (1931–2003), British art historian who taught chiefly at Princeton and Harvard. Specializing in the Italian Renaissance, he was involved in the restoration of the Sistine Chapel frescoes.

†Kathleen Weil-Garris Brandt (b. 1934), British-born art historian and Renaissance specialist at New York University; notable for identifying a marble statue at a French diplomatic office in New York as a cupid by Michelangelo.

hair and wrinkles—the man had been flirtatious—and said, "Yes, but he doesn't look it."

Rome. Monday, July 14, 1985

It was over before I remembered that this is Bastille Day. And all that reminds me of now is that history is full of mistakes. We might invert the old saw—about the land minus history is a happy one—by saying that where there are no mistakes, there is no history.

Suitably, a quick visit to the Porta Portese at 8:00. Landed myself with a big medal of Victor Emmanuel II, commemorating the sixth anniversary of his death, which occurred in 1878. Regretted having resisted an Indian bronze inkwell in the shape of a little elephant and several of those Victorian crystal cubes incised with mottoes and rebuses.

One of them said, "For yew eye live." Get them next time if they are still there.

Milton Gendel, 1975 (Photograph by Igor Palmin)

Acknowledgments

I first heard about Milton Gendel when I was working with Graydon Carter at *Vanity Fair*. Graydon knew Milton, and because I was frequently in Rome, he mentioned one day that he thought I'd enjoy meeting him. He was certainly right about that. Ultimately, *Just Passing Through* owes its existence to Graydon's suggestion.

Many individuals have had a hand in the preparation of this book—indeed, in making the book possible. To begin with, I am grateful for the generosity of the Fondazione Primoli, which has made Gendel's photographs available for publication. Special thanks go to the foundation's president, Roberto Antonelli, and to its archivist, Valeria Petitto, as well as to Fabrizio Fasano and Cecelia Burla. Davide di Giovanni was instrumental in furnishing the necessary photographic images from the foundation's archives. Lewis Khan in London provided high-quality images from photographs that exist only as prints in Gendel's scrapbooks; my thanks to Christine Walsh of *The Atlantic* for putting us in touch. Thanks also to Ingrid Becker-Ross-Troeller, who granted permission to use two photographs by her late husband, Gordian Troeller; and to Yuri Palmin, who likewise granted permission to use a photograph by his late father, Igor Palmin.

Friends and acquaintances of Gendel assisted in a variety of ways. James Reginato arranged my first meeting with Milton, making the calls that put us together; a short item Jim wrote for *V.F.* about Milton's six-decade Roman holiday inspired the subtitle for this book. Other friends and acquaintances of Gendel and his family consulted their memories and provided hard-to-find information about specific events or general back-

ground: Gaia de Beaumont, Sabina Bernard, Joan Juliet Buck, Marella Caracciolo Chia, Barbara Drudi, Claudia Fitzherbert, Giles Fitzherbert, David Friend, Lindsay Harris, Benedetta Lysy, Katia Lysy, Peter Benson Miller, and Lady Teresa Waugh. Sue Parilla, a longtime *Atlantic* colleague, was invaluable as an all-around researcher.

Finally, as ever, I am grateful to the superb team at Farrar, Straus and Giroux: Jonathan Galassi, who saw the possibilities for a book of this kind; Ileene Smith, a shrewd and knowing partner who not only brought her editorial skills to the task but also had the great advantage, and pleasure, of having known Gendel and his family; and Ian Van Wye, Nancy Elgin, Debra Helfand, Janet Biehl, Rose Sheehan, and Erika Seidman. The book was designed by Jonathan Lippincott, whose elegant work speaks for itself.

Raphael Sagalyn, friend and agent, has been a counselor on this as on every project.

More than many books, *Just Passing Through* has been a family affair. The material centers around a family—a very extended family that also includes widening circles of friends. Milton Gendel's daughter, Anna Gendel Mathias, and Gendel's wife, Monica Incisa della Rocchetta, have been deeply involved in the making of this book. Anna's husband, Charles Mathias, whom I met after Gendel's death when the apartment in Palazzo Primoli was being unpacked and repacked, has been a source of patient counsel and support. To have friends like these as collaborators has been a reward in itself.

My wife, Anna Marie, has always been my first collaborator and my first reader. Milton recorded everything in his diaries, and so of course his first meeting with Anna Marie is there. I will always cherish the memory of the moment. Milton's hands were shaking, as they often did in his later years—it was hard to play host. Anna Marie disappeared into the palazzo's antique kitchen. She emerged shortly with a plate of biscuits and a pot of tea.

A Note About the Editor

Cullen Murphy is an editor at large of *The Atlantic*, where he was previously the managing editor; he has also been the editor at large of *Vanity Fair*. Over a period of four decades his reporting and writing have taken him frequently to Rome. His books, which cover a wide range of subject matter, include *Are We Rome? The Fall of an Empire and the Fate of America* (2007); *God's Jury: The Inquisition and the Making of the Modern World* (2012); and, most recently, *Cartoon County: My Father and His Friends in the Golden Age of Make-Believe* (2017). He is currently completing a book about the fountains of Rome.